W9-AEA-098

American Masters

with contributions by
Catherine Aman
Ellen S. Collison
Starr Figura
Judith Holme
Margaret Kinzer
Jean L. Linton
Bruce Robertson
Douglas Shawn

AMERICAN MASTERS:
Works on Paper from
The Corcoran Gallery of Art

by
Edward J. Nygren
Linda Crocker Simmons

Smithsonian Institution Traveling Exhibition Service
and The Corcoran Gallery of Art

Washington, D.C. 1986

This exhibition was developed by the Corcoran Gallery of Art and circulated by the Smithsonian Institution Traveling Exhibition Service. SITES is a program activity of the Smithsonian Institution that organizes and circulates exhibitions on art, history, and science to institutions in the United States and abroad. Funding towards the development of the project was provided to the Corcoran Gallery of Art by the National Endowment for the Arts.

Published on the occasion of an exhibition organized by the Smithsonian Institution Traveling Exhibition Service and the Corcoran Gallery of Art and shown at:

Oklahoma Museum of Art, Oklahoma City, Oklahoma

The Queens Museum, Flushing, New York

The Corcoran Gallery of Art, Washington, D.C.

Burling Library, Grinnell, Iowa

Cincinnati Art Museum, Ohio

The Society of the Four Arts Palm Beach, Florida

Cover:
Childe Hassam, *Big Ben,* 1897–1907, gouache and watercolor over charcoal on gray-tan paper

Title page:
John Frederick Kensett, *Building by a Dam,* c. 1850–1860, graphite with sgraffito on tinted prepared Ackerman paper

Edited by Diana Menkes and Nancy Eickel

Designed by Polly Sexton

Composed in Sabon by Carver Photocomposition, Inc.

Printed by Eastern Press, Inc.

American Masters: Works on Paper from The Corcoran Gallery of Art
© 1986 Smithsonian Institution and The Corcoran Gallery of Art.
All rights reserved.
Library of Congress Cataloging-in-Publication Data

Corcoran Gallery of Art.
 American masters.

 Includes bibliographical references and index.
 1. Art, American—Exhibitions. 2. Art, Modern—United States—Exhibitions. 3. Corcoran Gallery of Art—Exhibitions. I. Nygren, Edward J. II. Simmons, Linda Crocker, 1948– . II. Smithsonian Institution. Traveling Exhibition Service. IV. Title.
 N6505.C65 1986 741.973'074
 86–17848
 ISBN 0-86528-035-5

Contents

Acknowledgements

GOOD PARTNERSHIP IS KEY TO THE success of any joint project. Over the past several years the Corcoran Gallery of Art and the Smithsonian Institution Traveling Exhibition Service (SITES) have formed strong ties in developing exhibitions that serve both institutions' goals as well as their shared commitment to American art. Past exhibitions—on the history of genre in this country and on the drawings of the American expatriate John Singer Sargent—were developed in 1981 and 1983 from the Corcoran's rich holdings and traveled to institutions throughout the United States under the auspices of SITES. Again, in 1986, this collaborative spirit is renewed through the exhibition and its accompanying catalogue, *American Masters: Works on Paper from the Corcoran Gallery of Art*. Drawn from the Corcoran's extensive collections and jointly organized by the Corcoran and SITES, *American Masters* represents the cooperation and interest in American art we and other institutions on the tour share.

Many persons both in and outside of our organizations contributed to this endeavor. At the Corcoran Gallery of Art we thank William Bodine for his adminis-

trative work; Barbara Moore for her organizational and educational expertise; Elizabeth Beam and Rebecca Tiger Gregson for their attention to registrarial concerns; Katherine M. Kovacs and Ann Maginnis for their research assistance; Dare Hartwell for her coordination of conservation needs; Starr Figura, Nancy Huvendick, Sallie Bodie, and Belinda Barham for preparing the manuscript; and John Birmingham for matting and preparing the works for exhibition. The conservation treatment of many works was performed with great care and ability by Katherine G. Eirk of Bethesda, Maryland, and Sian Jones of Baltimore, Maryland.

At the same time we extend gratitude to those at SITES whose efforts were vital to the project's realization. Among them are Lori Dempsey, who oversaw the development of the exhibition and catalogue; Judith Bell, who completed preliminary negotiations; Patty Pelizzari, who compiled the checklist and other publication materials; Andrea Stevens and Nancy Eickel, who produced the catalogue; and Mary Jane Clark and the SITES registrars, particularly Cheryl Korte and Carol Harsh, who directed the packing

and traveling of these artworks. In addition, we recognize the staff of the Office of Exhibits Central, whose work made these objects safe for extensive travel.

We also want to thank those other individuals who have been generous with their time, personal knowledge, and expertise in art history during the compilation of the catalogue material. Special appreciation is extended to the artists and their families and friends, who responded to our many inquiries regarding these drawings. With their enthusiasm and assistance, *American Masters: Works on Paper from the Corcoran Gallery of Art* offers a revealing glimpse into the mystery of the artistic process.

PEGGY A. LOAR
Director, SITES

MICHAEL BOTWINICK
Director, The Corcoran Gallery of Art

American Masters:
Works on Paper from
The Corcoran Gallery of Art

WORKS ON PAPER ARE DEMAND-ing. Their intimate size and style frequently require close examination; they engage a viewer in a private dialogue. Few have the sheer physical presence of a painting or sculpture. Works on paper also demand attention because they are so seldom on view, which is a result of their need to be protected in a way that other works of art do not require. Their seemingly fugitive nature keeps them hidden from the most diligent museum goer for years on end. When they are placed on public view, they are shown in a controlled environment of reduced light levels that insures their preservation and signifies their specialness. But modern conservation concerns neither prescribe nor explain the pleasure that works on paper give to artist and public alike. They have an aura of their own, an appeal that is in part due to the special insight they provide into the creative process.

The Corcoran is fortunate to have a large collection of works on paper. The seventy-five pieces in this exhibition were chosen from over seventeen hundred created by more than six hundred American artists. Given the size of the collection, the selection was

the result of a long and trying process: many objects by acknowledged American masters, as well as masterworks by lesser-known artists, had to be eliminated. From the outset, certain criteria guided the selection. Most important was quality. The works chosen represent a high level of accomplishment. The artists—whether historical or contemporary, known or unknown—are American masters, who used their significant talents and skills to fashion distinguished works. But other factors were also taken into consideration in the selection. First, it was felt that the chronological breadth of the entire collection should be suggested. The pieces span almost two hundred years and range from John Singleton Copley's pencil and chalk study of 1785–1786 for the *Siege and Relief of Gibraltar* to John Alexander's 1982 watercolor *Welcome to My World*. Second, no artist was to be represented by more than one work. In the case of John Singer Sargent, for example, *Olimpio Fusco* was chosen from the 105 drawings by that artist in the collection. Third, all media with one exception were included: there are drawings in pencil and ink, chalk and charcoal; paintings in

watercolor and gouache, oil and acrylic; and collage. Only pure pastel, because its fragile nature made travel prohibitive, was excluded.

The selections also typify the way in which an artist works with paper, the way in which he or she uses materials and to what end. Some, such as the Copley or Mayer pieces, are studies for oil paintings. Others, such as the Hill or Bontecou, are finished works of art. The McEntee and Haseltine were sketched from nature at a time when artists made annual pilgrimages to the country or abroad with sketchpad in hand. The Weir and Gibson are illustrations. Others are designs for three-dimensional works: Antonakos and Stackhouse offer detailed drawings of sculpture; Christo and Oppenheim, conceptual presentations. Ranging from preliminary ideas that reveal the artistic process to compositions as fully realized as any oil painting, these seventy-five pieces show how works on paper can vary in size from the small to the monumental, in execution from the spontaneous to the carefully wrought.

Because of their chronological range and thematic differences,

these objects further serve as an index of changes in style and of shifts in cultural attitudes. The works of Vanderlyn, Abbot, Cole, Harvey, and Mayer from the early nineteenth century show artists defining and idealizing the American experience—its people and landscape, its history and heritage—in a naturalistic style appropriate to their narrative and moral purposes. Watercolors from the post-Civil War period, such as the Homer and La Farge, show an increased introspection and heightened aestheticism, while the visual conventions of the Leutze and the Hassam hint at the impact of successive European styles on American art.

The works of the early twentieth century—the Farny and Dewing, the Prendergast and Bellows, the Demuth and Hartley—underscore the dramatic differences in aesthetic sensibilities around the time of the famous Armory Show of 1913. The dynamic and divided nature of American art as it embraced or rejected the European avant-garde is evident in the diversity of points of view in the modernism of Chaffee and Zorach, the social realism of Marsh and Crite, the idealization of Lachaise and Kroll, the abstraction of Calder and Morris. The stylized, ideogramic watercolors of Indians, though peripheral to the artistic mainstream, add a native note to American pluralism of the 1920s and 1930s. The collage introduced a new mode of expression.

Art of the post-World War II period proved no less diverse. Pearlstein, Jamieson, Wesselmann, and Gordy all use the nude, but to dramatically different ends. From highly naturalistic to broadly stylized, from cooly abstract to intensely expressionistic, these figural compositions reflect divergent personal and aesthetic attitudes about the nature of American society and art. The last several decades have been even less artistically monolithic. The works of McNeil, Guston, Motherwell, Rockburne, Christo, Dow, and Dunlap cover a wide artistic spectrum. There is no single voice, no stylistic homogeneity. One unifying force does exist, however, in much contemporary art—an underlying interest in process. In process for its own sake, but also as a visual expression of the unconscious, of the nonverbal. Today, we recognize the way in which art, whether abstract or representational, is a silent language. These works give voice to that concept.

Process and diversity are not unique to American art in the second half of the century. And styles as well often transcend national boundaries. But just as the works from the nineteenth century in this exhibition present a variety of thematic issues that objectify broad cultural attitudes and are public in their moral purposefulness, those from recent years display in their multiplicity and idiosyncracy of styles and techniques a sensibility that is at heart subjective and private. This selection of seventy-five works from the Corcoran collection serves, in effect, as a miniature survey of the ideas and concerns of American art of the past two hundred years.

EDWARD J. NYGREN
Curator of Collections

LINDA CROCKER SIMMONS
Associate Curator for Prints and Drawings

October 1, 1987

Mr. George McNeil
195 Waverly Avenue,
Brooklyn, New York 11205

Dear Mr. McNeil,

The exhibition <u>American Masters: Works on Paper from the Corcoran Gallery of Art</u> is in the middle of a two-year traveling tour. As you may know the following work by you:

<u>Dionysus</u> 1973
Craypas and wash on Arches paper

is among the seventy-five pieces chosen for this exhibition. We are delighted with the show and the public response to it. A copy of the catalogue is enclosed. I hope you will be able to attend the reception here at the Corcoran on October 19th. If you are unable to come please feel free to visit the Gallery when convenient. A schedule of the upcoming dates and locations for the traveling tour is enclosed. You may have other opportunities to see the exhibition at one of these institutions.

I hope you will enjoy the exhibition and I look forward to greeting you on the 19th.

Sincerely,

Linda Crocker Simmons
Associate Curator of Collections, Prints and Drawings

AMERICAN MASTERS: WORKS ON PAPER FROM
THE CORCORAN GALLERY OF ART

Itinerary

1987

October 17- December 6 Corcoran Gallery of Art
 Washington, D.C.

1988

January 15 - February 28 Burling Library
 Grinnell, Iowa

April 4 - May 1 Cincinnati Art Museum
 Cincinnati, Ohio

June 7 - July 21 Midland Art Council
 Midland, Michigan

Catalogue of the Exhibition
Notes On The Entries

Title and date: If the artist's original title is known or if a previously published or historically relevant one has been determined, this is the title used.

The date of execution is given as precisely as possible. In general, a time span of several years— e.g., 1930–1935— means that the work was probably completed during one of those years, not *over* that five-year period.

Dimensions: Measurements are given in inches and centimeters, height preceding width.

Medium: A precise listing of materials and methods is given. If a work (other than a collage) has been completely adhered in some manner to a mount, it is described as "laid down."

Inscriptions: Artists' inscriptions are included, enclosed in quotation marks. Slashes with space before and after are used to indicate lineation—the demarcation from one line to the next. In the rare cases when slashes are used without ᵔace before and after, this signifies that ᵔ artist himself has written a slash, ᵔt always with dates (e.g., 6/72).

ᵔ locations of the inscriptions on ᵔ recto or verso side of the work of ᵔn as follows:

ᵔper left
ᵔer center
ᵔ right
ᵔeft

ᵔ center
ᵔower right

ᵔnnotations (anything written by anyone other than the artist) are not recorded unless they provide vital information, and then they are distinguished from inscriptions.

Source and accession number: The source and manner of acquisition for each object are given with the Corcoran Gallery accession number. The familial relationship of the donor to the artist is given when it is known.

Footnotes: Citations for *American Drawings, Watercolors, Pastels and Collages in the Collection of the Corcoran Gallery of Art* by Linda Crocker Simmons, et al., (Washington, D.C.: Corcoran Gallery of Art, 1983) are abbreviated to *American Drawings, Watercolors . . . in the Collection of the Corcoran.*

John Singleton Copley
(1738–1815)

COPLEY WAS BORN JULY 3, 1738, IN Boston. His stepfather, Peter Pelham, portrait painter, engraver, and schoolteacher, became Copley's earliest teacher and introduced him to the work of John Smibert. Other colonial painters such as Robert Feke and Joseph Blackburn influenced the young painter's work. By the age of nineteen Copley had established a reputation in Boston as a portrait painter. In 1765 he sent his painting *Boy with a Squirrel* to London, where it was favorably received. He was encouraged by Joshua Reynolds to seek further study abroad. However, it was not until 1774 that he embarked for Europe, touring Italy to study and copy classical and Renaissance art before settling permanently in London. Turning to historical painting, he achieved popular and critical acclaim, as well as membership in the Royal Academy. Copley, who never returned to America, died in London, September 9, 1815, at the age of seventy-seven.

Three Figures Pulling on Spanish Colors[1] (Study for *Siege of Gibraltar*, 1783–1791, oil on canvas, collection of the Corporation of London) 1785–1786
Charcoal heightened with white chalk with graphite grid on blue-gray paper
13⅞ × 22⅜ in. (35.3 × 56.9 cm)
Inscribed, l.r.: "This is Siege of Gibraltar."[2]
Museum purchase 1948
Acc. No. 48.10

The British fortress of Gibraltar had been besieged by Spain before in the century, but the great siege began in June 1779 and reached a critical point in September 1782 when the Spanish, equipped with ten specially built floating batteries armed with some two hundred cannon, commenced an all-out assault. The battle lasted the whole day of September 13; that evening one of the Spanish boats caught fire, enabling the British to shoot into the night with accuracy, and the assault failed. This important victory at Gibraltar was widely celebrated in England, creating public demand for written accounts and prints of the action. Less than six months after the victory the Corporation of the City of London commissioned Copley to paint the historic event.[3] The result was Copley's largest work (almost 18 × 25 feet), eight years in the making.

Copley initially planned to depict the dramatic scene in the harbor with a view of the Rock and the British officers in the background.[4] But in 1786, when Copley sketched the proposed composition onto canvas, a major complication arose. Officers who had participated in the battle saw the sketch and protested that they were not sufficiently prominent; a new vantage point had to be chosen. Eventually a somewhat concocted scene was agreed upon. The officers would be shown at the South Bastion (though General Elliott had actually been on King's Bastion). Copley would condense his earlier design of events in the harbor into the left side of the canvas.[5]

The *Morning Post* on October 2, 1786, noted that Copley was "literally laying siege to Gibraltar, as he has models not only of the fortress, but of gun boats, shiptackle, men, and every instrument of destruction arranged before him in all the stages of his progress." Another visitor noted that "the picture was immense; and it was managed by means of a roller, so that any portion of it, at any time, might be easily seen or executed. The artist himself was raised on a platform."[6]

In early 1788 Copley completed an oil sketch of the whole composition. This sketch incorporates many harbor studies, including the Corcoran drawing, which was done between 1785 and 1786. The three figures were to be modified in the final composition as emphasis shifted from historical accuracy to characterization of the heroic officers; however, they survive in the final oil to the far left on the bow of the first ship, dramatically pulling down the Spanish colors.[7] Copley has modified their arrangement by bringing the middle figure to the fore. The effect is a greater emphasis on the reach and sweep of their action that contributes height to the left side of the composition.

Copley made many preparatory drawings on blue-gray paper. Here it is squared with a grid of graphite lines as an aid in transferring the elements of the drawing, presumably to an intermediate study. This drawing is one of a group sold from the library of Copley's son, Lord Lyndhurst.[8] Later, Copley's granddaughter, Martha Babcock Amory, and her family purchased them. Subsequently they were given to a servant in whose family they descended until their sale and dispersal in 1947.[9]

CA

1. Called simply *Three Men* in *American Drawings, Watercolors . . . in the Collection of the Corcoran*, the title *Three Figures Pulling on Spanish Colors* is from Jules David Prown, *John Singleton Copley*, Vol. II: *In England 1774–1815* (Cambridge, Mass.: Harvard University Press,

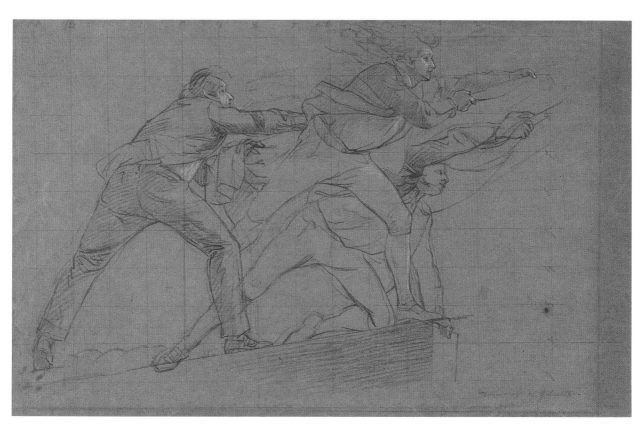

John Singleton Copley
Three Figures Pulling on Spanish Colors
1785–1786

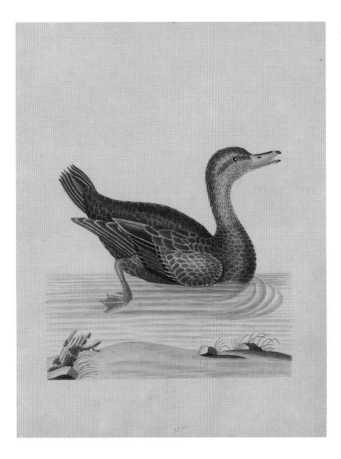

John Abbot
Roan Duck
c. 1792–1802

Joshua Shaw
Landscape with Deer, North Carolina
c. 1818–1821

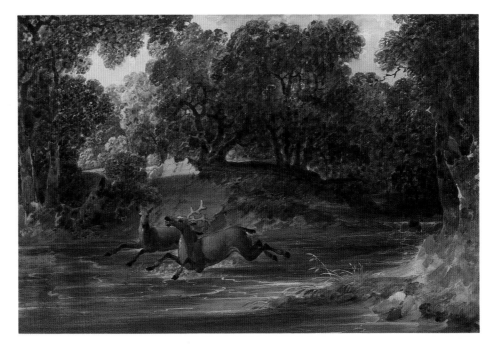

1966), p. 449.

2. Prown does not believe the inscription was written by Copley (ibid.).

3. Ibid., p. 323.

4. National Gallery of Art, John Singleton Copley 1738–1815 (Washington, D.C.: Smithsonian Institution Press, 1965), p. 110.

5. Prown, pp. 324–326.

6. Morning Post and Thomas Frognall Didbin, Reminiscences of a Literary Life (London, 1836), p. 151, as quoted in National Gallery, p. 110.

7. Prown, pp. 328–330.

8. David B. Warren, Bayou Bend: American Furniture, Paintings and Silver from the Bayou Bend Collection (Houston: Museum of Fine Arts, 1975), p. 135, item 252.

9. Helen Comstock, "Drawings by John Singleton Copley," Panorama: Harry Shaw Newman Gallery 2 (May 1947): 100.

2

John Abbot
(1751–c. 1840)

BORN IN LONDON ON JUNE 11, 1751, Abbot was the son of a barrister who encouraged his scientific and artistic inclinations. He was taught the rudiments of drawing, perspective, and printmaking at home by Jacob Bonneau, an engraver and drawing master. An avid naturalist, Abbot left London in 1773 under the sponsorship of the Royal Society and private collectors to gather specimens in Virginia. As the American Revolution got underway, Abbot moved south, to Burke County, Georgia, where he remained from early 1776 until his death some sixty-four years later.[1]

Roan Duck c. 1792–1802[2]
Watercolor over graphite on paper laid down on paper with a painted frame
11³⁄₁₆ × 8¹¹⁄₁₆ in. (28.5 × 22.1 cm)
Inscribed, l.c.: "125"[3]
Museum purchase through a gift of Mrs. H. S. Black 1981
Acc. No. 1981.6

During his long life Abbot completed over five thousand watercolors of the flora and fauna of Georgia. Most of the paintings were acquired by English collectors; this particular work was among a group of thirty-three illustrations of Georgia birds purchased by Chetham's Library in Manchester, which in 1792 had bought a hundred similar works through Abbot's London agent, John Francillon.

Abbot's ducks usually float passively on the water, but here the vigorously swimming bird has animation. Commonly known as the Black Duck (Anas rubripes), the subject is one of the most numerous surface-feeding ducks in the Northeast. In Georgia, however, it was not common in the artist's time nor is it today. Abbot usually wrote commentaries on his subjects; his description of the Roan Duck reads:

> Length 26 inches, breadth 38. Frequents the Ponds and Swamps in Company with the Mallards, but the Drake wants the curled feathers in the tail, it is certainly a distinct species (have been told they are in great plenty to the Southward without any Mallards), they are not common in these parts.[4]

Abbot often presented a single specimen in an abbreviated natural setting, indicating the influence of George Edwards, an important eighteenth-century British ornithologist. Abbot as a young man had met Edwards and acquired his publications. This elegant watercolor in addition displays Abbot's talent for composition and his technical skill in capturing the nuances of the bird's color and texture through his delicate application of watercolor.

JLL

1. Vivian Rogers-Price, John Abbot in Georgia: The Vision of a Naturalist Artist (1791–ca. 1840) (Madison, Ga.: Madison-Morgan Cultural Center, 1983), is the only major scholarly study of the artist. The information given above is based on that catalogue.

2. Published with the date of c. 1790 in American Drawings, Watercolors . . . in the Collection of the Corcoran, the work has been assigned this range of dates by Rogers-Price, p. 83.

3. The correct number should be 126 to correspond to Abbot's entry for this bird in "Notes on the Birds Continues," Special Collections Division, University of Georgia Libraries, Athens, Georgia; see Rogers-Price, p. 83.

4. Rogers-Price, p. 83.

3

Joshua Shaw
(1776–1860)

BORN IN BELLINGBOROUGH, LIN-colnshire, England, Shaw was orphaned at an early age. Apprenticed to a sign painter, he worked in Manchester for a time before turning to the fine arts. After a period in Bath, he went to London, where he exhibited at the Royal Academy and the British Institution. In 1817 he brought Benjamin West's Christ Healing the Sick to Philadelphia. His reasons for settling in America are not known. Shaw specialized in landscapes of a poetic vein, which exhibit his firsthand knowledge of current British ideas and taste. He was a pivotal figure in the development of landscape painting in America and an outspoken defender of artistic interests in Philadelphia. Inventor as well as artist, he eventually settled in Bordentown, New Jersey. He died in nearby Burlington, on September 8, 1860.

Landscape with Deer, North Carolina c. 1818–1821
Watercolor and gouache over
 graphite on paper
9 × 13½ in. (22.8 × 34.3 cm)
Inscribed, verso of backing sheet,
 l.c.: "North Carolina / J. Shaw"
Museum purchase through a be-
 quest of James Parmelee 1965
Acc. No. 65.7

Around 1818 Shaw embarked on a project to bring before the public "correct delineations of some of the most prominent beauties of natural scenery in the United States." It was a joint effort, with Shaw doing the drawings and John Hill, also a recent emigrant from England, transforming them into prints. Thirtysix plates were projected, but only twenty were published in 1820 as *Picturesque Views of American Scenery.*[1] Although the sites were identified, the landscapes are more evocative than topographic.

Shaw's travels in search of subjects for this portfolio took him to North Carolina. It is possible that this watercolor dates from that period. Although a later date cannot be ruled out since Shaw made at least one other trip south in 1821 and sometimes painted works from sketches done years before,[2] the technique of this piece suggests it was created shortly after the artist came to America. Its style and palette are particularly reminiscent of the work of the contemporary English watercolorist John Varley. The finish and the composition indicate it was executed in a studio rather than on the spot.

The subject, too, strikes an English note. Inscribed "North Carolina" on the back of the mounting paper, the locale presumably is that state. However, Shaw has interpreted the area in British terms: the frolicking deer would be more at home in views of English parks than in the Carolina wilderness; and the bucolic composition with its russet foliage, twisted tree trunks, and delightful stream conforms to the aesthetic concept of the picturesque. *Landscape with Deer* is an accomplished watercolor by an artist who clearly had command of current British landscape theory and practice.

EJN

1. Joshua Shaw, *Picturesque Views of American Scenery* (Philadelphia: M. Carey and Sons, 1820), p. 1. Hill (1770–1850) came to Philadelphia from his native London in 1816, and *Picturesque Views* was his first major commission.

2. In 1822 Shaw published the *U.S. Directory for the Use of Travellers and Merchants*, which contained information on the various regions in the United States, including the Carolinas. In 1830, he exhibited a South Carolina view with deer at the Pennsylvania Academy; in 1835, a scene in North Carolina; and in the same year, he recorded having seen in Georgia in 1821 the view he had just painted. For a discussion of Shaw's life and work, see Miriam Carroll Woods, "Joshua Shaw (1776–1800): A Study of the Artist and His Paintings," master's thesis, University of California, Los Angeles, 1971.

4

Thomas Doughty
(1793–1856)

BORN IN PHILADELPHIA ON JULY 19, 1793, Doughty was apprenticed to a leather currier as a young man. Essentially self-trained as an artist, he first exhibited at the Pennsylvania Academy of the Fine Arts in 1816. Four years later he decided to devote himself to landscape painting.[1] In 1824 he was elected to the Pennsylvania Academy, honorary membership in the National Academy of Design followed, and by 1829 Doughty was in Boston, exhibiting his works at the Athenaeum. On his return to Philadelphia the next year he began to publish the magazine *The Cabinet of Natural and American Rural Sports*. With its failure in 1832 he went back to Boston. He eventually settled in New York, which remained his home until his death on July 22, 1856.

Harper's Ferry from Below
 c. 1825–1827
Pen with black and brown ink and
 watercolor wash on paper
7³⁄₁₆ × 11⅛ in. (18.1 × 28.2 cm)
Inscribed, l.l.: "Harpers Ferry from
 below/Doughty"
Museum purchase through a gift of
 Orme Wilson 1964
Acc. No. 64.14

Harpers Ferry was made famous by Thomas Jefferson, who wrote in *Notes on Virginia*: "The passage of the Potomac through the Blue Ridge is perhaps one of the most stupendous scenes in Nature. . . . In the moment of their junction [the Shenandoah and the Potomac rivers] rush together against the mountains, rend it asunder, and pass off to the sea."[2] Generally this grand scene was viewed from the hills above the confluence of the rivers, from the Jefferson Rock. Doughty may have been the first artist to capture the sublimity of the landscape from below, a viewpoint which emphasizes the rocks, the rushing waters of the Potomac, and the heaviness of the riverbanks looming over the federal armory buildings of the town of Harpers Ferry.

The straightforward character of the drawing, its linear forms, and clear tints relate it to topographical sketches of the period and establish its affinity with British watercolors as well as those of such Philadelphia contemporaries as Charles Willson Peale, John Rubens Smith, and Joshua Shaw. This sketch may be a preliminary

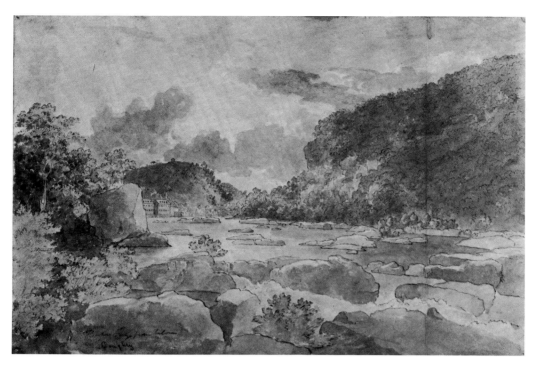

Thomas Doughty
Harper's Ferry from Below
c. 1825–1827

Thomas Cole
Sketch of Tree Trunks
1823–1825

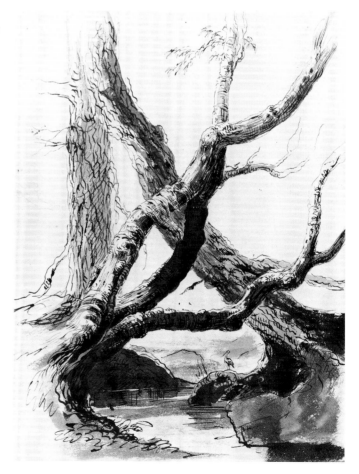

study for a painting of Harpers Ferry that Doughty exhibited at the National Academy in 1826 or at the Boston Athenaeum in 1827, one of which could have been the work he created for the steamboat *Albany* in 1827.[3] These oils, however, have not been located. The vertical fold along the right side of the paper suggests how the artist could have adapted the sketchbook page to a painting format.

BR

1. Frank H. Goodyear, Jr., *Thomas Doughty 1793–1856: An American Pioneer in Landscape Painting* (Philadelphia: Pennsylvania Academy of the Fine Arts, 1973), p. 14.

2. Thomas Jefferson, *The Life and Selected Writings of Thomas Jefferson* (New York: Random House, 1972), pp. 192–193.

3. David Sellin, *American Art in the Making: Preparatory Studies for Masterpieces of American Painting, 1800–1900* (Washington, D.C.: Smithsonian Institution Press, 1976), p. 18.

5

Thomas Cole
(1801–1848)

BORN IN BOLTON-LE-MOORS, LANcashire, England, on February 1, 1801, Thomas Cole came to America with his parents in 1818. After assisting with his father's wallpaper and floorcloth enterprises in Steubenville, Ohio, and Pittsburgh and attempting a career as an itinerant portrait painter for a year, Cole settled in Philadelphia in 1823 to seriously pursue art studies. In this he was mainly self-taught, drawing from casts in the Pennsylvania Academy of the Fine Arts and examining the paintings in the Academy's permanent collection and annual exhibitions. Two years later an exhibition of several landscapes in New York brought him recognition. One of the founders of the National Academy of Design in New York in 1826, Cole played a leading part in the development of American art in the second quarter of the nineteenth century. He is considered the seminal figure in the emergence of an American school of landscape painting now known as the Hudson River School. He eventually settled in Catskill, New York, the area that inspired so many of his scenic views. He died there on February 11, 1848.

Sketch of Tree Trunks
1823–1825[1]
Black ink, wash, and graphite on paper
14 11/16 × 10¾ in. (37.4 × 27.3 cm)
Museum purchase 1949
Acc. No. 49.48

As early as 1823, when he was still living in Pittsburgh, Cole began to do detail studies from nature.[2] An inveterate sketcher, he filled numerous books with drawings made during his later tours of the Catskills, White Mountains, and the other areas he often visited with fellow artists. Some of these sketches eventually were turned into paintings.

This ink and wash drawing, which may be compositionally indebted to a Dutch prototype, seems less a sketch from nature than a study done or at least finished in the studio. The intricate organization of the large stylized tree trunks, the placement of the heron in the middle distance, the soaring birds and mountains glimpsed through trees flanking a meandering river all suggest, as does the tracing of the three overlapping branches on the reverse, that this is a composed work rather than a spontaneous sketch. The dramatic chiaroscuro and controlled use of wash to create a focal point further support such a premise.

This composition resembles other early drawings of fantastically gnarled trees at the Detroit Institute of Arts.[3] With its air of stillness and isolation, it establishes a romantic mood. No painting based on this sketch has been identified; however, the bold handling of the trees and the drama of the wilderness setting relate it to such oils as *Lake with Dead Tree* of 1825 (Allen Memorial Art Museum, Oberlin) and *Landscape with Tree Trunks* of 1828 (Rhode Island School of Design).

EJN

1. I wish to thank Ellwood C. Parry III for providing comments on the date of this work.

2. See a tree study dated May 20, 1823, in the Albany Institute of History and Art, reproduced in Howard S. Merritt, *To Walk with Nature: The Drawings of Thomas Cole* (New York: Hudson River Museum, 1982), No. 1.

3. See, e.g., 39.108, 39.161, and 39.162; two of these are illustrated in Merritt, Nos. 3 and 5. Similar works can be found in Cole's last sketchbook of a trip to the White Mountains in 1827, also in the Detroit Institute of Arts. And see *Tree Sketch from Nature near Pittsburgh*, from 1823, at the New-York Historical Society.

6

George Harvey
(c. 1800–c. 1878)

BORN IN TOTTENHAM, ENGLAND, around 1800, Harvey spent the majority of his active career as an artist in America. He arrived in New York in 1820. Becoming a miniature painter, he was elected an associate of the National Academy of Design in 1828. Poor health led him to retire in 1835 to Greenburgh, near Hastings-on-Hudson, where he helped design Washington Irving's home, Sunnyside. It was about this time that Harvey took up landscape paint-

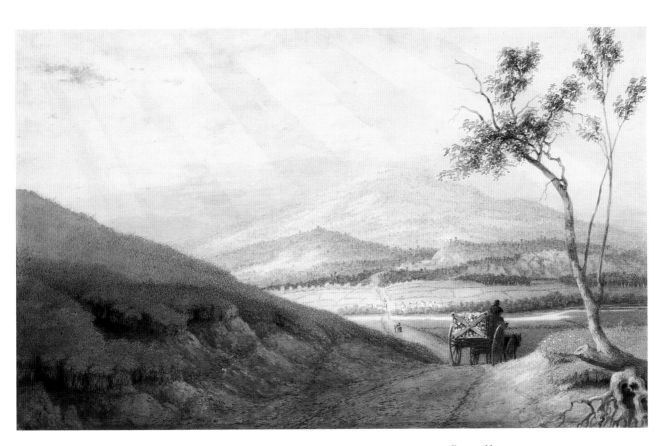

George Harvey
*A Gleamy Effect—Hollidaysburg,
Pennsylvania*
c. 1836

ing and conceived of a series of works dealing with atmospheric effects in North America. He planned to publish them as prints; however, except for the four compositions issued separately in 1841, the publication of "Atmospheric Landscapes of North America" never was realized. Harvey returned periodically to England, where he died around 1878.

A Gleamy Effect—Hollidaysburg, Pennsylvania c. 1836[1]
Watercolor, gouache, and sgraffito on paper
8⅜ × 13¹¹/₁₆ in. (21.3 × 34.7 cm)
Inscribed on original mat, u.c.: "A Gleamy Effect"; l.c.: "Hollidaysburg Pennsylvania"
Museum purchase 1948
Acc. No. 48.20

In Harvey's preface to *Scenes of the Primitive Forest of America at the Four Periods of the Year* (1841), he commented on the genesis of his series of atmospheric studies: "exercise in the open air [at Greenburgh] led me more and more to notice and study the ever-varying atmospheric effects of this beautiful climate. I undertook to illustrate them by my pencil and thus almost accidentally commenced a set of Atmospheric Landscapes."[2] The publication listed the titles of all forty works, so presumably they were completed by then. Although it is not known when Harvey began the series, he had executed at least twenty-two prior to a trip to England in 1838 when he was trying to raise money for their publication.[3] All forty were exhibited in New York in 1843 and at the Boston Athenaeum the following year.

Hollidaysburg, in south-central Pennsylvania, was the terminal point of the Pennsylvania Canal,

built between 1826 and 1840 to compete with the successful Erie Canal of New York. Two other places on the canal figure in the series. Harvey also exhibited several works of the same area at the National Academy in 1837. Presumably all were done from studies made in the mid-1830s, and in fact Harvey mentioned in the catalogue for an 1850 exhibition that this watercolor was made "fifteen years since, before the village had obtained any importance."[4]

The series depicted the extreme variety of landscape and climate in America in contrast with that of England.[5] Settings ranged from Ohio to New England, from Indian summer to snowy winter, from the prairies to Niagara. But the real subject of the series was the quality of light in Harvey's adopted country. The artist's training as a miniaturist influenced his watercolor technique. His precise style gives an almost scientific objectivity to his observations of weather, while small hatched brushstrokes and vivid colors impart a clarity to these luminous landscapes.

BR

1. I wish to thank Stephen Edidin, who is engaged in a study of the artist, for discussing this work with me, in particular for helping to establish a more specific date for the work, which was published as c. 1835–1840 in *American Drawings, Watercolors . . . in the Collection of the Corcoran*.
2. George Harvey, *Harvey's Scenes of the Primitive Forest of America at the Four Periods of the Year* (New York, 1841), quoted by B.N. Parker, "George Harvey and His Atmospheric Landscapes," *Bulletin of the Museum of Fine Arts, Boston* 41 (February 1943): 7–9.
3. *Ibid.*
4. *Harvey's Royal Gallery of Illustration* (London: W.J. Golbourn, 1850), p. 16. No. 8.
5. For a discussion of these works, see Donald A. Shelley, "George Harvey and

His Atmospheric Landscapes of North America," *New-York Historical Society Quarterly* 32 (April 1948): 104–113.

7

John Vanderlyn
(1775–1852)

BORN IN KINGSTON, NEW YORK, October 15, 1775, John Vanderlyn was the grandson of the Hudson River valley portrait painter Pieter Vanderlyn. He began his artistic career studying with Archibald Robertson, a miniature and landscape painter. His evident ability prompted Aaron Burr to arrange for him to study with Gilbert Stuart in Philadelphia from 1795 to 1796 and in Paris under Antoine Paul Vincent from 1796 to 1801. After two years in New York he returned to Paris, where he produced some of his best work, including *Marius on the Ruins of Carthage,* which received a gold medal from Napoleon at the Salon of 1808. He returned to New York in the winter of 1815 and in 1819 exhibited his immense cyclorama of the gardens and palace of Versailles. But although he subsequently received some important portrait commissions, he achieved neither critical acclaim nor financial success in America. To raise money he repeatedly pawned his Napoleonic gold medal and finally decided to return to Paris. He worked there from 1842 to 1844, his genius questioned by unfounded rumors that he had employed an assistant to paint works for his signature. Few recognized his great ability during his lifetime, and he remained obscure, dying penniless and alone in a rented room in Kingston on September 23, 1852.

Study for the Figure of Alonso de Ojeda[1] (for the *Landing of Columbus*, 1837–1846, oil on canvas, U.S. Capitol) c. 1840
Black, brown, and white chalk on gray paper
24 × 18¹³⁄₁₆ in. (61 × 47.8 cm)
Museum purchase through a bequest of Mr. and Mrs. George Lathrop Bradley 1980
Acc. No. 1980.89

Vanderlyn might be regarded as the archetypical thwarted American painter. He studied in Paris, learning not only the latest Neoclassical style but also the hierarchical order which ranked historical, allegorical, and mythological subjects above mere portraiture. Back in the United States he was unable to find ready patronage for his more elevated subjects and was frequently forced to paint portraits or copies of his well-known pictures to make a living. Business ventures such as the New York Rotunda, built to exhibit his immense Panorama of the Palace and Gardens of Versailles, became costly and bitter disappointments. When he finally received a federal commission to paint *The Landing of Columbus*, the project took nearly a decade to complete and was not an entirely happy process.[2] *The Landing* is immense, 12 × 18 feet, and required monumental efforts to create. Vanderlyn returned to Paris via San Salvador, Columbus' first landfall in the New World, and there he recorded the local vegetation, one of the many elements that would comprise the finished composition.[3] In Paris over the next seven years he produced the remaining studies and assorted drawings. A preliminary oil sketch of c. 1840 (National Museum of American Art) shows the figure in the Corcoran drawing, Alonso de Ojeda, on the left

side of the composition, facing away from Columbus.[4] Ojeda, a young, ambitious adventurer who went on to explore and attempt to colonize other parts of the New World, sailed on his own to join Columbus in Hispaniola during Columbus' third voyage, not his first one. In the final painting in the Rotunda of the Capitol, Ojeda—in fine attire including a wide-brimmed plumed hat, short cloak thrown back from his left shoulder, and puffed trunk hose—now has a rifle on his right shoulder, providing an inward pointing axis on the left to balance the figure of Columbus on the right.

This strongly defined nude study is lit from the left and above. The depth of volume is achieved through the contrast of shadows against the applied white highlights, as seen in his bent right arm and legs. The elimination of most details allowed Vanderlyn to deal with the surfaces and achieve the goal of this study in three dimensions.

Vanderlyn worked in the accepted academic manner to execute this painting. He began by sketching each figure in his composition, first nude, then draped. Next drapery studies modeling the whole form or segments in light and dark were drawn. Finally, he drew each figure in the costume of the period. During the years in Paris he employed a studio assistant, probably James Wells Champney.[5] For five years Champney made costume studies and helped in the studio, leading to rumors that the finished painting was his own effort.[6] Scholars today do not find any basis for these accusations and are confident the finished canvas and numerous figure studies are Vanderlyn's. Costume studies do survive and are acknowledged to be the work of his assistant.[7]

LCS

1. Titled *Standing Male Nude* in *American Drawings, Watercolors . . . the Collection of the Corcoran*, the identity of the figure was uncovered in the key to the Rotunda painting published in Charles E. Fairman, *Art and Artists of the Capitol of the United States of America* (Washington, D.C.: GPO, 1927), p. 115.
2. *Ibid.*, p. 78.
3. Kenneth C. Lindsay, *The Works of John Vanderlyn: From Tammany to the Capitol* (Binghamton: University Art Gallery, State University of New York at Binghamton, 1970), p. 143.
4. *Ibid*, p. 89.
5. John K. Howat, "Kensett's World," in John Paul Driscoll and John K. Howat, *John Frederick Kensett, An American Master* (Worcester, Mass.: Worcester Art Museum, in association with W. W. Norton, New York and London, 1985), p. 25.
6. Lindsay, p. 143.
7. *Ibid.*

8

Emanuel Leutze
(1816–1868)

BORN IN SCHWÄBISH-GMÜND, GERmany, on May 24, 1816, Leutze at the age of nine immigrated with his family to Philadelphia, where he received his first art instruction. From 1836 to 1839 he worked as an itinerant portrait painter in Virginia, Maryland, and Pennsylvania. In 1841, with the encouragement and help of patrons such as Edward L. Carey, he went abroad to paint and study in Düsseldorf, whose academy was pre-eminent in the art world of the time. Even before he began studying with Karl Friedrich Lessing at the academy he had completed and sold to the Düsseldorf Art Union an historical painting, *Columbus before the High Council of Salamanca*.[1] During the two decades that Leutze lived in Germany he welcomed and often shared his studio with young

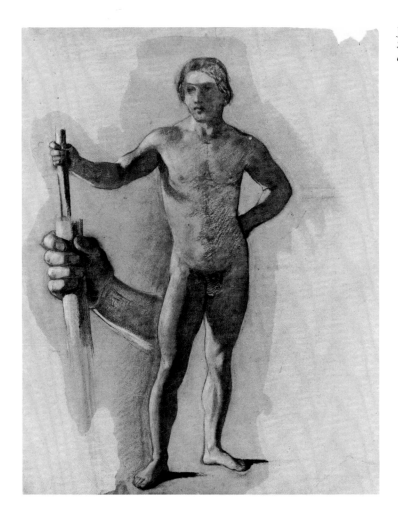

John Vanderlyn
Study for the Figure of Alonso de Ojeda
c. 1840

Emanuel Leutze
Bacharach
1841

American artists attracted by the Düsseldorf Academy, including Eastman Johnson, Worthington Whittredge, and Albert Bierstadt. During this time he regularly sent his paintings to the United States for exhibition and sale. In 1859 he himself returned, seeking government and private commissions, one of which materialized as the monumental *Westward the Course of Empire Takes Its Way*, a mural in the House of Representatives. He died at the age of fifty-two in Washington, D.C., on July 18, 1868, during one of the capital's notorious heat waves.[2] Both a son and a grandson of Leutze's became rear admirals in the U.S. Navy.

Bacharach 1841
Watercolor, wash, and graphite on
 paper
10¹³⁄₁₆ × 15¹¹⁄₁₆ in. (27.5 × 39.9 cm)
Inscribed, l.c.: "E. Leutze [erased] /
 Bacharach Sept. 14, 1841"
Gift of Rear Admiral E. H. C.
 Leutze, son of the artist 1917
Acc. No. 17.12

Leutze is best known for his historical paintings, the most famous being *Washington Crossing the Delaware*. The subject and style of *Bacharach* are probably the result of his earliest training in Philadelphia with John Rubens Smith, one of the leading drawing masters of the day.[3] Here Leutze employed a tight, closely controlled line to depict precise details. The masses of solids, their surfaces highlighted or shadowed, were defined by loosely worked washes of watercolor.

It appears that Leutze was touring the Rhine area before beginning studies at the Düsseldorf Art Academy, where he had enrolled for the fourth quarter of 1841.[4] A sketch dated September 10, 1841, in a private collection in Munich,[5]

shows a peasant from Assmannshausen, a Rhine village noted for its wine. By September 14, Leutze was sketching in Bacharach, another village along the river famous for its wine as well as its medieval fortifications and late-Romanesque church.

The image is very likely a *plein-air* sketch. The effect of sunlight falling from the upper left is consistently recorded in the foliage, the masonry walls of the foundation, and the tracery of the windows. One distinctive element seen on the right side of the sheet is Leutze's signature, erased at some time in the past, and the inscribed location and date. Both lines of text slant upward in his characteristic manner.

LCS

1. Ann Hawkes Hutton, *Portrait of Patriotism* (Radnor, Penn.: Hilton Book Co., 1959), pp. 28–31.
2. Hutton (p. 138) quotes newspaper accounts attributing his death to "heat prostration and sunstroke" and calling him the "most successful painter of his generation."
3. Barbara Groseclose, *Emanuel Leutze, 1816–1868: Freedom Is the Only King* (Washington, D.C.: Smithsonian Institution Press, 1975), p. 14.
4. *Ibid.*, p. 16.
5. *Ibid.*, pp. 123–134. In Groseclose's catalogue *Bacharach* is titled *Cathedral Ruins*.

9

Robert Walter Weir
(1803–1889)

BORN JUNE 18, 1803, IN NEW YORK City, Weir was the son of a prosperous merchant. The failure of his father's business in 1811 ended his school days. He was about seventeen or eighteen when he received his first art instruction from John Wesley Jarvis and an English heraldic artist, Robert Cooke. In 1824 he traveled to Italy for three years, studying first

with Pietro Benvenuti, a history and portrait painter, and later living in Rome with Horatio Greenough, the American sculptor. Upon his return to the United States he launched his art career, which included exhibiting and teaching at the National Academy of Design. In 1834 he became the first American-born instructor of drawing at West Point, a post he held for forty-two years while teaching such cadets as Ulysses S. Grant, Robert E. Lee, and James McNeill Whistler. During these years he maintained close ties to New York City and its artistic and literary circles. The final years of Weir's life were spent at Castle Point, Hoboken, and then in New York City, where he died May 1, 1889.

*When Other Friends Are Round
 Thee*[1] (illustration for "When
 Other Friends," in *Poems* by
 George Pope Morris)
c. 1850–1853
Brown ink wash and sgraffito
9 × 6⁵⁄₁₆ in. (22.8 × 16 cm)
Inscribed, l.l.: "Robt W. Weir"
Gift of Rudolph Max Kauffmann
 1947
Acc. No. 47.20

Robert Weir has been described as the "representative artist of his age."[2] His career followed the accepted path from early instruction by an older artist through European travel to a return to the United States to exhibit and teach. Yet within this outline Weir's career was also unusual in many ways. His teaching had considerable influence on his pupils, who included his own sons, John Ferguson Weir and Julian Alden Weir, who both became noted artists.[3] Often identified as a painter of the Hudson River School, Robert Weir is also known as a major illustrator of historical and literary subjects. Indeed, his ca-

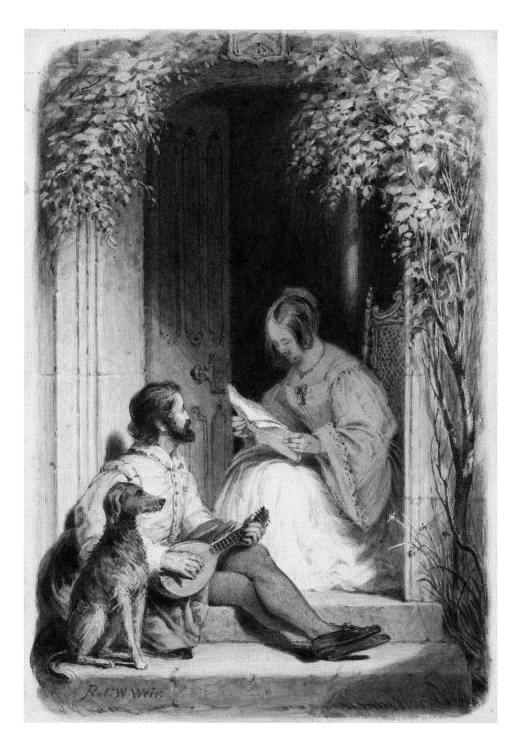

Robert Walter Weir
When Other Friends Are Round Thee
c. 1850–1853

reer can be seen as forming a bridge between literature and the visual arts. Weir illustrated prose and poetry by James Fenimore Cooper, Sir Walter Scott, and Washington Irving among others. As a young man he painted the image of Santa Claus "laying a finger aside of his nose" for the first publication in 1823 of the poem beginning " 'Twas the night before Christmas." Many of his associates in the Sketch Club in New York were writers, poets, editors, and publishers, chief among them William Cullen Bryant.[4] It is not surprising therefore to find Weir illustrating *Poems* by George Pope Morris, published in 1853 by Scribner's. Morris is best known today for "Woodsman, Spare that Tree," which appeared in the same volume. Eleven of the thirteen illustrations for *Poems* were prints after drawings by Weir. Many of these steel engravings were made by Alfred Jones, one of the most noted engravers of the period.

In the illustration for "When Other Friends" the romantic imagery of vine-covered doorway, costumed musician, and seated young lady merely suggests the throbbing emotions expressed in lines such as "Thou art the star that guides me,/Along life's troubled sea;/And whatever fate betides me,/This heart faithful still turns to thee." Weir has included a dog and other elements not described in the poem. His illustration reflects the elements he stressed in his teaching: a careful observation of light, a precise definition of space, and a distinct rendering of atmospheric effects. This image and others of Weir's illustrations are descriptive of the subject but are not overburdened with expressions of saccharine romanticism.

LCS

1. Titled *On the Doorstep* in *American Drawings, Watercolors . . . in the Collection of the Corcoran,* the actual identity and title of this drawing have since been found in Michael E. Moss, *Robert W. Weir of West Point, Illustrator, Teacher and Poet* (West Point, N.Y.: United States Military Academy Library and the West Point Museum, 1976), p. 62.

2. William H. Gerdts, *Robert Weir: Artist and Teacher of West Point* (West Point, N.Y.: Cadet Fine Arts Forum of the U.S. Corps of Cadets, 1976), p. 9.

3. Holly Joan Pinto, *William Cullen Bryant, the Weirs and American Impressionism* (Roslyn, N. Y.: Nassau County Museum of Art, 1983), pp. 6–7, 10–11.

4. Gerdts, pp. 14–17; Pinto, pp. 6, 8–10.

10

Frank Blackwell Mayer
(1827–1899)

BORN INTO A PROMINENT BALTImore family on December 27, 1827, Mayer was encouraged to become an artist by Alfred Jacob Miller, a painter and family friend. After some private drawing lessons, he studied briefly in 1847 at the Pennsylvania Academy of the Fine Arts. In the same year Mayer helped found the Maryland Art Association, and he was later instrumental in establishing two other artists' organizations in Baltimore. It was in the late 1840s that he became the pupil of the recently emigrated European artist Ernst Fischer. In 1862 Mayer went to Paris, where he worked under Charles Gleyre and Gustave Brion and exhibited regularly at the Salon. Mayer returned to Baltimore in 1870 and six years later settled in Annapolis, where he died on July 28, 1899.

Study for "Leisure and Labor"
c. 1858
Watercolor and gouache over graphite on paper
7½ × 9¹¹⁄₁₆ in. (19.1 × 23 cm)
Inscribed on original mat, l.l.:
 "A.W. Drake, / with regards of F. B. Mayer. / Doing and Dreaming [erased] / With [erased] / Annapolis. 23 May 1879."
Museum purchase 1966
Acc. No. 66.24

Despite the inscribed date, which records when Mayer gave this watercolor to A. W. Drake, the art editor of *Century Magazine,* it undoubtedly served as a preliminary study for the 1858 painting *Leisure and Labor,* also in the Corcoran collection. Purchased in 1859 by William Wilson Corcoran, the painting was at one time known as *Doing and Dreaming.*[1] There are differences between this work and the oil: the painting does not have a sign on the roof of the blacksmith's shop, and a greyhound stands on the young man's right, replacing the seated dog. However, most details correspond closely and the compositions are identical.

A host of studies for the work, ranging in date from 1845 for a similar overall design in pen and ink to 1857 for a pencil sketch of the horsetail hanging on the right door, suggest how long the idea for the painting was germinating in the young artist's mind.[2] Two settings have been suggested: Pikesville, just to the northwest of Baltimore, where Mayer frequently went to visit maternal relatives; and western Maryland.[3] Whatever the actual locale, the scene is clearly in rural Maryland.

Both titles for the work—*Leisure and Labor* and *Doing and Dreaming*—imply a moral message, not uncommon in genre

23

Frank Blackwell Mayer
Study for "Leisure and Labor"
1858

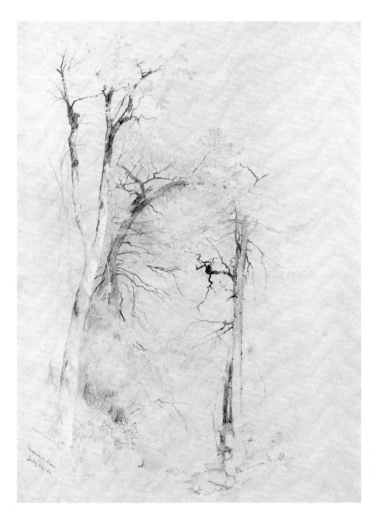

Jervis McEntee
Kaaterskill Clove
1860

24

Durand, Thomas P. Rossiter, and John William Casilear. In 1840 he went to Europe with these artists and remained to study and paint for nearly seven years. When Kensett returned to America late in 1846 he enjoyed a warm reception, prepared by the many landscapes he had sent home for exhibition. His popularity continued as his subjects turned to the American landscape—the Adirondacks, Lake George, the Hudson River, and Niagara. Throughout his career he regularly exhibited at the National Academy of Design, which had made him an academician in 1849. He was a member of the Century Association, the Sketch Club, and the Union League Club, which sponsored the Metropolitan Fair, the inspiration for the Metropolitan Museum of Art, of which Kensett was a founding trustee in 1870. Kensett never married. He continued to live and paint in New York and travel until his death on December 14, 1872.

Building by a Dam c. 1850–1860
Graphite with sgraffito[1] on tinted
 prepared Ackerman paper
7³⁄₁₆ × 10½ in. (20.7 × 26.6 cm)
Inscribed, l.l.: "JFK" [monogram]
Museum purchase 1948
Acc. No. 48.11

Colored papers have fascinated artists and have been used by them since the fifteenth-century. In some cases the entire sheet is covered by a solid tone; in others, only a portion is tinted. In the nineteenth century papers with a graded tone like this one, varying from blue for the sky to brown for the earth, were commercially produced.[2] The artist drew or painted his middle and dark tones on the sheet, and for the highlights he scratched away the surface to reveal the white beneath. The paper used here was produced by the English firm Ackerman, still in existence in London. Kensett has drawn his image with graphite and then has created the sparkling water trickling over the dam and running down the rocks by scraping away the brown surface to expose the chalky white beneath.

Identified with the Hudson River School and with Luminism, Kensett's work conveys a poetic sensibility and quiet response to the American landscape. The clear, sunny stillness of this little scene must have suited the artist's temperament[3] and confirmed his view of that "beautiful harmony in which God has created the universe."[4] His skills as a draftsman are evident here: the rapidity and assurance of execution can be seen in the contrast between the rounded forms of rocks in the foreground and darkness of the water surface compared with the lightly shaded rocks, dam, and the building of the middle ground. The distant hills beyond the dam are lightly but carefully delineated. A sense of animation comes from the scratched-out highlights illuminating the trickling water, but the general feeling is one of quiet tranquility. The traits seen here—transparent light, calm weather, and compositional balance—are found in Kensett's drawings and paintings throughout the late 1850s and into the 1860s.[5]

The sense of stability of the scene is reinforced by the shallowness of the space and the extreme horizontality of the mirroring lines in the surface of the pool and the edge of the dam. Even the colors of the sheet agree with his chromatic thinking and are consistent with the restricted palette he utilized in his oil paintings. As he described his chromatic theory, "the main masses are made of cool greens, grey, drab and browns intermingled, and are always harmonious and agreeable."[6] It has been suggested that "all his pictures are biographical, for they all reveal the fidelity, the tenderness and the sweet serenity of his nature."[7]

LCS

1. The word *sgraffito*, derived from the Italian *sgraffiare*, "to scratch," is usually used to describe a technique of decorating ceramics by incising through a coating of slip, or walls by scratching through variously colored layers of plaster.
2. Andrew Robison, *Paper in Prints* (Washington, D.C.: National Gallery of Art, 1977), pp. 25–27.
3. John Paul Driscoll and John K. Howat, *John Frederick Kensett, An American Master* (Worcester, Mass.: Worcester Art Museum, in association with W. W. Norton, New York and London, 1985), "The Last Summer's Work" by Oswaldo Rodriguez Roque, pp. 155–156.
4. Kensett quoted in *ibid.*, "From Burin to Brush: The Development of a Painter," by John Paul Driscoll, p. 63.
5. *Ibid.*, p. 121.
6. Kensett quoted in *ibid.*, p. 126.
7. *Ibid.*, "Kensett's World" by John K. Howat, p. 35.

13

John William Hill
(1812–1879)

BORN JANUARY 13, 1812, IN LONdon, Hill was the son of John Hill, an aquatint artist who moved to Philadelphia in 1816, then to New York City and eventually to a farm in West Nyack, New York, where his son made his lifelong home. Apprenticed to his father for seven years, Hill served as a topographical artist for the New York Geological Survey from 1836 to 1841. During the late 1840s he joined the Smith Brothers publishing firm and traveled extensively in New England and upstate New York producing wa-

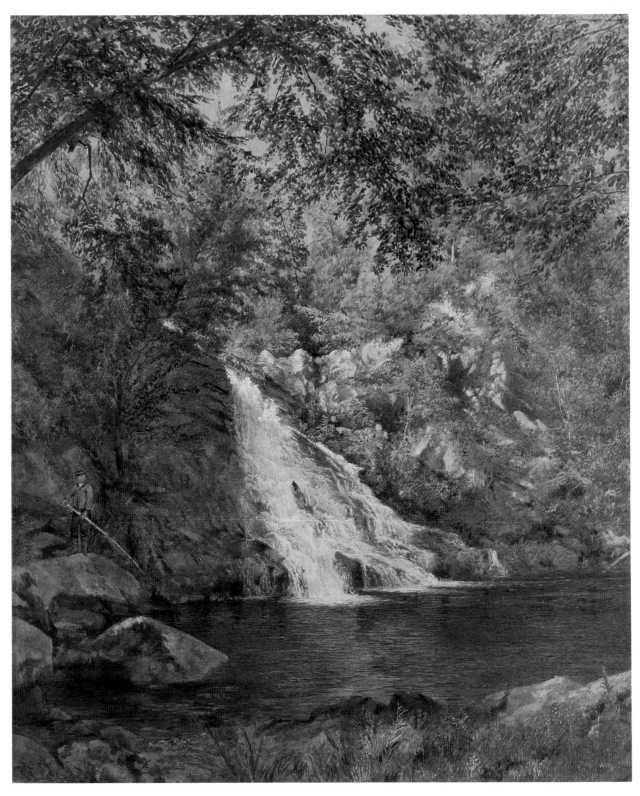

John William Hill
The Waterfall
1860s–1870s

tercolor views of major cities. After reading John Ruskin's *Modern Painters* he altered his style and subject matter, concentrating especially on depictions of fruit, birds, flowers, and plants in natural settings. With the artist William Trost Richards and his own son, John Henry Hill, among others, he was a founding member in 1863 of the Association for the Advancement of Truth in Art, which proposed reform in American art and architecture following Ruskin's dictates. Hill died in West Nyack on September 24, 1879.

The Waterfall 1860s–1870s
Watercolor and gouache over
 graphite on white-surfaced paper
 board
16⅝ × 13¹³⁄₁₆ in. (42.3 × 35.1 cm)
Inscribed, l.r.: "J.W. Hill"
Museum purchase 1948
Acc. No. 48.21

John William Hill is considered the leading exponent of the new "naturalism" in American art spawned by the writings of the English critic Ruskin. Prior to 1855, when he first read Ruskin, Hill's work was generally in the romantic tradition of the Hudson River School. Ruskin's ideas dramatically changed his style and his approach.[1] Following Ruskin's advice to "practice the production of mixed tints by interlaced touches of pure color out of which they are formed, use the process at the parts of your sketch where you wish to get rich, luscious effects,"[2] he developed his own distinctive brushstroke and use of color.

Hill's stipple technique, as seen in this watercolor, achieved brilliant color and a high degree of exactitude in recording the scene. The minute strokes give a palpa-

ble quality of reality to the sunlit foliage, sparkling waterfall, and shimmering pool. Minuscule daubs of pure color are laid over veils of light wash of another tint, as in the rock outcroppings. Each brushstroke is inseparable from what it represents: shadow, leaf, watery reflection, rock, or tree trunk. Luminosity in the water and reflections of sunlight on thousands of leaves come, not from brushstrokes of paint, but from small areas of bare paper.

The combination of rocks, water, and foliage appealed to Hill, who preferred the clear light of mid-morning or afternoon to reveal the details of nature.[3] From the 1850s on he showed a marked preference for watercolor over oil. In technique, color, approach, and subject, Hill achieved a complete synthesis of Ruskin's ideas and applied them to an American subject.

LCS

1. Linda S. Ferber and William H. Gerdts, *The New Path: Ruskin and the American Pre-Raphaelites* (Brooklyn: Brooklyn Museum, 1985), p. 180.
2. Ruskin, quoted in *ibid.*, pp. 181–182.
3. *Ibid.*

14

James Renwick Brevoort
(1832–1918)

JAMES BREVOORT WAS BORN IN Yonkers, New York, on July 20, 1832. The descendant of early Dutch settlers, he worked with his cousin James Renwick, the architect, and studied at New York University and the National Academy of Design. In 1856 Brevoort began exhibiting landscapes at the National Academy; he also exhibited at the Boston Athenaeum and the Pennsylvania Academy of the Fine Arts. The

National Academy elected him an associate member in 1861, and two years later made him an academician. Brevoort often portrayed specific locations in Europe and the northeastern United States, but he also explored the special qualities of certain times of day, seasons, and climatic conditions. He died on December 15, 1918, in Yonkers.

Castleton, Vermont 1871
Graphite on paper
11¹³⁄₁₆ × 17³⁄₁₆ in. (30 × 43.7 cm)
Inscribed, l.r.: "Castleton Vt. /
 August, 1871—"
Gift of Mrs. Rudolph Eickemeyer,
 daughter of the artist 1938
Acc. No. 38.9

Castleton lies in the west central part of Vermont, not far from Lake George, a fashionable summer resort and a mecca for landscape artists throughout much of the nineteenth century. Brevoort visited the area in 1871. Two other works at the Hudson River Museum document his stay in Vermont and New Hampshire in the late summer of that year. These finished drawings as well as his canvases and watercolors reveal Brevoort's interest in portraying domesticated rural settings rather than the scenic grandeur of America that artists such as Albert Bierstadt were painting.[1]

Just a few years before Brevoort executed this beautifully articulated drawing of a picturesque New England view, the art critic Henry T. Tuckerman had observed: "Brevoort's landscapes are broad and truthfully characteristic of American scenery, with pleasing atmospheric effects."[2] These artistic qualities undoubtedly contributed to his being appointed Professor of Scientific Perspective at the National Acad-

emy in 1872. His ability to capture a sense of place as well as the essence of a particular kind of day is evident in this well-constructed and evocative drawing. The rich chiaroscuro in the foreground, the subtle rendering of the building in the distance, and the effective use of the white areas of the paper suggest the brilliance and sultriness of an August day; at the same time they display the artist's mastery of technique.

EJN

1. Sutherland McColley, *The Works of James Renwick Brevoort* (New York: Hudson River Museum, 1972), pp. 14, 18.
2. Henry T. Tuckerman, *Book of the Artists* (1867; reprint, New York: James F. Carr, 1967), p. 566.

15

William Stanley Haseltine
(1835–1900)

HASELTINE WAS BORN IN PHILAdelphia on June 11, 1835; his father was a prosperous merchant, his mother, an amateur artist. In 1855, the year after he graduated from Harvard, Haseltine traveled to Germany with his art teacher, Paul Weber. Haseltine remained there until 1858, studying in Düsseldorf under Andreas Achenbach. On his return to America he established himself in New York in the Tenth Street Studio Building where Emanuel Leutze, Albert Bierstadt, Frederic Church, and John F. Kensett also had studios. Shortly after his second marriage in 1866, Haseltine moved to Paris. Although he visited the United States on many occasions, he lived in Europe the rest of his life, first in France and then in Rome. A founder of the American Academy in Rome, Haseltine was noted for his landscape subjects. He exhibited widely in America

and Europe and was elected to many societies, including the National Academy of Design. He died in Rome on February 3, 1900.

Blankenberge 1876
Gouache over graphite on blue
 paper laid down
15¹⁄₁₆ × 22¹⁄₁₆ in. (38.5 × 56 cm)
Inscribed, l.r.: "W.S.H. / Blanken-
 bergh—July 2nd / 1876"; l.l.:
 "15"
Gift of Mrs. Roger H. Plowden,
 daughter of the artist 1952
Acc. No. 52.4

This gouache of fishing vessels beached on the sands near the small Belgian port of Blankenberge on the North Sea was painted several years after Haseltine had settled permanently in Europe. Between 1874 and 1876 the artist made several trips from his home in Rome to Holland and Belgium, drawing architectural monuments as well as the coastal scenes in which he specialized. Haseltine's interest in recording the strong, clear light of that transitional area where land meets sea and sky relates his work to that of contemporaries such as Kensett, Fitz Hugh Lane, and Martin Johnson Heade, major figures in American Luminism.[1]

The picturesque subject matter as well as the crisp lines and the meticulous detail of the drawing reflect the romantic Düsseldorf style and the fine draftsmanship acquired during his early training under Weber and Achenbach. Solidly drawn and silhouetted against the grainy blue paper that suggests the sky, these stranded weathered boats are clearly out of their element; pointing out to sea, they seem to yearn for their natural environment.

JLL

1. See the catalogue by John Wilmerding, et al., *American Light: The Luminist Movement, 1850–1875* (Washington, D.C.: National Gallery of Art, 1980), for a discussion of Haseltine in the context of Luminism.

16

Winslow Homer
(1836–1910)

WINSLOW HOMER WAS BORN IN Boston on February 24, 1836. At the age of nineteen he was apprenticed to a lithographer, where he developed his natural drawing abilities. In the late 1850s he moved to New York and became a freelance illustrator for *Harper's Weekly*, which after the outbreak of the Civil War sent him to the front as an artist-correspondent. In 1865 he was made a full member of the National Academy of Design and in 1876 was elected to the American Society of Painters in Water Colors. Shortly after returning from a two-year stay in England in 1883 Homer settled in Prout's Neck, Maine, where he lived the rest of his life in relative isolation and produced the powerful images of man's confrontation with nature for which he is best known. He died there on September 10, 1910.

Woman Sewing c. 1879[1]
Watercolor over graphite on paper
9¾ × 7⅞ in. (24.8 × 20 cm)
Inscribed, l.l.: "Homer"
Bequest of James Parmelee 1941
Acc. No. 41.15

Homer first exhibited a watercolor as a discrete work of art at the American Society of Painters in Water Colors in New York in 1870. However, it was not until the mid-1870s that he conscientiously took up the medium, probably as a result of the international exhibition held by the

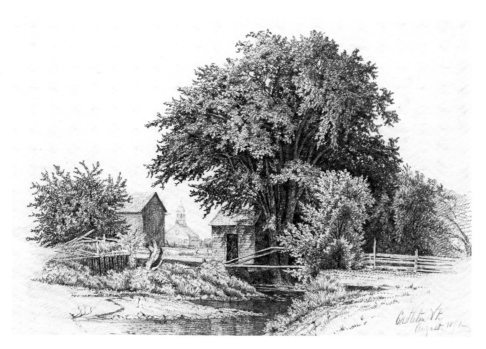

James Renwick Breevort
Castleton, Vermont
1871

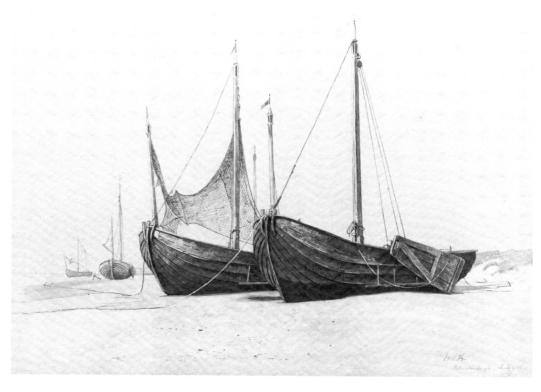

William Stanley Haseltine
Blankenberge
1876

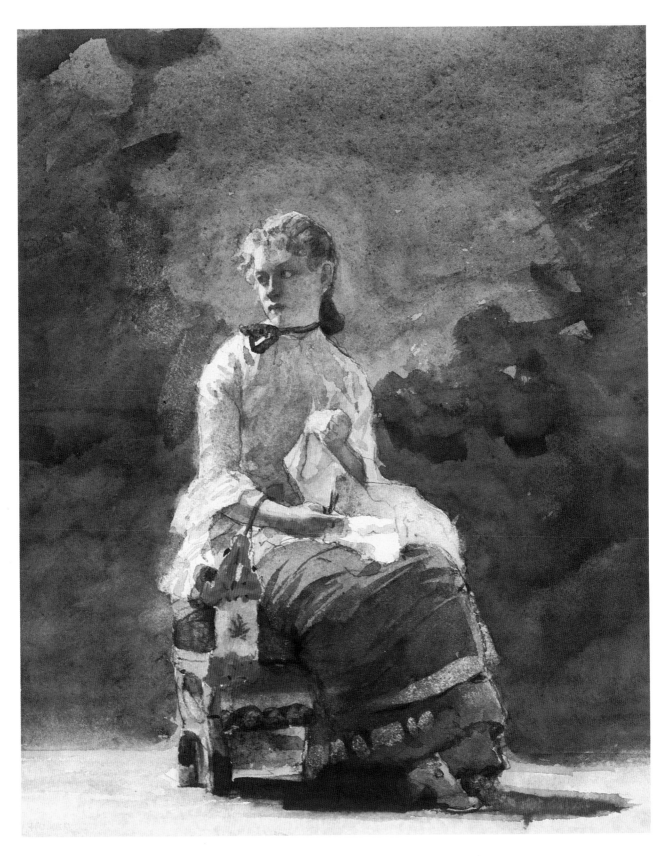

Winslow Homer
Woman Sewing
c. 1879

Society in 1873.[2] Recognition of his watercolors followed. His natural and easy style of execution as well as his brilliant handling of chiaroscuro were generally admired, but some critics took issue with what they considered his lack of finish.[3]

Woman Sewing belongs to a group of paintings in oil and watercolor that Homer produced between 1874 and 1879 depicting women at work or in repose. It has been suggested that the figure in many of these works was the object of the artist's unrequited love and that her rejection contributed to Homer's withdrawal from society.[4] Whoever the sitter was and whatever her relationship to the artist may have been, the compositions revolve around a solitary figure, isolated in space, who is close to the viewer yet physically and psychologically removed. The attitudes explored in these works, which may reflect Homer's disenchantment with women,[5] set them apart from other treatments of the theme of women in domestic settings by the artist's contemporaries.

In *Woman Sewing*, the setting is undifferentiated yet emotionally charged. Interrupted in her activity, the young woman looks up, presumably at the cause of the intrusion. The immediacy of action and the sitter's wary glance are reinforced by the nervous underdrawing, the agitated handling of light as it falls on the figure, and the swirling background washes. These visual elements create an unexpected tension and turmoil in a work which at first glance seems to be simply a depiction of a quiet homely scene.

EJN

1. Although published as 1878–1879 in *American Drawings, Watercolors . . . in the Collection of the Corcoran* and in *Of Time and Place: American Figurative Art from the Corcoran Gallery* (Washington, D.C.: Smithsonian Institution Traveling Exhibition Service and the Corcoran Gallery, 1981), p. 63, this watercolor is very close in style and execution to *Girl Seated*, dated 1879, illustrated in Helen A. Cooper, *Winslow Homer Watercolors* (New Haven and London: Yale University Press and National Gallery of Art, 1986), p. 35.

2. Cooper, p. 18.

3. See, e.g., S. N. Carter, "The Water-Color Exhibition," *The Art Journal 5* (1879): 93–94, and George William Sheldon, *American Painters* (New York: Appleton, 1879), p. 25. Also see Cooper, pp. 24–32.

4. Henry Adams, "Winslow Homer's Mystery Woman," *Art and Antiques* (November 1984): 38–45; also *Birmingham Museum of Art Bulletin* (1983): n.p.

5. Adams, *op. cit.*

17

Thomas Moran
(1837–1926)

BORN JANUARY 12, 1837, IN Bolton, an industrial town in Lancashire, England, Moran in 1844 immigrated with his family to America and settled in Philadelphia. After a two-year apprenticeship to an engraver, Moran studied painting in his elder brother Edward's studio, where he came under the influence of the landscape artists Paul Weber and James Hamilton. In 1861 he took the first of many trips to Europe. While in England he was impressed by the work of Turner, whose style had a discernible impact on Moran's subsequent Venetian scenes. Recipient of many prizes, Moran was elected a member of the National Academy of Design in 1884. He lived in Philadelphia and New York before moving to Santa Barbara, California, in 1916, where he died ten years later on August 26.

View of Venice 1888
Watercolor and gouache over
 graphite on gray paper
11¼ × 16⅜ in. (28.7 × 41.8 cm)
Inscribed, l.r.: "Moran, 1888."
Bequest of James Parmelee 1941
Acc. No. 41.18

Today Thomas Moran is best known for his dramatic interpretations of some of America's most sublime scenery in the Grand Canyon and Yellowstone. However, his locales ranged from the meadows of Long Island to the coast of California. European views also figured prominently in his oeuvre. His favorite subject was Venice, which he painted more than a hundred times.[1] In the late nineteenth century Venice was filled with artists from many countries, attracted to its decaying beauty and its extraordinary light. Moran visited the city in 1886 and 1890. Like all of his finished compositions, this particular piece was done later in the studio from studies. A fully realized work, it nevertheless probably served as a preliminary idea for *Splendor of Venice* of 1889 (Philbrook Art Center, Tulsa), which presents a similar view from the same vantage point. Moran placed "no value upon literal transcripts from Nature."[2] This work exemplifies his tendency toward idealization and his desire to convey an impression of a place rather than record its topography. Here he has altered the shapes of the buildings and angles at which they are seen, while maintaining their relative positions: the Campanile, Ducal Palace with the domes of Saint Mark's behind, and the Bridge of Sighs occupy the center; on their left, across the Grand Canal, is the Salute. But Moran was clearly not

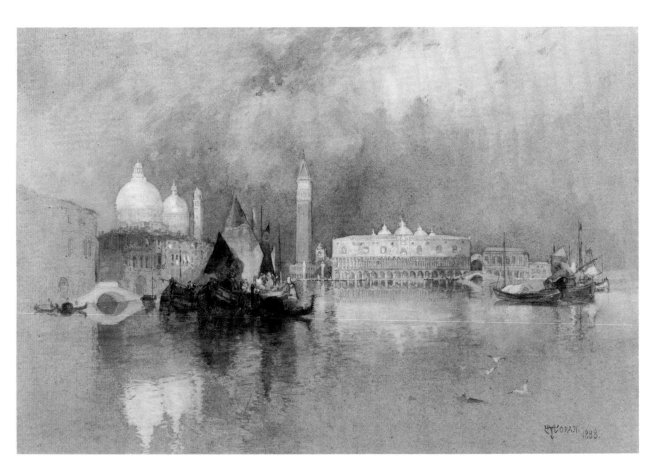

Thomas Moran
View of Venice
1888

simply interested in depicting a well-known view. Presented as if glimpsed from an approaching ship, the architectural grandeur of Venice is dramatically revealed through the clearing mist and clouds, the vessels and fisherfolk in the foreground adding a picturesque note.

Writing to a friend in the year he created this work, Moran remarked: "Venice is an inexhaustible mine of pictorial treasures for the artist and of dreamy remembrance to those who have been fortunate enough to visit it."[3] *View of Venice* provides early evidence of his enduring fascination with the city. Its jewel-like colors and engulfing light transform solid buildings and ships into a shimmering fantasy. Moran presents us with a dream of Venice and, in so doing, conveys a sense of the city's enchantment for artists and tourists alike.

JLL

1. For a recent discussion of American artists in Venice and Moran's place in this tradition, see Margaretta M. Lovell, *Venice, The American View 1860–1920* (San Francisco: Fine Arts Museums of San Francisco, 1984), pp. 66–70.
2. G. W. Sheldon, *American Painters* (enlarged edition, 1881; reprint, New York: Benjamin Bloom, 1972), p. 125.
3. Quoted in Lovell, p. 66.

18

Samuel Colman
(1832–1920)

BORN IN PORTLAND, MAINE, March 4, 1832, Colman was the son of a bookseller and publisher who soon moved his family to New York City. Colman's art studies may have begun under Asher B. Durand, but this has been questioned. His first painting was exhibited in 1850 at the

National Academy of Design in New York. He made two trips abroad—in 1860–1862 and 1871–1875—to further his artistic studies. During the earlier trip he visited places few American artists had seen, such as Spain and Morocco, and the resultant paintings were so well received that two years later, in 1864, he was elected full academician in the Academy of Design. In the mid-1860s Colman began to work in watercolor, and in 1866 he was one of the founders of the American Society of Painters in Water Color. In 1877 he was one of the founders of the Society of American Artists, and in 1878 he joined the newly formed New York Etching Club. In addition to etching, during the latter part of this decade he was active in interior decoration, associated with Edward C. Moore, Louis Comfort Tiffany, and John La Farge. During the last two decades of the century Colman resumed his travels to various parts of the American West, Europe, and Canada. After 1900 he painted less while writing two books on art[1]; the second was published five days before Colman died at his home in New York on March 26, 1920.

*Half Dome and Royal Arches,
Yosemite, from Glacier Point*
1870s–1900
Gouache and watercolor over
graphite on blue-gray paper
9¹¹⁄₁₆ × 13⅝ in. (24.6 × 34.6 cm)
Museum purchase through a gift of
Ralph Cross Johnson 1980
Acc. No. 1980.86

A painter in the Hudson River School tradition, Colman is best known for his bold, vigorously brushed, yet accurate depictions of the American West. He was also one of this country's pioneer

artists in the media of watercolor and etching. Prior to the 1860s painting in watercolor was a medium not particularly favored among American artists.[2] Colman was one of the first to champion its special qualities. His travels in Europe and across the North American continent provided a repertoire of subjects, scenes, and settings which appealed to his interest in color, light, and atmosphere. A desire to render broad masses with a fluid brushstroke in pure tints and tones made watercolor an ideal medium for him. The brilliant colors of western mountain ranges and valleys were effectively and beautifully captured in this medium.

Colman's initial western trip was made about 1870, a few years after Albert Bierstadt's first visit but before his friend Thomas Moran's premier expedition.[3] The images he produced recall the color, light, and atmosphere of the English artist Turner, whose work Colman knew and admired.[4] Like Moran and Bierstadt, Colman captures the grandeur of the peaks and valleys of massive mountain ranges, but he does it on a much smaller scale; few of his watercolors known today are over 24 inches wide.[5]

LCS

1. *Nature's Harmonic Unity. A Treatise on Its Relation to Proportional Form*, with 302 illus. by the author (New York: Putnam's, 1912) and *Proportional Form. Further Studies in the Science of Beauty* (New York: Putnam's, 1920).
2. Wayne Craven, "Samuel Colman (1832–1920): Rediscovered Painter of Far-Away Places," *American Art Journal* (May 1976): 24.
3. *Ibid.*, p. 26.
4. *Ibid.*, p. 34.
5. *Ibid.*, p. 34 and Gloria-Gilda Deak, *The Romantic Landscapes of Samuel Colman at Kennedy Galleries* (New York: Kennedy Galleries, 1983), n.p.

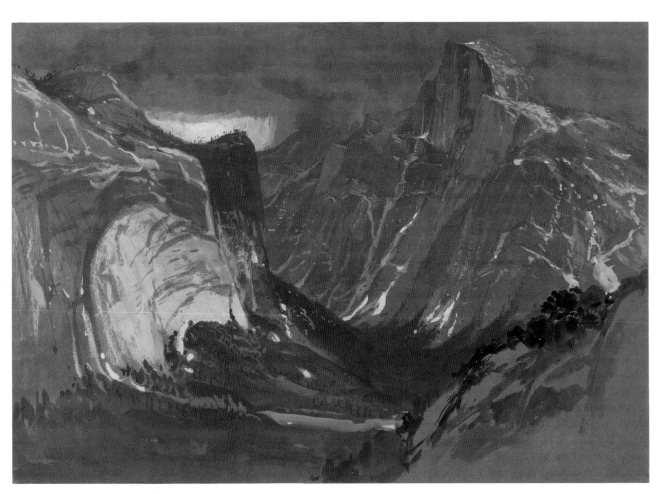

Samuel Colman
Half Dome and Royal Arches, Yosemite,
from Glacier Point
1870s–1900

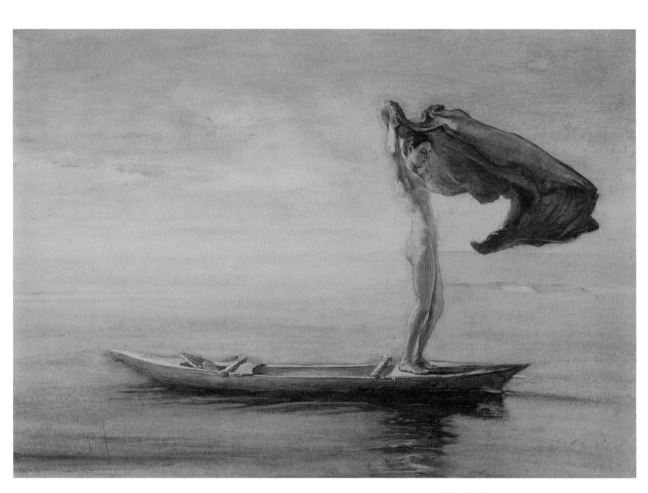

John La Farge
Fayaway Sails Her Boat, Samoa
1890

19

John La Farge
(1835–1910)

BORN MARCH 31, 1835, IN NEW York City, La Farge was the son of a French immigrant who instilled in him an intense pride in his ancestry. Although as a young boy La Farge had received instruction in watercolor, it was not until 1856 when he went to Europe to study that he considered becoming an artist. In 1858 he returned to America and continued painting instruction with William Morris Hunt. In 1862 he began exhibiting at the National Academy of Design and seven years later was elected a member. During the 1860s he produced literary illustrations and exhibited paintings at the annual Salon in Paris and the Centennial Exposition in Philadelphia. From 1876, the year he received the commission to decorate Boston's Trinity Church, until 1890, much of his work was on murals and stained glass windows, including commissions for St. Thomas Church, New York, and Memorial Hall, Harvard University. One of the first American artists to visit Japan and the South Seas, La Farge wrote and lectured on his travels as well as on art. A retrospective exhibition of his work was organized in 1910 by the Museum of Fine Arts, Boston. He died the same year, on November 14, in Providence, Rhode Island.

Fayaway Sails Her Boat, Samoa[1]
1890
Watercolor and gouache over
 graphite on cream-surfaced art-
 ist's board
15³⁄₁₆ × 21¹³⁄₁₆ in. (38.6 × 55.4
 cm)
Inscribed, l.l.: "LA FARGE Samoa"
Museum purchase 1960
Acc. No. 60.6

A young girl stands nude, holding a blue lavalava[2] to catch the wind as she balances on the end of a slender canoe. Her slightly flexed knees are the only indication of her response to the swell running beneath the craft. This beautiful, subtly colored image, vibrating with arrested motion, was painted by John La Farge in 1890 at the start of a trip in the South Seas with the writer Henry Adams. The pair visited the Hawaiian Islands, Tahiti, Samoa, Fiji, Sydney, Java, and Ceylon before continuing around the world. They left Tahiti just four days before Paul Gauguin arrived.[3] La Farge, like Gauguin, found the South Pacific alluring. He sensed in the islanders' traditions a survival or a revival of a life of simplicity and nobility.

His respect for the dignity of the human form is captured in this watercolor and expressed in a letter: ". . . I can see here, probably for the last time, a rustic Boetian antiquity, and if I live to paint subjects of the nude and drapery, I shall know how they look in reality."[4] However real La Farge's nude girl may be, she appears remarkably Caucasian in her facial features, color of skin, hair style, stance, and build, compared with La Farge's other Samoan studies and with Gauguin's Polynesian women. La Farge had set out for the Marquesas that were so disturbing in Herman Melville's *Typee,* but it was in Samoa that he lingered, thrilling to and recording the dances, rituals, landscapes, and atmosphere of his "Purple Isles of Eden." The visual poet in him was excited by what he saw and combined with the colorist to produce what may be his most beautiful watercolors. During the eleven months spent in the Pacific, La Farge produced over 210 watercolors, eleven oils, and forty drawings.[5]

A beautiful sense of balance is imparted to this work, not only by the placement of the figure in relation to the long, shallow boat, but also by the lovely color harmony achieved. The blues of water and lavalava mirror each other and play against the peach-colored reflections on the ripples. The direct application of pigment in the girl's body contrasts with the soft, fluid washes of color in the sky and the paleness of the water's surface around the dugout canoe. The support La Farge used is a thin Japanese paper laid down over a thick, textured board.

LCS

1. This work was given the title *Samoan Girl in a Canoe* and dated c. 1890–1891 in *American Drawings, Watercolors . . . in the Collection of the Corcoran;* however, La Farge titled it *Fayaway Sails Her Boat, Samoa,* when it appeared facing p. 68 in his *Reminiscences of the South Seas* (New York: Doubleday, 1912).
2. In *Reminiscences,* p. 191, La Farge describes the lavalava, a Samoan word for the rectangular cotton cloth worn like a skirt by Polynesian men and women, especially in the Samoa Islands. La Farge also describes how the lavalava was used in bidding farewell: "Long after we had set sail we could see them move their drapery as goodbye" (p. 91).
3. Henry A. La Farge, "Travels in the South Seas," in *Exhibition of Paintings, Watercolors and Drawings by John La Farge (1835–1910) from His Travels in the South Seas, 1890–1891* (Salem, Mass.: Peabody Museum, 1978), p. 7.
4. *Ibid.,* p. 5, quoting John La Farge.
5. *Ibid.,* p. 7.

20

William Trost Richards
(1833–1905)

BORN NOVEMBER 14, 1833, IN Philadelphia, Richards left high school in 1847 to support his family; by 1850 he was designing ornamental metalwork for Archer, Warner and Miskey, manufactur-

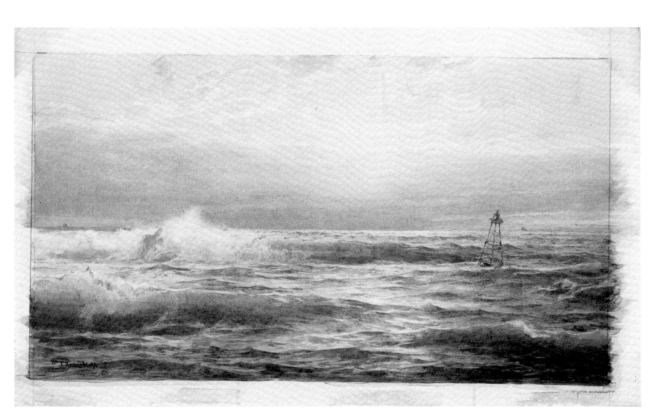

William Trost Richards
The Bell Buoy
1894

ers of gas fixtures. Evenings he spent studying wood engravings and doing his own painting, which he began to exhibit in 1852 at the Pennsylvania Academy of the Fine Arts. In 1855 he used his savings to study abroad for a year. Upon returning he married and continued to design metalwork until he started receiving substantial patronage for his painting. By 1871 he was an academician of the National Academy of Design and the Pennsylvania Academy. He was also a member of the Association for the Advancement of Truth in Art, which promoted the ideas of John Ruskin, which greatly influenced Richards. In 1880, after two years abroad, Richards settled in Newport, Rhode Island, where he built a house called Gray Cliff. During his later years he received medals from the Pennsylvania Academy and the Paris Exposition and was often abroad, painting in such places as the Channel Islands. He died November 8, 1905, at his home in Newport.

The Bell Buoy 1894
Watercolor on paper
15⅜ × 26⅜ in. (39.6 × 66.9 cm)
Inscribed, l.l.: "Wm T Richards 94"
Gift of Charles C. Glover, Jr.
 1958
Acc. No. 58.32

During the last two decades of his life Richards' interest turned from painting landscapes and still lifes to recording the seacoast and open ocean in a highly realistic manner. From the late 1850s he had been striving for an "exacting fidelity to nature."[1] To achieve such veracity required painstaking observation: it is said that he frequently stood for long periods ankle deep in the waves gazing across the water.[2] Such close attention to the sea brought tangible results: most of his marine paintings capture a luminosity in the water that eludes many a photographer but which the human eye can perceive.[3]

In the Corcoran watercolor the waves that crash and curl toward the viewer are illuminated by late afternoon sunlight. The cool mauve tones are delicately balanced by the greens of the deeper depths. The sun's reflections separate the foam-topped waves from the gently bobbing buoy that balances them on the right. Part of Richards' facility in depicting the sea comes from his sensitive use of watercolors. As early as 1860, more than thirty years before this work was executed, Richards was already proficient in this medium. He was a member of the American Watercolor Society, and over 185 of his watercolors were acquired by his friend and major patron, George Whitney, of Philadelphia.[4]

Whitney owned the earliest rendering known of this composition with bell buoy. In Richards' letters to Whitney from 1875 to 1894 he frequently enclosed tiny watercolors, including one measuring 3 × 5 inches painted on May 12, 1889, in which the buoy is on the left side.[5] In Richards' next rendering of the subject, in oil on canvas, 40 × 72 inches, the buoy is moved to the right side. That painting, executed in 1891, was exhibited the same year at the Pennsylvania Academy in their sixty-first annual exhibition.[6] Ever an artist to pursue variations on a theme, Richards three years later painted the Corcoran watercolor. The buoy now is nearer the viewer and a long, white-capped wave in the right foreground of the oil has been eliminated. Evi-dently the bobbing bell buoy was a subject of abiding interest, and other renderings of it may yet be discovered.

LCS

1. Linda S. Ferber and William H. Gerdts, *The New Path, Ruskin and the American Pre-Raphaelites* (Brooklyn: Brooklyn Museum, 1985), p. 214.
2. Henry P. Rossiter, *M. and M. Karolik Collection of American Watercolors and Drawings 1800–1875*, Vol. 1 (Boston: Museum of Fine Arts, 1962), p. 264.
3. Linda S. Ferber, *William Trost Richards: American Landscape and Marine Painter 1833–1905* (Brooklyn: Brooklyn Museum, 1973), pp. 36, 42.
4. Ferber and Gerdts, p. 214.
5. Linda S. Ferber, *Tokens of a Friendship: Miniature Water Colors by William Trost Richards from the Richard and Gloria Manney Collection* (New York: Metropolitan Museum of Art, 1983), p. 98.
6. *Ibid.*, p. 98, and letter from Kathleen A. Foster, Pennsylvania Academy of the Fine Arts, Philadelphia, to Linda C. Simmons, January 29, 1985.

21

Walter Paris
(1842–1906)

BORN FEBRUARY 28, 1842, IN LONdon, Walter Paris was educated as an architect. Between 1863 and 1872 he was the architect of the British Government in India and taught drawing at the Royal Military Academy in Woolwich. Emigrating from England in 1872, he concentrated on painting in his studio in Union Square in New York, where he was instrumental in founding the Tile Club, an artists' society. He also pursued his musical interests as an amateur violinist. After Paris moved to Washington, D.C., in 1874 he made several trips west, most often to Colorado, and it was his western impressions that resulted in his most popular American landscapes. A lifelong bachelor, he remained active in Washington

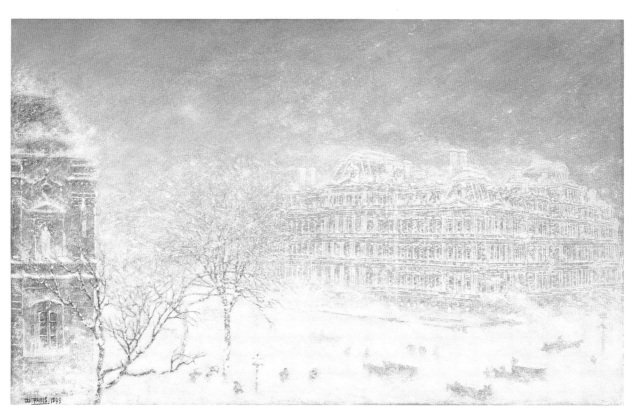

Walter Paris
The Great Blizzard of 1899
1899

art circles, an associate and exhibitor at the Washington Watercolor Club, until his death on November 26, 1906.

The Great Blizzard of 1899 1899
Gouache, watercolor, and charcoal
 on pale-gray paper
17⅞ × 29¼ in. (45.4 × 74.3 cm)
Inscribed, l.l.: "W. Paris 1899"
Bequest of the artist 1909
Acc. No. 9.13

According to the *Washington Post* of February 14, 1899, the preceding day's snowfall was part of a history-making week of winter weather. In characteristically melodramatic Victorian language, one columnist described how "the snow king swept down on Washington yesterday . . . accompanied by his mother, the frigid storm king [sic] and the two held a wonderful carnival in the Capital City." It is this winter carnival that provides the context for Paris' large gouache and watercolor view of the State, War, and Navy Building immediately west of the White House. The largest office building in the world when it was finally completed in 1888, it is now called the Old Executive Office Building.[1] Paris' architectural background and orientation toward detail were well suited to suggesting the 900 columns and 1,572 windows of Alfred B. Mullet's French Renaissance Revival building. Paris used charcoal not only to delineate the facade but also to capture the tracery of the tree branches reaching across Pennsylvania Avenue from the Corcoran Gallery of Art.[2]

In this painting by an artist best known for his western landscapes, we also see the use of an uncommon medium for Paris—gouache. In this method of paint-

ing, watercolor is thickened with a white pigment to create an opaque medium which here effectively conveys the bulk of the snow as it swirls off the buildings and hinders the progress of the tiny figures. The fleecy quality of the paint combined with the charcoal forms a pattern which flattens the space within the picture, further accentuating the enclosing presence of the blizzard. Well thought of as a painter in Washington art circles, Paris exhibited at the Corcoran during his lifetime, and this particular work was lauded by a local critic as a "very difficult theme, most skillfully rendered."[3]

JH

1. See Mina Wright, *The Old Executive Office Building: A Victorian Masterpiece* (Washington, D.C.: GPO, 1984).

2. Designed by James Renwick, today it is a Smithsonian museum for the decorative arts named after its architect, while the Corcoran Gallery became newly established two blocks away in a building which opened in 1897.

3. Leila Mechlin, quoted in the Walter Paris entry in *Dictionary of American Biography*, ed. Dumas Malone, Vol. VII (New York: Scribner's, 1962), p. 203.

22

John Singer Sargent
(1856–1925)

JOHN SINGER SARGENT WAS BORN in Florence on January 12, 1856, to wealthy Americans who had left Philadelphia several years before to live the life of expatriates in Europe. At an early age Sargent displayed artistic talent. After some private lessons and limited training at the Accademia delle Belle Arti in Florence, he and his family moved to Paris, where he entered the studio of Carolus-Duran, one of the leading portrait painters of the day, and studied at the Ecole des Beaux-Arts. Al-

though Sargent painted landscapes and genre pieces in oil and watercolor throughout much of his life, he is best known for his portraits of fashionable society on both sides of the Atlantic. He was elected to the Royal Academy in 1897. Sargent died in London on April 14, 1925.

Olimpio Fusco c. 1900–1915
Charcoal and stump on laid
 Michallet paper
24½ × 18⅝ in. (62.2 × 43.3 cm)
Inscribed, l.c.: "Olimpio Fusco/63A
 Aspiniea Rd/Hammersmith"
Gift of Mrs. Frances Ormond (Violet Sargent) and Miss Emily Sargent, sisters of the artist 1949
Acc. No. 49.104

A master draftsman and an incessant sketcher, Sargent made portrait drawings throughout most of his artistic career. These works, which range from quick pencil sketches on scraps of paper to highly finished charcoal drawings on tinted stock, can be divided into three general categories: drawings of friends and associates done for personal pleasure, preliminary studies for oil portraits, and finished portraits of famous and fashionable people.[1] The present drawing, with its inscription identifying the sitter as an Italian living in an unfashionable part of London, clearly belongs to the first category. Executed at a time when Sargent was working on religious murals for the Boston Public Library (1890–1916), the charcoal is undoubtedly a portrait of one of the models Sargent was employing at that time for the project.

The exact date of this piece is open to question,[2] but the watermark indicates that it was done at the same general time as studies

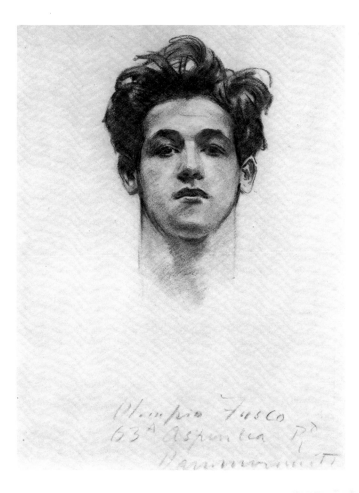

John Singer Sargent
Olimpio Fusco
c. 1900–1915

Thomas Wilmer Dewing
Head of a Woman
c. 1909

43

for the final phase of the Boston Library murals. Whatever its precise date, this work brilliantly displays Sargent's mastery of the charcoal medium and his method of drawing. The rich blacks in the hair and eyebrows in conjunction with the highlight erasure on the nose reveal how the artist proceeded from middle tones to the extremes of dark and light to create form. The softness of line emphasizes the sensuality of the sitter, who looks down with melancholic eyes as if from a pedestal. The embodiment of ideal male beauty, Fusco's chiseled head seems, despite its earthy lushness, spiritually aloof as it floats disembodied high in the pictorial space of the paper.

EJN

1. For a survey see Trevor Fairbrother, *Sargent Portrait Drawings* (New York: Dover, 1983).
2. Fairbrother tentatively dates the work between 1905 and 1915. In *John Singer Sargent: Drawings from the Corcoran Gallery of Art* (Washington, D.C.: Smithsonian Institution Traveling Exhibition Service and Corcoran Gallery of Art, 1983), p. 59, I suggest a date of c. 1900–1910. While the paper argues for the earlier date, Fairbrother compares this work with pieces executed after 1910; therefore, a more inclusive date than the one I offered seems warranted.

23

Thomas Wilmer Dewing
(1851–1938)

BORN IN BOSTON ON MAY 4, 1851, Dewing was the descendant of an old Massachusetts family. Having worked as a young man for a lithographic firm in his native city, he spent some time in Albany executing portrait drawings before studying in Paris between 1876 and 1878. In 1880 he settled in New York. Elected a full member of the National Academy of

Design in 1888, Dewing, who was influenced by Vermeer and Whistler, gained recognition for his poetic paintings, pastels, and silverpoints of women in idealized or undefined settings.[1] In 1898 he became associated with a group called Ten American Painters, or The Ten, which included John Twachtman, Childe Hassam, Willard Metcalf, Edmund Tarbell, and J. Alden Weir, artists generally considered Impressionists. Dewing enjoyed an enviable reputation at the turn of the century, but his genteel style fell out of favor after World War I. He died in New York on November 6, 1938.

Head of a Woman[2] c. 1909
Silverpoint on white prepared paper
13¹¹/₁₆ × 11¾ in. (34.8 × 29.9 cm)
Inscribed, l.r.: "T W Dewing"
Bequest of James Parmelee 1941
Acc. No. 41.4

Dewing took up silverpoint around 1894 at a time when there was a revival of interest in this demanding medium.[3] Executed on special paper with a stylus made of silver, the resultant drawing allows for no erasures; its thin pale lines create a delicate, almost ethereal image. In this example, the grayish line tones have tarnished to a soft brown, adding to the ephemeral quality of the piece. A contemporary described Dewing's silverpoints as "emanations of the spirit" and felt they provided the best insight into the artist's aesthetic.[4]

The identities of Dewing's subjects—he usually drew female heads—are not important. Although undoubtedly representing a specific model, this is less a portrait of an individual than an embodiment of the artist's concepts

of intellectual beauty. With her long neck, rounded jaw, full lips, and tightly modelled nose, the woman is a type frequently encountered in his work.[5] Not conventionally pretty, she projects intelligence. As one critic observed, Dewing's ideal is "a person who can think, and her thoughts are hers."[6] She is a mature, thoughtful, dignified, somewhat aloof woman.

Admired for their technical virtuosity as well as their poetic sensibilities,[7] Dewing's silverpoints were in great demand at the time that this work was executed. Because they were so difficult to do, he created very few. It seems likely, therefore, that this piece was done shortly before it was purchased in 1909 from the artist's New York dealer by James Parmelee, a trustee of the Corcoran, for his own collection.

EJN

1. See Sarah Lee Bruns, *The Poetic Mode in American Painting: George Fuller and Thomas Dewing* (Ann Arbor: UMI Research Press, 1979).
2. Published as *Head of a Girl* in *American Drawings, Watercolors . . . in the Collection of the Corcoran*, the work undoubtedly depicts a woman, as do most of his other compositions.
3. See Bruce Weber, *The Fine Line: Drawing with Silver in America* (West Palm Beach: Norton Gallery and School of Art, 1985), pp. 20, 27, 28. I also want to thank Susan Hobbs, who is preparing a catalogue raisonné of Dewing's work, for discussing this piece with me.
4. Charles H. Caffin, "The Art of Thomas W. Dewing," *Harper's Weekly* 116 (April 1908): 721.
5. Several of Dewing's contemporaries describe his female type and their innate intelligence; e.g., Ezra Tharp, "T.W. Dewing," *Art and Progress* 5 (March 1914): 160, speaks of Dewing's depictions as a "Hymn to Intellectual Beauty." Caffin, p. 724, enumerates the characteristics of Dewing's ideal female head, including those listed above.
6. Tharp, p. 156.
7. Caffin, p. 721.

George Bellows
(1882–1925)

BORN IN COLUMBUS, OHIO, AU-gust 12, 1882, the son of a builder and architect, Bellows was educated there, distinguishing himself in athletics and music. When he decided to become an artist in 1904 he enrolled at the New York School of Art. Rapidly his abilities were recognized and various honors followed, including election to the National Academy of Design in 1909. In 1910 he married a fellow art student and musician, and they resided in New York except for vacations in New England and New Jersey. In 1910 he began teaching life and composition at the Art Students League, and the next year his first one-man exhibition was organized at the Madison Gallery. The historically important Armory Show was organized with his assistance in 1913, the same year he received the First Hallgarten Prize at the National Academy. Bellows began to work in lithography in 1916 and became one of the great printmakers of his day, as well as a sought-after illustrator of books and magazines such as *Collier's* and *The Masses*. He neither traveled nor studied abroad, an aspect of his career which, coupled with his subjects—city scenes, sports, landscapes, figure compositions—has led him to be identified as one of the most American of artists. He achieved a great deal before he died of appendicitis at the age of forty-three, January 8, 1925, in New York.

Children Playing in a Park c. 1905
Pen and black ink over graphite on
　illustration board
21⅞ × 28¹⁵⁄₁₆ in. (55.5 × 73.5 cm)
Museum purchase 1960
Acc. No. 60.17

George Bellows arrived in New York in September 1904, after leaving Ohio State University in the spring and playing semi-professional baseball during the summer. The trip east was financed by the sale of several drawings.[1] Since high school he had contributed drawings to student publications, emulating the styles of such popular illustrators as Howard Chandler Christy, James Montgomery Flagg, and Charles Dana Gibson.[2] Soon after his arrival Bellows enrolled in the New York School of Art, directed by William Merritt Chase. Among his fellow students were Edward Hopper and Rockwell Kent. It was here under Robert Henri's tutelage that Bellows said his life began. Henri taught a broad, vigorous style based on direct observation, encouraging the depiction of motion and the use of chiaroscuro to create depth. Bellows responded, and his own style began to change. This large ink and pen drawing is a transitional work, probably executed during his first year at the art school. It retains some aspects of his youthful, illustrator-inspired style but also looks ahead to elements that would become characteristic of his mature work.

A seemingly endless crowd fills a park, flowing into the distance through a break in the trees. In the foreground lively boys playing baseball and a form of hockey on roller skates swirl around a nurse and her younger charges. With an economy of line Bellows quickly notes their actions and facial features, creating in some cases caricatures, like that of the boy skating toward the right foreground. Charming vignettes appear in the scene: a little child crouches near the center to see a wheeled toy being towed by two other children; a child climbs over a park bench; a man reads the newspaper; a woman holds a bonneted baby. The figures gradually dissolve into a few sketchy lines on the left or right. The open left area is balanced by the heavily cross-hatched region on the center right, and the whole scene is surmounted by the massed foliage of shade trees.

This drawing in ink and pen is executed over graphite. Bellows' line, tracing around the figures, and cross-hatching for mass are very similar to that of illustrators such as Gibson. However, the inclusion of a multitude of figures and the urban park scene look ahead to works Bellows would soon create in oil. The drawing was given to Bellows' friend and fellow art student Robert Gilmor Bowie, who later gave up his own art work to become a civil engineer. He continued to follow Bellows' career, cheering on his successes and rise to fame and finally mourning his early demise.[3]

LCS

1. Trinkett Clark, "Chronology," in *Bellows: The Boxing Pictures* (Washington, D.C.: National Gallery of Art, 1982), p. 101.
2. Linda Ayres, "Bellows: The Boxing Drawings," in *Bellows: The Boxing Pictures*, p. 49.
3. Mrs. Robert Gilmor Bowie to Mary E. Hoffman, Registrar, Corcoran Gallery of Art, May 1960.

Charles Dana Gibson
(1867–1944)

ON SEPTEMBER 14, 1867, IN ROX-bury, Massachusetts, Charles Dana Gibson was born into an old New England family of clergymen, soldiers, statesmen, and artists. In 1886, after two years at the

George Bellows
Children Playing in a Park
c. 1905

Charles Dana Gibson
*His Granddaughters Discover That He
Knows the Words of the Star Spangled
Banner*
1920s

Art Students League in New York, he sold his first drawing to the recently established humor magazine *Life*—the beginning of a career-long association. Through that publication and others such as *The Century* and *Collier's Weekly* Gibson became known for his beautifully drawn satires of New York life. His socially conscious images came to include the statuesque, aristocratic young woman known as the Gibson Girl. In 1905, at the height of his popularity, the artist decided to study painting in Europe, where he remained for two years working in France, England, and Germany. Financial reasons forced his return to America, to his career as an illustrator, and to *Life*, where he served as editor until 1932. Into the 1940s he continued to draw, paint, and publish books of his drawings. A large retrospective of his work, including oil portraits, was organized at the Cincinnati Museum of Art in 1942 to honor his seventy-fifth birthday. Gibson died December 23, 1944.

His Granddaughters Discover That He Knows the Words of the Star Spangled Banner 1920s
Black ink and pen over graphite on illustration board
14�5/16 × 20⅞ in. (36.7 × 53 cm)
Inscribed, l.r.: "CD Gibson"; l.l. to l.r.: "Mr Pipp no. 5 his granddaughters discover that he knows the words of the Star Spangled Banner."
Gift of Orme Wilson 1965
Acc. No. 65.28.1

Mr. Pipp was created in a series of articles published in the comic magazine *Life* beginning in September 1898.[1] Amusing accounts of his life and travels with a wife and two daughters continued in serial episodes until the daughters were married and infant grandchildren appeared on Mr. Pipp's knee. The popularity of the character continued into the next century, and Gibson was persuaded to resurrect the humorous little man in the 1920s to be "re-educated" by his flapper granddaughters.[2]

Mr. Pipp, standing at attention, warbles the many verses of the National Anthem, much to the quizzical interest of the young women and their male friend, who lounges arrogantly while awaiting his after-dinner coffee. Also surprised is the man behind the piano, who appears to be following the words in a musical score. As earlier with his Gibson Girl, the artist has deftly and economically delineated not only the current dress fashion but also the popular mannerisms of the time—in this case the languid sophistication of the twenties.

This vigorous drawing illustrates Gibson's ability to capture characters and scenes in a humorous manner. He typically formulated the composition first in pencil, reworking several figures with a turn of the head or twist of the body.[3] When the drawing achieved the nuances he wished to convey, Gibson used a pen and black ink to reiterate the lines and produce the image we see. Here, as in his drawings of the 1890s, he combines rows of lines with areas of cross-hatching to create masses and planes. He also retains the use of a fragmented line to define edges as in the outlines of most figures and especially the profile of the soignée young woman on the left.

LCS

1. Woody Gelman, *The Best of Charles Dana Gibson*, reproduces the entire series of nineteenth-century images of Mr. Pipp as published originally in one volume under the title *The Education of Mr. Pipp* (New York: R.H. Russell, 1910).
2. Fairfax Downey, *Portrait of an Era as Drawn by C.D. Gibson* (New York: Scribner's, 1936), p. 249.
3. Paul Cummings, "American Drawings," in *The Figure in Context* (Washington, D.C.: International Exhibitions Foundation, 1984), p. 56.

26

Childe Hassam
(1859–1935)

BORN OCTOBER 17, 1859, IN DORchester, Massachusetts, Frederick Childe Hassam was the son of a well-to-do Boston merchant, whose prosperity ended in the Boston fire of 1872. As a young man Hassam was successful as a freelance illustrator. Private lessons from Ignaz Marcel Gaugengigl augmented his evening classes at the Boston Art Club until 1883, when he left for a year in Europe. Upon his return he married and established a home and studio for the next two years in Boston. The following three years were spent in Paris, where he studied briefly at the Académie Julian. The Hassams returned to the United States in 1889 and settled in New York. He exhibited frequently with the Society of American Artists, but dissatisfaction with the Society's exhibition practices led him to join with J. Alden Weir and John H. Twachtman in 1897 to form a group eventually called The Ten, which exhibited together for the next twenty years. Hassam enjoyed numerous successes during his long career, including thirty-five major prizes. He continued to paint and produce prints throughout the last years of his life. He died at East Hampton, Long Island, his long-time summer residence, on August 27, 1935.

Big Ben 1897–1907
Gouache and watercolor over charcoal on gray-tan paper
8¹¹⁄₁₆ × 11⅝ in. (22 × 29.5 cm)
Inscribed, l.r.: "Childe Hassam /
 1897 Childe Hassam / 1907"
Bequest of James Parmelee 1941
Acc. No. 41.11

The prominent feature of this scene, the tower that holds the well-known time piece Big Ben, looms out of the mist and rain of a London evening. Nearer to the viewer pedestrians and vehicles negotiate a rain-soaked Westminster Bridge. The Houses of Parliament are also distinguishable on the skyline to the left. Hassam must have known this scene well. During his lifetime he made four trips to Europe and on each of them he spent time in London.[1] On the earliest visit he became acquainted with Turner's atmospheric paintings and Whistler's nocturnal scenes. Both artists had an effect on Hassam's choice of subject and style: his paintings often became a distillation of responses to emotions evoked by a time of day, the effects of light, and the qualities of atmosphere.

This painting was probably begun in 1897 during his third trip to Europe, then significantly reworked in 1907. It is difficult to discern what the initial image was. Microscopic examination reveals many changes to an underdrawing of charcoal, much of which bears little relationship to the present image. Changes between the initial drawing and final image are indicated by the nearly obliterated horizontal strokes near the tops of the righthand row of street lamps as well as the large pool of gray gouache in the sky above the towers of the Houses of Parliament. The earlier date and signature from 1897 have been partially obliterated by three horizontal daubs of light gray watercolor intended to blend the letters and numerals into the image of wet pavement. Evidently Hassam felt this work was significantly interesting to continue to rework it over a period of ten years.

Hassam had lived in Paris from 1886 to 1889 and knew the works of the French Impressionists from his other trips to Europe.[2] Although often identified with American Impressionists, he ignored the optical dismemberment and reblending of color. This scene combines a number of elements which had appeared in Hassam's art since the mid-1880s: an urban street scene alive with the motion of people and vehicles, and a pearly, almost palpable mist-laden atmosphere strained through shadows and rain, imparting a reflective surface to the pavement and sidewalks, mirroring and transfiguring the solid forms above. He retained a quick, short brushstroke and with an economy of means and a shorthand of forms succinctly stated the essence of his subject. In this case it is the quintessential rainy evening in London.

LCS

1. Donelson F. Hoopes, *Childe Hassam* (New York: Watson-Guptill, 1979), pp. 11–12, 14, 15; "Childe Hassam—A Retrospective View in Progress," in Stuart Feld, *Childe Hassam, 1859–1935* (East Hampton: Guild Hall Museum, 1981), pp. 19–21, 23.
2. Feld, pp. 19–20.

27

Henry François Farny
(1847–1916)

HENRY FARNY WAS BORN ON JULY 15, 1847, in Ribeauville, France. In 1853, the family moved to western Pennsylvania and then settled in Cincinnati, where the teen-aged Henry was apprenticed to a lithographic firm and began doing illustrations for *Harper's Weekly*. By 1866 he was in New York working for the magazine. The following year Farny went to Rome as an assistant to the painter Thomas Buchan Read; he also studied in Vienna and Munich before returning to Ohio in 1870. In 1881 he made the first of several trips to the West, the last in 1894. His illustrations appeared in various magazines in the 1880s, but by 1893 demand for his paintings made it possible for him to give up graphic work and devote himself entirely to fine art. He died in Cincinnati on December 23, 1916.

The Indian Bear Hunter 1911
Gouache and watercolor over
 graphite on illustration board
10³⁄₁₆ × 5¹³⁄₁₆ in. (25.9 × 14.8 cm)
Inscribed, l.r.: ".Farny ./ ⊙ /1911"
Gift of Mr. and Mrs. Hamilton
 Robinson 1978
Acc. No. 1978.22

Although Henry Farny painted other subjects and worked in oil, he is probably best known for his beautifully detailed small-scale representations, in gouache and watercolor, of Indian life at the turn of the century. One of the foremost artists of the genre among a generation that included Frederic Remington, Charles Russell, Charles Schreyvogel, and George de Forest Brush, Farny felt that "the plains, the buttes, the whole country and its people are fuller of material for the artist than any country in Europe."[1]

Farny turned to Indian subject matter after his initial journey West in 1881. On this and subsequent trips he sketched, collected artifacts, and took photographs

Childe Hassam
Big Ben
1897–1907

Henry François Farny
The Indian Bear Hunter
1911

which served as props and sources for the works he created in his studio. As a result, the same motifs reappear in his compositions. Early along Farny began to use a symbol after his name—a circle with a dot in the center—supposedly an emblem for the name Wasitcha ("white face maker chief") given him on adoption into the Sioux tribe.[2] A variation on this symbol occurs in his inscription.

The Indian Bear Hunter comes at the end of the artist's career; its format, execution, and theme are characteristic of Farny's mature style. The meticulous attention to detail and the unsentimental treatment of the subject offer a sensitive but detached picture of an arduous life. The Indian is shown eking out an existence by traditional means in a harsh environment. By this time, the once plentiful bison herds had been decimated through wanton hunting by whites, and the Indian had for the most part been relegated to barren reservations.

The solitary hunter first appears in Farny's work in the 1880s, but it is around 1900 that the theme becomes recurrent.[3] So, too, the representation of a winter landscape occurs with greater frequency after the turn of the century. The small format, typical of Farny's work in the medium, encourages the viewer to contemplate this exquisite piece as a jewel-like miniature or icon. While the naturalism of the landscape and figure do not idealize the scene, the golden light of a setting sun adds a poetic note to the composition, and alludes, perhaps, to the passing of a way of life.

EJN

1. Quoted in Denny Carter, *Henry Farny* (New York: Watson-Guptill Publications in cooperation with the Cincinnati Art Museum, 1978), p. 21.

2. Carter, p. 24; also see *Henry Farny* (Cincinnati: Indian Hill Historical Museum Association, 1975), [p.4].

3. Carter, p. 28. Several similar compositions, all from the first decade of the century, are illustrated in Carter, pp. 123, 127, 158, 166.

28

Maurice Brazil Prendergast
(1859–1924)

BORN OCTOBER 10, 1859, IN ST. John's, Newfoundland, Maurice Prendergast moved with his family to Boston when he was two years old. After an apprenticeship to a show-card painter, he sketched in watercolor for ten years. Beginning in 1891 he studied in Paris for three years at the Colarossi and Julian academies. In 1897 he established a studio in Boston which he maintained between numerous trips to Europe until 1914, when he and his brother Charles, an artist and frame-maker, moved to New York. Prendergast's work was exhibited regularly, and he received extensive commissions for illustrations. In 1904 he became a member of The Eight, which included William Glackens, Robert Henri, George Luks, John Sloan, Ernest Lawson, Everett Shinn, and Arthur B. Davies, artists joined by their anti-academic attitudes and interests. They—especially Davies—were largely responsible for organizing the Armory Show of 1913, which included seven of Prendergast's paintings. His final years were spent living and working with his brother in a Washington Square apartment, where he died February 1, 1924.

Summer Day, New England
1913–1916
Watercolor over charcoal on paper
12 × 17^{15}/$_{16}$ in. (30.5 × 45.5 cm)
Inscribed, l.r.: "Prendergast"
Museum purchase through a gift of
 Margaret M. Hitchcock 1969
Acc. No. 1969.37.2

From the 1890s through the end of his career Maurice Prendergast established a direction and subject range that he pursued in endless variation. During his travels to Paris he assimilated the artistic currents of Post-Impressionism and the Fauves. In his scenes of figures in urban, holiday, and park settings he used heightened color liberated from form to create patterns and a free brushstroke to augment both color and patterns. From late 1899 through the early years of this century he worked to de-emphasize drawing and specificity of place.[1] He began to apply unmixed watercolors in broad washes, as in the sky seen here, as well as in the swirling, fluid strokes in the grass, the foliage, and the trunks of the trees. His favorite palette was limited to bright primary colors whose intensity is enhanced by surprising juxtapositions. The purity of the color applied can be seen in the high sheen retained by the darker greens in the trees, evidence of the gum arabic utilized as the vehicle for the ground pigment.[2]

Dating Maurice Prendergast's work can be perilous, since he often continued to work on paintings for many years and had the habit of working in several modes simultaneously.[3] This work is dated from 1913 to 1916 for several reasons. When purchased by the Corcoran from a benefit auction it was identified by Mrs. Charles Prendergast, sister-in-law

Maurice Brazil Prendergast
Summer Day, New England
1913–1916

of the artist, as "executed circa 1913,"[4] while its style of painting was typical for the next few years. Subject matter is of little assistance in assigning a date, since by the beginning of the 1910s this sort of summer scene had become a symbol for all such scenes rather than a depiction of a particular place. Nothing here actually identifies the setting as New England, yet it is known that Prendergast spent several summers during this time painting along the New England coast of Massachusetts and Maine,[5] and similar works from this period have comparable titles.

LCS

1. Eleanor Green, "Art of Impulse and Color," in *Maurice Prendergast*, exhibition catalogue (College Park: University of Maryland Art Gallery, 1976), p. 18.

2. Consultation with Katherine Eirk, paper conservator, November 1, 1985.

3. Green, p. 14.

4. *Summer Day, New England*, Parke Bernet Sale #2438, May 11, 1966, donated by Mrs. Charles Prendergast, Westport, to benefit the Whitney Museum of American Art (illustrated in black and white).

5. Green, p. 140.

29

Hendrik Glintenkamp
(1887–1946)

BORN IN AUGUSTA, NEW JERSEY, on September 10, 1887, Glintenkamp studied art at the National Academy of Design from 1903 to 1906, followed by two years with Robert Henri at the New York School of Art. After 1908 he shared a studio with Glenn O. Coleman and Stuart Davis. In addition to teaching art in Hoboken and New York, he contributed drawings to *The Masses* and edited other periodicals. Noted as a printmaker as well as a painter, he produced many woodblocks and illustrations. In 1917 he moved to Mexico to avoid the draft and later lived and traveled in Europe. Glintenkamp returned to New York in 1934 where he taught, worked with the WPA, was a member of the American Artists Congress, and pursued his art. He died there on March 20, 1946.

Woman Strolling 1914
Watercolor and gouache over
 graphite on paper
14¹⁵/₁₆ × 10¹⁵/₁₆ in. (38 × 27.8 cm)
Inscribed, verso, u.r.: "Glinten-
 kamp"[1]; u.l.: "B-661–1914-";
 l.l.: "B-66/1914–B-66"
Museum purchase 1965
Acc. No. 65.11

This striking watercolor is not a typical work for Glintenkamp, who is known for a more realistic style that reflected his studies under Robert Henri.[2] In 1913 Glintenkamp exhibited a painting in the Armory Show, which may have been his first exposure to avant-garde developments in European art of the early twentieth century. Stuart Davis, his friend and fellow contributor to *The Masses*, described the profound effect of what they saw exhibited as "the greatest shock to me—the greatest single influence I have ever experienced in my work. All my immediately subsequent efforts went towards incorporating Armory Show ideas into my work." Davis further notes that he responded particularly to the paintings by Gauguin, van Gogh, and Matisse.[3]

Glintenkamp, like Davis, quickly assimilated the ideas and styles seen at the Armory Show, especially the work of Matisse, who was represented by fifteen canvases. This work, painted the following year, demonstrates his understanding of Fauvist concerns for arbitrary color and the distortion of form for expressive effect. In fact, both the woman's angular features and the color scheme used—blue, green, orange, and pink—bring to mind Matisse's *Young Sailor* (1906), which was in the Armory Show.

Glintenkamp worked over a quick sketch which originally included a small dog in the lower left corner. However, he eliminated the dog as an unnecessary anecdotal element to concentrate attention on the central figure. It is interesting to note that this sheet had been previously used by Glintenkamp: the verso bears a cognate image of a woman's profile also executed in a Fauvist palette.

LCS

1. Glintenkamp signed his work with his last name or "Glint," occasionally exhibited under the name Henry Glintenkamp (as in the Armory Show), but in his family his first name was known only as Hendrik. Phone call to Hendrik Glintenkamp, son of the artist.

2. Sandra Leff, introduction to *Henry Glintenkamp, 1887–1946: Ash Can Years to Expressionism. Paintings and Drawings, 1908–1939* (New York: Graham, 1981), p. 3.

3. Davis, quoted in Stuart Davis entry in *The Figure in American Art, 1764–1983*, one of *Three Simultaneous Exhibitions, May 1986* (New York: Kennedy Galleries, 1986), n.p.

30

Marguerite Zorach
(1887–1968)

MARGUERITE THOMPSON WAS born September 25, 1887, in Santa Rosa, California. After enrolling at Stanford University she decided instead to study art in Paris. Between 1908 and 1912 she traveled in Europe, the Near East, and the Orient. Her art instructors in Paris included the Scottish

Hendrik Glintenkamp
Woman Strolling
1914

Marsden Hartley
Abstraction
1915–1916

Marguerite Zorach
Sailing Vessel
1916

Fauve John Duncan Fergusson. While in Paris she met William Zorach, an American sculptor and painter, whom she married after returning to the United States in 1912. The couple settled in New York, their residence for the next twenty-five years. Summers were spent—eventually with son Tessim and daughter Dahlov—in New England. Motherhood limited her flexibility as a painter, so during the 1920s and 1930s she turned to writing and working in wool. In the last years of her life she returned to painting and exhibited regularly until her death on June 27, 1968, in Brooklyn.[1]

Sailing Vessel 1916
Graphite and stump on paper
15¼ × 11¼ in. (38.6 × 28.5 cm)
Inscribed, l.r.: "Marguerite Zorach / 1916"; incised, l.l.: "Marguerite Zorach"
Museum purchase 1967
Acc. No. 67.35

Sailing Vessel was drawn during the summer of 1916, the first of four spent in Provincetown where Marguerite Zorach often painted and drew at the harbor. In this drawing it is easy to see that her exposure to the avant-garde in Paris opened her mind to Cubism, which she had a chance to become reacquainted with during the Armory Show of European modernists in 1913 in New York. The Zorachs' visits to Alfred Stieglitz's gallery "291" on Fifth Avenue, where progressive artists exhibited regularly, and their close friendship with Max Weber—one of the Stieglitz circle whom they met in 1915—encouraged her to study Cubism more seriously.[2] Where she departed from the technical theory of Cubism was in her sense of environment, her practice of painting out of doors,

and her coloristic approach.

The year 1916 was additionally significant for Marguerite Zorach. In the company of the most innovative American artists of the period, she was chosen to participate in the "Forum Exhibition of Modern American Painters" at the Anderson Galleries in New York. This exhibit of the work of seventeen artists was essentially the American answer to the European artists on display at the Armory Show three years earlier.[3]

JH

1. See Roberta Tarbell, *Marguerite Zorach: The Early Years, 1908–1920* (Washington, D.C.: Smithsonian Institution Press, 1973).
2. *Ibid.*, p. 45.
3. See "In Explanation," *The Forum Exhibition of Modern American Painters* (New York: Anderson Galleries, 1916), and Anne Harrell, *The Forum Exhibition: Selections and Additions* (New York: Whitney Museum of American Art, 1983).

31

Marsden Hartley
(1877–1943)

ON JANUARY 4, 1877, MARSDEN Hartley was born into a working-class family in Lewiston, Maine. After a difficult childhood that included the death of his mother and prolonged separation from his father, Hartley rejoined his family in Cleveland where they had moved. At nineteen, he started studying with John Semon and later became a student at the Cleveland School of Art. In 1899, through a modest stipend from a trustee, Hartley went to New York, where he attended first the Chase School and then the National Academy of Design. By 1909 Hartley was part of the progressive group of artists revolving

around Alfred Stieglitz and his "291" gallery. In 1912 he went to Europe, where he explored Cubism and developed an abstract style marked by patterned surfaces and charged with personal symbolism. While in Germany in 1913 he was asked to exhibit with *Der Blaue Reiter*, a group of artists founded by Franz Marc and Wassily Kandinsky. Shortly after his return to America at the end of 1915, his art became increasingly representational. Although his style underwent significant changes over the next twenty-five years, he remained committed to an expressionistic form of representation until his death in Ellsworth, Maine, on September 2, 1943.

Abstraction 1915–1916[1]
Charcoal on Ingres paper
25 × 19 in. (63.5 × 48.3 cm)
Museum purchase 1967
Acc. No. 67.2

Between early 1912 and late 1915 during two extended stays in Europe, Hartley assimilated the most advanced artistic ideas of the period and fashioned a distinctive abstract style that placed him in the forefront of American painters of his generation. Throughout this period he frequently exhibited drawings with his oils. Six, for example, were shown at the famous Armory Show in New York in 1913 along with two canvases. And this particular work probably was one of three he had on view at the landmark "Forum Exhibition of Modern American Painters" held at the Anderson Galleries in New York in March 1916, shortly after his return from Germany.[2]

This drawing contains motifs that entered Hartley's visual vocabulary during those three heady

years he spent in Paris and especially in Berlin—an eight-pointed star; wavy forms; crisp straight lines with angular projections; circles enclosing geometric elements. For this reason, this work and several others were designated "Berlin Symbols" when they were put on the market in 1959 by the Hartley estate.[3] However, the drawing cannot be associated with any particular canvas Hartley produced in that city, and, in fact, it may have been done after his return to America.

The simplified geometry of the design as well as its compositional balance and spatial isolation relate it more to the abstractions the artist produced in Provincetown in the summer of 1916 than to the overall patterned surfaces of the Berlin pictures.[4] Like the Provincetown oils, this drawing seems unusually controlled and self-contained. Probably executed shortly before it was exhibited in 1916, it could conceivably have served as a kind of departure point for the restrained and emotionally neutral paintings that followed.[5]

EJN

1. In *Drawings, Watercolors . . . in the Collection of the Corcoran Gallery* the work is entitled "Berlin Symbols #6" and given a date of 1914–1915.
2. Elizabeth McCausland noted that when she saw this work in a New York warehouse in November 1945, it bore a label indicating that it had been No. 168 in the Forum Exhibition (Elizabeth McCausland Papers, microfilm roll D269, 403, Archives of American Art). She also identified it as a "still life drawing" and tentatively dated it first 1912 and then 1913. In the checklist of the Forum Exhibition, No. 168 was untitled (microfilm roll N69–98, 665).
3. See letter to the author from Michael St. Clair, Babcock Galleries, dated April 2, 1986. A related drawing is in the Brooklyn Museum.
4. For examples see Barbara Haskell, *Marsden Hartley* (New York and London: Whitney Museum of Art in association with New York University Press, 1980), pp. 38–51, 54, 62–64.
5. *Ibid.*, p. 52.

32

Charles Burchfield
(1893–1967)

BORN APRIL 9, 1893, IN ASHTABULA Harbor, Ohio, Charles Burchfield was to become one of the most romantic of twentieth-century American landscape painters. He attended the Cleveland School of Art (now the Cleveland Institute of Art) from 1912 to 1916. Working first as a wallpaper designer for Birge and Sons, by 1929 he had gained a reputation as a regional realist exhibiting regularly in New York and elsewhere. From 1921 until his death on January 10, 1967, he lived in Buffalo.

May Morning 1915
Gouache and graphite on paper
11⅞ × 8¹⁵⁄₁₆ in. (30.2 × 22.7 cm)
Inscribed, recto, l.r.: "Chas Burchfield/May 1915"; verso, ctr.: "May 1915"
Museum purchase through a gift of Laura T. Magnuson 1981
Acc. No. 1981.90

When Charles Burchfield made this drawing in 1915 he was twenty-two and still in art school, but his apprenticeship as an artist was already over. Beginning that summer and during the next three years, Burchfield produced the works that were to be the foundation and inspiration of his life. Fifty years later he wrote:

1915 was the year that ideas came to me which were to haunt me for the rest of my life; ideas and visions of paintings that were far beyond my ability or knowledge to carry out and still are, after fifty years, an unfilled dream. . . . I made hundreds and hundreds of studies of clouds, trees, fields, fieldflowers and grasses, moonrises, sunsets and storms. All the ideas and materials for a lifetime had to be gathered that summer or never.[1]

Inspired by Wagner's leitmotifs and by Chinese scroll painting, Burchfield "determined to formulate a set of conventions based on Nature."[2] He made "all-day sketches," trying to telescope time and events into his own leitmotifs on a single sheet "in a musical composition in painting."[3] Explaining one of his abstractions, he said:

Everything was reduced to the twelve colors of the color wheel, plus black and white with minimum modifications. Thus sunlit earth would be orange, shadows on it, red-violet; sunlit grasses, yellow; shadows, blue or blue-green, and so on. They were executed in flat pattern with little or no evidence of a third dimension.[4]

May Morning, with its stylized patterning and limited palette of yellows, greens, and blues, exemplifies Burchfield's inventively abstract and synesthetic approach to the natural world.

BR

1. *Charles Burchfield: His Golden Year. A Retrospective Exhibition of Watercolors, Oils and Graphics* (Tucson: University of Arizona Press, 1965), p. 15.
2. *Ibid.*
3. Quoted in John I. H. Baur, *The Inlander: Life and Work of Charles Burchfield, 1893–1967* (Newark; University of Delaware Press, 1982), p. 29.
4. *Burchfield: His Golden Year*, p. 16.

33

Charles Demuth
(1883–1935)

CHARLES HENRY BUCKIUS DEMUTH was born November 8, 1883, in Lancaster, Pennsylvania, a town

Charles Burchfield
May Morning
1915

Charles Demuth
Rooftops and Trees
1918

that remained of great importance to him and to his work throughout his life. At a young age he displayed an interest in art and was given lessons with local artists. He subsequently studied formally at Drexel Institute and for several years at the Pennsylvania Academy of the Fine Arts. From 1912 to 1914 he lived in Paris, studied at the Julian and Colarossi academies, and was a member of Gertrude and Leo Stein's circle, which included Ezra Pound and Marcel Duchamp. Upon his return he lived in Provincetown, which had become a summer haven for the Greenwich Village avant-garde, and in Lancaster and New York. Commenting on Demuth's popularity, Duchamp called him "one of the few artists whom all other artists liked as a real friend, a rare case indeed."[1] Demuth exhibited widely, beginning with a series of one-man shows at the progressive Daniel Gallery in New York in 1914 and continuing with exhibits at the Museum of Modern Art, the Whitney, and the Venice Biennale. He was known for his lively vaudeville studies, perceptive illustrations for works by Henry James, Zola, and Poe, and especially for his fruit and flower watercolors which brought both popular and critical acclaim. What was to be a prolonged European trip in 1921 was cut short by a severe diabetic attack; returning to the United States, he received one of the earliest insulin treatments. Although his illness diminished his energies, he continued to introduce innovations in his work. He died at the age of fifty-two in Lancaster, October 25, 1935.

Rooftops and Trees 1918
Watercolor and graphite on paper
10 × 14 in. (25.4 × 35.6 cm)
Inscribed, l.l.: "C. Demuth 1918–"
Bequest of George Biddle 1974
Acc. No. 1974.3

Demuth was in Bermuda in the winter of 1916–1917, at the same time that Marsden Hartley was there, and both were experimenting with Cubism. Although Demuth had been exposed to Cubism earlier in Europe, it was not until he reached the haven of Bermuda that he began to introduce Cubist techniques into his own work. Bermuda's colonial buildings provided him with ample instances of angles and clearly defined forms.[2]

Demuth spent the summer of 1917 in Gloucester and there continued to work with Cubistic treatment of architecture and landscape. *Rooftops and Trees* is dated 1918 and was most likely made in Provincetown or Lancaster. It belongs in the group of "transitional landscapes" which were made after his Bermuda experiments and prior to his late architectural industrial landscapes. The paintings of this period were to make Demuth an important agent in the spread of Cubist theory in America.[3]

Demuth's process in creating these watercolors was to reduce forms to carefully drawn planes but add life with the curved shapes of plants.[4] The pieces are cool, light, and intellectual, the colors muted and delicate. In this respect the influence of Cézanne is readily apparent.[5] Demuth's work, however, differs from French techniques, including those of Picasso and Braque, who based their vision in a relentless analytic splintering of the object. Demuth instead analyzes the

many planes of the object, making them transparent or rotating them in space.

Rooftops and Trees appears to be composed of floating planes, some disconnected and some intersecting. The chimney, trees, and window provide a center for the rotating, dynamic whole. These central forms are the darkest and the most solid. Varying textures are created by the mottling and blotting of the paint.[6] Toward the edges the paper is without paint. This difference in the application of the paint reinforces the strength of the center and the sense that other planes are circling around it. Space, in the painting, is shallow; the many surfaces of the sky close off the back. The dark diagonal roof edges at the bottom contribute an upward lift to the expanding whole.

Sherman Lee writes that Demuth's Cubist works are "austere products of the intellect, fortified by the sensuous element of color."[7] Demuth has also been categorized as a Regionalist and a Precisionist, placing him within the "American tradition of linear, 'clear edge' painting which extends from John Singleton Copley to Will Barnet and Ellsworth Kelly." His oeuvre, however, defies such simple labels. He had the remarkable ability to work in styles ranging from Cubistic purity to naturalistic complexity, each new motif demanding a different approach.[8]

CA

1. Marcel Duchamp, "A Tribute to the Artist," in Andrew Carnduff Ritchie, *Charles Demuth* (New York: Museum of Modern Art, 1950), p. 17.
2. See Emily Farnham, "Charles Demuth's Bermuda Landscapes," *Art Journal* 25 (Winter 1965–1966): 130–137.

3. *Ibid.*, pp. 130 and 134 ff.

4. Betsy Fahlman, *Pennsylvania Modern: Charles Demuth of Lancaster* (Philadelphia: Philadelphia Museum of Art, 1983), p. 21.

5. Farnham (pp. 130–137) points out that Demuth would have seen Cézanne's work in the American collections of Alfred Stieglitz and Dr. Albert Barnes.

6. Discolored spots caused by mold damage remain on the drawing at center and to the left following conservation treatment. There are three large gray spots surrounded by numerous smaller dots.

7. Sherman Lee, "The Illustrative and Landscape Watercolors of Charles Demuth," *Art Quarterly* 5 (Spring 1942): 171.

8. Richard J. Boyle, *Three American Masters of Watercolor: Marin, Demuth, Pascin,* catalogue for the Ferdinand Howald Collection, Columbus Gallery of Art, pp. 9, 7.

34

Jules Pascin
(1885–1930)

PASCIN WAS BORN JULIUS MOR-decai Pincas on March 31, 1885, in Vidin, Bulgaria, and raised in Bucharest, the son of a wealthy grain merchant. As a youth he left his father's firm to study painting in Vienna and later in Munich. In 1905 he began contributing cartoons to the satirical Munich weekly *Simplicissimus.* By this date he had begun to sign his work "pascin," an anagram of his given names.[1] At the end of 1905 he moved to Paris and then in 1914 to New York, where he moved in a circle of anti-conservative artists including Walt Kuhn and Yasuo Kuniyoshi, who had known his work from the 1913 Armory Show. During this time he traveled and sketched with great relish in the South and the Caribbean. The same year that he became a U.S. citizen, 1920, he returned to Paris. True to his tempestuous nature, Pascin committed suicide June 5, 1930, leaving his estate to his wife and his mistress.[2] Known

for his draftsmanship and highly expressive line (especially as applied to sensual sketches of nude women), he was admired in the 1920s, neglected during the next three more respectable decades, and restored to renown in the 1960s, with large exhibitions in America and abroad.

Enlèvement d'Europe 1920–1925
Pen and brown ink with watercolor and metallic washes on paper
$18^{15}/_{16} \times 22^{15}/_{16}$ in. (48.1 × 58.3 cm)
Inscribed, l.r.: "Enlèvement d'Europe"
Museum purchase through a gift from Mrs. J. L. M. Curry 1977
Acc. No. 1977.19

Enlèvement d'Europe (the Rape of Europa) is characteristic of Pascin's graphic work of the 1920s in both its free linear style and the fanciful treatment of the subject matter with an underlying lascivious humor. Pascin frequently treated mythological and biblical scenes in graphic media[3] and usually reserved painting in oil for more serious portraits and figure studies. The high degree of finish, elaborate use of exotic media, and detailed inscription suggest that this drawing was considered a finished work rather than a study or informal sketch.

Pascin's inventiveness in employing new materials is evident here: "He bent any medium to his purpose, ink thinned out with soda water, the burnt ends of matchsticks, dregs of coffee. . . ."[4] The silver and gold watercolor washes in this drawing are a felicitous combination. The use of monochromatic washes to obtain an even, shimmering surface of faceted forms probably reflects the artist's earlier interest in cubism. Even stronger is a sense of the influence of early Picasso both

in the drawing style and in the interpretation of the theme.[5]

From comparison with other narrative scenes and figure studies by Pascin, the Corcoran drawing can be dated to the early 1920s. The format of subject above a detailed calligraphic title is similar to other works such as *Socrates and his Disciples Mocked by the Courtesans* of 1921 (Museum of Modern Art, New York). The interlocking of figure groups, the substantial, full forms, and the use of fine hatching further relate this work to others dating between 1922 and 1925.[6]

LCS

1. Alfred Werner, "The Marvelous M. Pascin," in *Jules Pascin: Drawings* (New York: Washington Irving Gallery, 1959), n.p.

2. Tom L. Freudenheim, *Pascin* (Berkeley: University of California Art Museum, 1966), n.p., chronology section.

3. *Ibid.*, Part III.

4. Werner, n.p.

5. *Ibid.*, Part III.

6. Alfred Warner, ed. *Pascin: 110 Drawings* (New York: Dover, 1972), p. xvii, Plates 71 and 82; p. xviii, Plate 104, and *Pascin Exposition Retrospective* (Geneva: Musée d'Art et d'Histoire, 1970), Cat. No. 45, *Temple of Beauty,* 1925.

35

Opa Mu Nu
(Richard Martinez)
(b. 1904)

BORN IN 1904, OPA MU NU IS A SAN Ildefonso Indian, a tribe located in New Mexico which is famous for its polished black pottery. He attended the U.S. Indian School in Santa Fe before art classes were established. In 1931 he participated in the Exposition of Indian Tribal Arts and in 1932 and 1936 worked with Olive Rush on murals for the Indian School—one of the earliest mural projects executed by contemporary Indi-

Jules Pascin
Enlèvement d'Europe
1920–1925

Opa Mu Nu
Design of Leaping Deer
1920–1936

George Grosz
In der petite chaumière, Paris,
Montmartre
1924

ans in the Southwest. The artists involved subsequently formed a guild to execute large canvas panels of mural size which were exhibited in the East, among other places at the Corcoran Gallery and Rockefeller Center. Martinez remained active as a painter through the 1950s. Today he lives in retirement.[1]

Design of Leaping Deer 1920–1936
Gouache over graphite on paper
14⁹⁄₁₆ × 27¹⁵⁄₁₆ in. (37.2 × 71.6 cm)
Gift of Amelia E. White 1937
Acc. No. 37.68

Opa Mu Nu is one of an early group of painters active at San Ildefonso Pueblo during the 1920s who contributed to the development and popularization of a modern school of Indian painting in the Southwest. Many of his works are large paintings or murals. He has been very much influenced by fellow San Ildefonso artist Awa Tsireh (Alfonso Roybal, c. 1895–c. 1955). Traditional tribal images as well as the influence of Awa Tsireh can be seen in the leaping animals, arched rainbows, jagged lightning bolts, and stylized trees of this gouache. The decorative qualities are very strong, enhanced by the simplicity, balance, and abstraction of the forms.

The design is unified by the tripartite rhythm of trees and rainbows which bracket and contain the double features of stylized deer and rocks. The horizon line, from which all the elements spring, continues across the entire sheet, symbolically linking this little scene to others with which it could be united—a device natural for an artist accustomed, as was Opa Mu Nu, to the larger scope and format of mural painting.
LCS

1. Jeanne O. Snodgrass, *American Indian Painters: A Biographical Directory* (New York: Heye Foundation, Museum of the American Indian, 1968), p. 113. Note that he uses both names: Opa Mu Nu and Richard or Ricardo Martinez.

36

George Grosz
(1893–1959)

GEORGE GROSZ WAS BORN IN Berlin on July 26, 1893. His father, a barkeeper, died when George was six; his mother supported the family as a seamstress and later as a housekeeper for an army regiment. Grosz, who spent much of his youth in Stolp, Germany (now Slupsk, Poland), studied at the academies in Dresden and Berlin. By 1913 he had developed a distinctive linear manner that shows the influence of Futurism and Cubism. His mature style is marked by a deliberately crude use of line and color with which he scathingly satirized the ruling classes and bourgeois life in Germany. In 1931 he was invited to teach at the Art Students League in New York; in January 1933, the month the Nazis came to power in Germany, Grosz moved to the United States; he became a citizen five years later. In 1954 he had a retrospective exhibition at the Whitney Museum. After several visits to Germany, he returned in May 1959 to West Berlin, where he died on July 6.

In der petite chaumière, Paris, Montmartre[1] 1924
Watercolor, reed pen and ink on Canson and Montgolfier paper
18⁵⁄₈ × 24³⁄₄ in. (47.3 × 62.9 cm)
Inscribed, l.r.: "Grosz / Paris / 1924 / BM94"; l.l.: "Paris / Lx / No. 19 / in der petite chaumière Paris Montmartre"
Gift of Francis Biddle 1959
Acc. No. 59.31

In the spring of 1924 Grosz travelled to Paris with his wife. He had studied there briefly in 1913 at the Atelier Colarossi, where he perfected the quick sketch integral to his style before he came to America. By the time of the second trip, Grosz was beginning to enjoy an international reputation. Ecce Homo (1922), a devastating series dealing with the moral decay in Germany under the Weimar Republic, had brought him notoriety and legal action. Lionized and patronized by the very people he satirized, Grosz achieved a certain financial as well as artistic success.

In Paris, Grosz visited Jules Pascin, an old friend whose linear style may have influenced the younger artist, and Man Ray, the American Surrealist. He also played the tourist and "went to those hidden places which no foreigner ever gets to know."[2] This particular watercolor presumably depicts one of the bohemian nightspots he enjoyed in Montmartre.

He reportedly worked very hard in Paris,[3] finding his subject matter in the streets, bars, and brothels, as he did in Germany. But unlike the German pictures, Grosz's French drawings do not display the artist's distaste of mankind. Free of the corrosive atmosphere of his native land, the artist was perhaps unable to see the defects of an alien and seductive culture. A similar failing would occur on his coming to America.

The inscription—"in der petite chaumière" (an absurd mixture of German and French meaning "in the little thatched cottage")—and the subject are bizarre and enigmatic. The strange dress of the habitués clearly marks this as a

bohemian spot, but what if anything except idiosyncratic behavior is portrayed is difficult to say. The inscription offers no clue. Perhaps Grosz is presenting an amalgam of disconnected impressions, a technique he employed in his earlier Futuristic compositions. The vestiges of this aesthetic may be detected in the seeming third leg of the woman on the right and in the echoed profile of the large central transvestite figure. In any case, the work is typical of Grosz's mature manner in its economical and crude use of line to define form as well as in its irrational treatment of space and skewed perspective. It also exhibits the artistic philosophy Grosz articulated a few years after this piece was done:

> Realist that I am, I use my pen and brush primarily for taking down what I see and observe, and this is generally unromantic, sober and not very dreamy . . . when you take a closer look, people and objects become somewhat shabby, ugly and often meaningless or ambiguous.[4]

EJN

1. The watercolor has been published as *Le petit moulin, Montmartre* in Hans Hess, *George Grosz* (New York: Macmillan, 1974), p. 124; however, I have not been able to establish the basis for Hess' title.

2. Letter from Grosz to Otto Schmalhausen, April 8, 1924, quoted in Hess, p. 124.

3. Hess, p. 127.

4. George Grosz, *Love Above All* (1930; reprint, New York: Dover, 1971), preface [n.p.].

37

Fred Kabotie
(b. 1900)

BORN FEBRUARY 20, 1900, AT SHUNgopovi, Second Mesa, Arizona, Kabotie is a Hopi. Brought up within the traditional Hopi culture, he attended the Santa Fe Indian School, where he was encouraged to paint. In 1924 he graduated from the Santa Fe Public School. He worked at the Museum of New Mexico and in 1929 was commissioned by the Heye Foundation of New York to record tribal dances in painting. During the 1930s the Peabody Museum commissioned him to reproduce ancient kiva wall decorations being excavated at Awatovi pueblo. His reproductions were subsequently exhibited at the San Francisco World's Fair in 1939 and in 1940 at the Museum of Modern Art. Kabotie is the first American Indian to receive a Guggenheim fellowship. He has had great influence on younger Hopi artists and was art instructor at Oraibi High School in New Mexico from 1937 to 1959.[1] Kabotie is also founder and president of the Hopi Cultural Center, Second Mesa, Arizona, where he continues to live. His son Michael, born in 1946, is also a painter.[2]

Niman Kachina Dance[3] c. 1925–1930
Watercolor and gouache on artist board
19½ × 30 in. (49.6 × 76.2 cm)
Inscribed, l.r.: "Fred Kabotie"
Gift of Amelia E. White[4] 1937
Acc. No. 37.69

In the early part of this century there was a movement to introduce art materials and techniques such as watercolors and paper to young Indians in the hope that it would have two results: allow them to record traditional aspects of their culture and provide them with a source of income to alleviate their depressed financial situation.[5] This was generally contrary to official government policy, which promoted the suppression of individual Indian culture and advocated the assimilation of all Indians into the larger American society. In spite of government disapproval, a group of Indians, including Fred Kabotie, learned to paint and draw.

In the decades of the twenties and thirties galleries and museums began to exhibit Indian paintings in various cities around the United States. In 1932 the government prohibition against Indians depicting their culture in paintings was lifted, and the first officially sponsored art department was established at the Santa Fe Indian School.

Since painting on paper had never been an integral part of southwestern artistic activities, the styles developed by young Indian artists looked to both tribal and Anglo-American sources. Common features of these Indian paintings are flat, uniform images, dense concentrations of paint, outlines, an absence of shading, little use of perspective, and a preponderance of Indian subjects such as animals. Their work has been praised for its simplicity, balance, rhythm, and abstraction.[6]

One of Kabotie's major early watercolors is this work, *Niman Kachina Dance*, executed sometime during the late 1920s. The Hopi word *kachina* (= "supernatural") is used in three ways: it refers (1) to a large group of invisible life forces, including departed ancestors, (2) to the elaborately masked male members of the tribe who impersonate these supernatural spirits during dances given the first half of each year, and (3) to painted cottonwood dolls which represent the dancers.

Fred Kabotie
Niman Kachina Dance
c. 1925–1930

Here we see the important Niman, or Home-Going Ceremony, a dance performed annually in July before the spirits leave the pueblo to spend the next six months in the mountains.[7] Eighteen dancers—Hemis Kachinas in red and green masks, red sashes, patterned kilts, red moccasins, bodies blackened with corn smut—form a half-circle facing six kneeling manas, or kachina maidens, in masks and shawls who accompany the dancers on rasps.[8]

All figures are rendered without shading, the use of European perspective, or a ground line. They are highly stylized and are derived from conventional Indian designs which typically use flat areas of color and a repetition of forms to create patterns. In such early works Kabotie's figures are very static, while in later paintings he has given them greater mobility. Here, the solemn, still depiction of these kachinas is appropriate to this dance, which is described as very slow, all motions in concert to convey the stately reverent manner captured by Kabotie.

LCS

1. David M. Fawcett and Lee A. Callander, *Native American Painting: Selections from the Museum of the American Indian* (New York: Museum of the American Indian, 1982), pp. 17–18.

2. Jeanne O. Snodgrass, comp., *American Indian Painters: A Biographical Directory* (New York: Heye Foundation, Museum of the American Indian, 1968), pp. 89–90; also *Who's Who in American Art* (16th edition, 1984), p. 475.

3. Titled *Hopi Masked Dance* in *American Drawings, Watercolors . . . in the Collection of the Corcoran*, the specific dance was subsequently identified by Myles Sibhart, of the Indian Arts and Crafts Board, U.S. Department of the Interior.

4. Amelia White was a patron of Indian arts and crafts who participated in the organization of the Exposition of Indian Tribal Arts in 1930 which opened in New York in 1931. The exhibition catalogue, *Introduction to American Art*, illustrated this watercolor, untitled, as Plate XXXI.

5. Miriam A. Springuel, *Symbols and Scenes: Art by and about American Indians* (Washington, D.C.: Corcoran Gallery of Art, 1980), n.p. Also, Robert Fay Schrader, *The Indian Arts and Crafts Board, An Aspect of New Deal Indian Policy* (Albuquerque: University of New Mexico, 1983), pp. 3, 11–14.

6. Fawcett, p. 16.

7. Harold S. Colton, *Hopi Kachina Dolls* (Albuquerque: University of New Mexico, 1959), p. 88.

8. *Ibid.*, pp. 50–51.

38

Oliver N. Chaffee
(1881–1944)

BORN IN DETROIT, ON JANUARY 23, 1881, Chaffee was educated at the Detroit Academy before moving to New York. Between 1903 and 1906 he studied with Robert Henri, William Merritt Chase, and also with Charles Hawthorne in Provincetown. In 1906 he left for two years of travel in Europe and study at the Académie Julian in Paris. The year of his departure for Europe coincided with his first one-man exhibition in Detroit. Further exhibits included the showing of three paintings in the famous Armory Show of 1913. Chaffee married twice and lived alternately in Europe (Paris and Venice) and Provincetown. In the 1930s Chaffee exhibited less frequently. He died April 25, 1944, in Asheville, North Carolina, en route to Provincetown. A memorial exhibition of his work was organized that year by the Provincetown Art Association.[1]

Swan Song 1931
Watercolor over graphite on paper
12⅜ × 14⁹⁄₁₆ in. (31.4 × 37 cm)
Inscribed, recto, l.l.: "Oliver"; verso, u.l.: "Oliver Chaffee/'Swan Song'"
Museum purchase 1981
Acc. No. 1981.85

Oliver Chaffee was among those American modernists including Charles Demuth and Marguerite and William Zorach who were attracted to Provincetown and produced Americanized paintings and drawings derived from the European styles of Cézanne, Matisse, Picasso, and Braque. Chaffee painted portraits, interiors, and still lifes but remained most interested in nature and in realistically represented subjects. A recent exhibition catalogue states: "Chaffee's preoccupation with geometrical and mathematical concepts as bases for harmonious design was coupled with a strong personal feeling of vitality found in nature."[2]

In *Swan Song* Chaffee breaks up the subject in a Cubist fashion: the space is flattened and the representation is simplified. Unlike the Cubists he maintains a primitive sense of the swan and uses color expressionistically; his interaction of red and green is especially reminiscent of the Fauves.

The dynamic intensity of Chaffee's style is evident in the compositional tightness and the energy of linear motion. The strong horizontal and vertical pattern to which the swan's shape is subordinated—and which encases it—is unified by the diagonal downward movement of the bird's body balanced against the flat geometric forms of colors. These flat areas of amber, brown, green, and blue create the illusion of collage. Through these devices a harmonious relationship between the abstract forms and representation of the bird is achieved. In his time Chaffee was considered a leading modernist. He was also "averse to currying favor in influential art quarters. His recognition rested largely with Provincetown artists

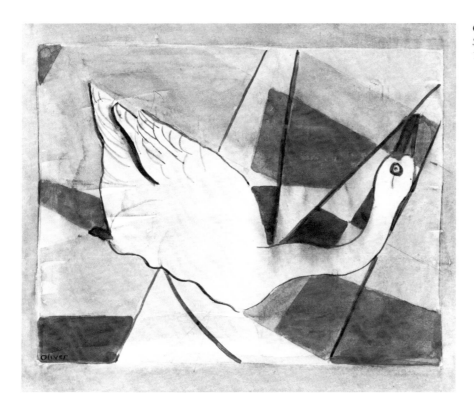

Oliver N. Chaffee
Swan Song
1931

Guy Pène du Bois
Terrace, Paris Café
1931

67

of liberal outlook, among whom he was often regarded as a mentor, generously passing on the insight he acquired. He was a modern before modernism became popular."[3]

JH

1. See *Oliver Chaffee 1881–1944* (Washington, D.C.: Barbara Fiedler Gallery, 1981), and chronology by Solveiga Rush therein.
2. *Ibid.*, essay, n.p.
3. Ross Moffett, *Art in Narrow Streets* (Falmouth, Mass.: Kendall Printing Co., 1964), p. 98.

39

Guy Pène du Bois
(1884–1958)

GUY PÈNE DU BOIS WAS BORN IN Brooklyn on January 4, 1884. As the son of a literary and music critic, Pène du Bois had early access to the artistic and intellectual circles of America and Europe. He studied at the New York School of Art under William Merritt Chase, Kenneth Hayes Miller, and Robert Henri, who was a major influence on his artistic development. Art critic as well as artist, Pène du Bois helped to organize the Armory Show of 1913. Although his work displays a modernist sensibility in the stylization of forms, he was fundamentally a realist and unsympathetic to abstraction. He died in Boston on July 18, 1958.

Terrace, Paris Café[1] 1931
Pen and black ink on paper
17�5/16 × 12³/16 in. (44 × 31 cm)
Inscribed, l.r.: "Guy Pène du Bois '31"; l.l.: "Terrace Paris Cafe"
Museum purchase through a gift of Mrs. J. L. M. Curry 1978
Acc. No. 1978.118

Following the dictates of his mentor, Robert Henri, Guy Pène du Bois looked to contemporary life for his subject matter. Almost from the beginning, his themes were taken from the rarefied social set epitomized by this drawing of a fashionable sidewalk café in Paris. Pène du Bois painted and drew what he knew best: international café society.

Despite the apparent rapid execution of this drawing, there is no reason to assume that it was drawn on the spot in Paris. In the first place, Pène du Bois had returned to New York in April 1930 after six years in France in the wake of the Depression, and it is likely he was not back in Paris in 1931. In addition, the stylized treatment of forms, which imparts a caricature-like quality to the piece, together with its highly structured composition suggests that it was designed in his studio.

Terrace, Paris Café presents a classic subject for the artist: an older, somewhat dissipated, rich man is in the company of a young woman. It is a theme Pène du Bois explored in other works of the period.[2] The *dramatis personae* in this set piece are clearly not individuals but types, some of whom reappear in slight variations in other works. The faces of the two main characters convey a sense of ennui, and this air of boredom is underscored by their lack of interaction; they are psychologically if not physically isolated. Pène du Bois presents a disenchanted view of the glamorous world of international society; robbed of animation and excitement, it becomes meaningless and depressing.

EJN

1. The title was inscribed originally on the front of the backing paper for this drawing.
2. See, e.g., *Pierrot Tired* (c. 1929–1930), Corcoran Gallery of Art, and *Nightclub* (1933), Hirshhorn Museum and Sculpture Garden, Smithsonian Institution.

40

Allan Rohan Crite
(b. 1910)

BORN MARCH 20, 1910, IN PLAINS-field, New Jersey, Crite was educated in Boston schools, including the English High School from which he received a diploma in 1929. He began his art education at the Boston Museum of Fine Arts School and continued it at the Massachusetts School of Art and Boston University. At the age of fifty he graduated from the Harvard University Extension School after having taken one course a year in his spare time. For over thirty years, until his retirement in 1972, Crite worked as a technical illustrator for the United States Navy. He has had one-man exhibitions at the Boston Museum, the Farnsworth Museum of Art, and the Fogg Art Museum among other places. His paintings and drawings are represented in many public and private collections. He continues to work in Boston and has recently converted his home into a private museum.

Skating 1933
Graphite on paper
12 × 17¹⁵/16 in. (30.5 × 45.5 cm)
Inscribed, l.l.: "Allan Rohan Crite / [monogram ARC] 1933"; l.c.: "Skating"
Museum purchase through a gift of Emily Crane Chadbourne 1981
Acc. No. 1981.33

Crite has two interests in this work: to record his community and to investigate the use of line. Skaters gliding across the ice, in a group or singly, are the subject here. The shape of their bodies

Allan Rohan Crite
Skating
1933

Gaston Lachaise
Nude with Drapery (No. 9)
c. 1931–1935

forms a rhythmic line across the sheet, the central group interlocking into a ripple of profiled chests, hips, and legs, while others, like the letterman, become bracketing elements in the composition. The fine cross-hatching that models the sleek bodies is confined by distinct outlines, while details have been eliminated to strengthen and streamline the figures. The shallow spatial depth combines with the outlined forms to create a frieze. The limits of the space and bas-relief effect are interrupted only by the receding skater. These are all qualities found in the Art Deco decoration and sculpture of the 1930s.

Crite is one of the outstanding Afro-American realists. He is known especially for his genre scenes of his native Roxbury and South End Boston. He has also produced an extraordinary series of illustrations for religious publications. He sees no dichotomy between secular and liturgical subjects in his art: "it's all of one piece. Life is a unit."[1]

This drawing, one of two in the Corcoran's collection, is a part of a series originating in the late 1920s when Crite began to record the life and people of his community. Looking back sixty years later, Crite sees such drawings as a record of "vanished bits of history in the city, as there was a great deal of a form of erasure of pages of life of the community."[2] Crite goes on to say, "the people in this drawing are not any specific people nor are they a conscious effort at portraiture as such though down through the years I do have a habit of making note of a face that interests me and that face in some form will find its way into a drawing." Recalling the past with a feeling of nostalgia, Crite writes,

"As I look at this drawing which recalls my youth . . . in the faces of one or two of the girls is a reminder of some girls I knew. . . ."[3]

LCS

1. Ed Rader, "Crite Commits Living History to Canvas," *Boston Ledger* (October 17–23, 1980): 15.
2. Letter from Allan Rohan Crite, Crite House Museum, Boston, January 28, 1986, to Linda C. Simmons.
3. *Ibid.*

41

Gaston Lachaise
(1882–1935)

BORN MARCH 19, 1882, IN PARIS, the son of a cabinetmaker, Gaston Lachaise received a traditional art education at the Ecole Bernard Palissy and the Académie Nationale; subsequently he exhibited at the Salon des Artistes. In 1901 he met and fell in love with Mrs. Isabel Dutard Nagle, an American visiting in Paris. After a year of military service and some time working for René Lalique, by early 1906 he had emigrated to the United States, where he worked in Boston with the sculptor Henry Kitson and in New York as chief assistant to Paul Manship. In 1917 he became a U.S. citizen and married the recently divorced Isabel Nagle. His first one-man exhibition took place in 1918 at the Bourgeois Gallery, New York. During the 1920s and 1930s his drawings, reproductions of his sculpture, and articles about him began appearing in *The Dial,* and he received numerous commissions for architectural ornaments and friezes, while becoming known especially for his single figures. A large exhibition of his sculpture and drawings was organized by the Museum of Modern Art during 1935, an acknowledgement of his achievement as a leader of the avant-garde. In the same year he died of complications following a tooth extraction in New York on October 18.

Nude with Drapery (No. 9)
c. 1931–1935
Graphite on paper
19 × 11¹⁵⁄₁₆ in. (48.3 × 30.4 cm)
Inscribed, l.r.: "G. Lachaise No. 9"
Museum purchase through a gift of
 Robert M. McLane 1977
Acc. No. 1977.2

The depiction of the female nude was at the center of Gaston Lachaise's creative life. The model and inspiration was Isabel Dutard Nagle, a Boston matron ten years his senior: "At twenty, in Paris, I met a young American person who immediately became the primary inspiration which awakened my vision and the leading influence that directed my forces. Throughout my career, as an artist, I refer to this person by the word, 'Woman.' "[1] Isabel became his lover and wife and remained an inspiration and source for his art through his life. After his death she noted, "his religion was myself and his work."[2]

This lifelong veneration—one of the greatest tributes to woman created by man—made Isabel's body into a twentieth-century Venus in sculpture and drawings. She was a "full-bosomed lady with generous proportions but not weighty." Nude photographs of her in the early decades of this century show "slender legs, ample hips, well-muscled abdomen, arched back, full bust, shoulders held back and a proudly turned head."[3]

Lachaise's translation of her form in this drawing looks back to the Venus of Willendorf dating from 18,000 B.C., one of the stone

carvings of "female bodies of refined grossness, with huge mounded breasts capable of suckling whole tribes. . . ."[4] Isabel's form has been amplified in the Corcoran's drawing: the pointed toes of gracefully mannered feet and gesturing hands lead the viewer's eyes to the ample child-bearing torso and the fruitfulness of her breasts. She is elevated physically and spiritually, so that her walk detaches her from the earth, yet she is the antithesis of the serene classical nude.

Rarely do Lachaise's drawings relate to specific sculptures. Usually executed in a sensuous undulating line, they are almost never shaded or modulated, nor do they have specific details. Here, the slight contraposto pose of striding legs and turned torso helps divide her form into a paired rhythm of ovoid parts. The simplification of forms and evident concern with the relation of mass mark this work as that of a sculptor.

Hints of physical degeneration began to appear in Lachaise's depictions of "Woman" before his death in 1935.[5] Although the Corcoran's drawing was made during his last years, it does not show any of this deterioration. Instead it continues the exuberance, vitality, power, and sensuality that form the central force of his "Woman."

LCS

1. Gerald Nordland, *Gaston Lachaise: The Man and His Work* (New York: Braziller, 1974), p. 8; also in Gaston Lachaise, "Comment on My Sculpture," *Creative Art* 3 (August 1928): xxiii.
2. Nordland, p. 56.
3. *Ibid.*, p. 9.
4. Lincoln Kirstein, *Gaston Lachaise Retrospective Exhibition* (New York: Museum of Modern Art, 1935), p. 14.
5. Nordland, pp. 167–171.

42

Everett Shinn
(1876–1953)

BORN IN WOODSTOWN, NEW JERsey, November 6, 1876, Everett Shinn began his artistic career as a mechanical draftsman. In 1893 he enrolled at the Pennsylvania Academy of the Fine Arts and fell under the influence of Robert Henri. Shinn supported himself as a staff artist for the *Philadelphia Press*, working with George Luks, William Glackens, and John Sloan. In 1897 Shinn moved to New York City and the *New York World*, and established a studio in Greenwich Village. In 1908 he was one of The Eight who exhibited at the Macbeth Gallery. Among The Eight were the five from Philadelphia who inspired a generation of progressive realism in American art. A lively man whose personal life was in perpetual disarray, Shinn chose subjects which were more fashionable, and his palette was brighter than the other artists associated with the Ash Can School. His mature career was a mixture of book and magazine illustration, society portraiture, scenic design, mural painting, and motion picture art direction. Shinn died in New York City, May 1, 1953.

Sixth Avenue and Fifty-Third Street
1935
Pen with red and black ink, colored pencil, and wash over charcoal and graphite heightened with white on composition board
10⅜ × 6⁷⁄₁₆ in. (26.4 × 16.4 cm)
Inscribed, l.l.: "6th Ave & 53rd St / Everett Shinn / 1935"
Museum purchase 1949
Acc. No. 49.25

Shinn had worked in Philadelphia and New York with Robert Henri, John Sloan, William Glackens, and George Luks. However, his choice of subjects, work as a decorator, and willingness to cater to collecting whims eventually placed a distance between him and these other painters. Many of his fellow artists had difficulty recognizing him as a serious or fine artist,[1] though Glackens' son Ira has described Shinn this way:

> Among The Eight, Shinn had the easiest talent, and this is perhaps why he is far from being the greatest of them. But since we should judge an artist by his finest achievements, let us value Everett Shinn for his wonderful depictions of the streets of New York, the lights of the city and the theatre, the hansom cabs and swirling traffic of a past he knew and drew so well.[2]

Once Shinn settled in New York in the late 1890s, uptown life became his subject, one that he depicted with verve and affection. Years of newspaper work led to his own graphic shorthand, a quick responsive style marked by telling detail and sharp insight.

His abilities as a draftsman are most evident in some of his smallest works. The street corner reproduced here is on a sheet of modest size, less than 11 × 7 inches. However, with a combination of media he fills it with the sudden emptiness of a busy city sidewalk. Pulled back and away from the center of the scene a bootblack sits in the recesses of a doorway while a knot of three people, possibly a family, hurry off to the left. Not even the El, visible beyond the street lamp, gives a suggestion of passing vehicles. Formed out of colored pencil, wash, and charcoal applied in varying layers, the figures and buildings are defined by swift, incisive pen and ink lines recording form and motion. The resulting

image is one embodied with a sense of immediacy and life. Here we see Shinn free of the affectations of the theater or the false trappings of society life. We see the city in which he lived and with which he felt such rapport.

LCS

1. Edith DeShazo, *Everett Shinn 1876–1953: A Figure in His Time* (New York: Clarkson N. Potter, 1974), p. 206.
2. *Ibid.*, p. xvii.

43

Leon Kroll
(1884–1974)

KROLL WAS BORN DECEMBER 6, 1884, in New York. His father was a professional cellist. His mother encouraged his early interest in art, and at sixteen he enrolled at the Art Students League and two years later entered the National Academy of Design. Regularly thereafter he won prizes in painting and sculpture in addition to a scholarship to study in Paris at the Académie Julian. His first one-man show was at the National Academy of Design in 1911, and two years later he was invited to exhibit in the famous Armory Show. Kroll was an influential teacher and was highly regarded by his fellow artists, as is indicated by the numerous times he served on exhibition juries. During most of his long career he resided in New York with summers spent in Maine, Massachusetts, or occasionally abroad. He died November 26, 1974, at Gloucester.

Studies of a Young Girl c. 1930
Charcoal and stump on white gessoed paper
22 × 27¹⁵/₁₆ in. (55.9 × 71 cm)
Inscribed, l.r.: "Leon Kroll"
Museum purchase 1938
Acc. No. 38.13

For over seventy years the painter Leon Kroll has been acknowledged for his technical mastery and accomplished draftsmanship. In much of his work he dealt with the human form and landscape. His usual procedure was to produce a series of drawings to be utilized in the organization and execution of his paintings. The model was first posed and drawn nude, then drawn again draped. Often he worked in charcoal on gesso-coated paper or board, his gesso prepared with "equal parts of gypsum, zinc white and rabbit skin glue-water."[1] The careful application of this mixture with a broad brush created a smooth and sensitive surface which allowed great scope for the use of charcoal.

Kroll was a leading interpreter of the human form, which he typically rendered as monumental figures, classicized human beings, idealized modern goddesses. Their smooth exteriors are matched by their interior serenity. The unobtrusiveness of his observations has been criticized as a bland formality that stops short of chilliness. The extreme control indicated by his working procedure precluded any spontaneous response to the subject. His drawings are very deliberate; each line functions to describe and emphasize the three-dimensionality of the form.

In all of his drawings Kroll demonstrates an ability to abstract and simplify the forms of nature, imparting to his images a decorative quality.[2] However, he never loses a sense of the worth of individual human beings. His people seem to come from a time lacking in turmoil, unrest, or unhappiness; a serenity emanates from their faces.

Other drawings of multiple views of the same person are known by Kroll. Some are quite clearly studies of one individual unified into a compositional whole as here. The marvelous depth of surface the artist often achieved is also evident in the subtle shading that models the two torsos in three dimensions. This young woman has been frozen for us by Kroll, serene and chastely nude, arrested in time.

LCS

1. Jane Rogers, "Leon Kroll," *American Artist* 6 (June 1942): 6.
2. Ivan Narodny, "Leon Kroll," in *American Artists* (New York: Roerich Museum Press, 1930), pp. 83–88. Bernard Danenberg, *The Rediscovered Years: Leon Kroll* (New York: Bernard Danenberg Galleries, 1970), pp. 1–4. *Leon Kroll* (New York: American Artists Group, 1946).

44

Frank Lloyd Wright
(1867–1959)

WRIGHT WAS BORN JUNE 8, 1867, IN Richland Center, Wisconsin. His mother was a school teacher; his father, an itinerant minister and music teacher. In 1887, after two terms spent studying engineering at the University of Wisconsin, Wright set off for Chicago, a city that had already built a reputation for forward-looking architecture. In 1888 he joined the architectural firm of Adler and Sullivan. Dankmar Adler was a genius at engineering, Louis Sullivan was the master of design and detail, and Wright learned from both partners before starting his own practice in 1893. The next thirty years yielded his best early architecture, including Robie House (1909) and the Imperial Hotel (1916). During the Depression years, which brought fewer com-

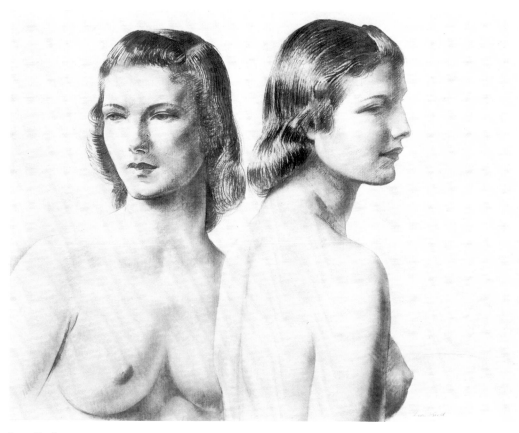

Leon Kroll
Studies of a Young Girl
c. 1930

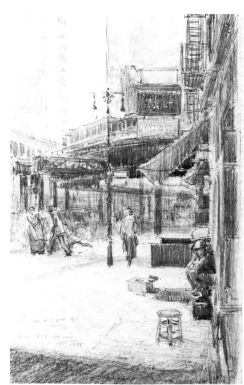

Everett Shinn
Sixth Avenue and Fifty-Third Street
1935

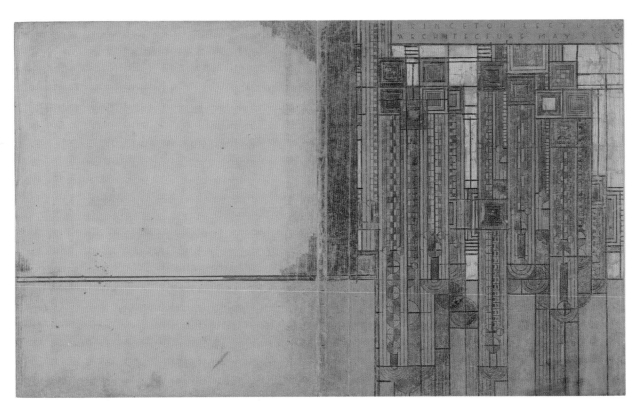

Frank Lloyd Wright
Cover Design for "Modern Architecture"
c. 1930

missions, Wright lectured and published several books, including his autobiography. Wright's stature was so great during his last twenty years that he was free to choose his projects. These ranged from the small, inexpensive Usonian homes to the massive Marin County Civic Center. Wright worked at his Arizona studio, Taliesin West, until a few days before his death at ninety-one on April 9, 1959.

Cover Design for "Modern Architecture" c. 1930
Colored pencil, wax crayon, and graphite on Manila file folder
12¹⁵/₁₆ × 21¾ in. (32.9 × 55.3 cm)
Inscribed, u.r.: "Princeton Lecture/ Architecture May 1930"; on spine u.c. to l.c.: "Frank Lloyd Wright Lecture"
Gift of Mr. and Mrs. Abul Huda Farouki 1984
Acc. No. 1984.30

In 1930 Frank Lloyd Wright agreed to give the Kahn Lectures at Princeton University when the original choice for speaker, European architect J. J. P. Oud, became ill.[1] Wright delivered six lectures, which were subsequently published in 1931 as *Modern Architecture*, Wright's first book about his own work published in the United States, with this drawing as its cover.[2] That Wright, who was over sixty at the time, was the second choice for lecturer and that this was his first American book come as a surprise today. Wright enjoys a remarkable reputation as an innovative and influential architect, one whose name is associated with many important movements, including the Arts and Crafts style, the Prairie School, and the Bauhaus. However, in 1930 the austerity of the International Style was seen as the only truly progressive style, which

made Wright's idiosyncratic romanticism seem old-fashioned. Wright's subsequent lectures, publications, and projects in the 1930s changed this perception of him.

In his cover design for *Modern Architecture* Wright has made a pattern of highly abstracted saguaro cactuses—tall green fluted stems with vertical branches, blossoms, and fruit—rising from the sandy desert into a white sky. He had spent much of 1927–1928 in the Arizona desert working on projects some of which were never built. One unrealized structure was a resort hotel, San-Marcos-of-the-Desert. Numerous drawings in colored pencil, Wright's favorite medium, were produced: red, purple, and green are used in the elevation drawings; tall cactuses dot the landscape.[3] Wright admired the saguaro and had it in mind when he designed the hotel "to grow out of the desert by way of desert materials. . . ."[4] The exterior was to be marked with vertical flutes. In the drawing, the rapidly multiplying squares of the stalks are like the heavily patterned textural blocks Wright planned to use in another hotel project he was working on at the time.[5]

Using nature in both structural design and ornamental detail was a tradition with Wright. As a young architect he had incorporated stylized sumac leaves and beards of wheat in the window designs for his Prairie Style houses; rock ledges were used to explain cantilevering at Falling Water (1935), and trees were metaphors for center-core skyscrapers like the Johnson Wax Tower (1944). For Wright, the cactus motif was a natural choice for the cover of a book on modern archi-

tecture. He saw in the saguaro a lesson waiting for any architect intelligent and modest enough to apply it:

> The Saguaro, perfect example of reinforced building construction. Its interior rods hold it rigidly upright maintaining its great fluted columnar mass for centuries. A truer skyscraper than our functioneers have yet built.[6]

MK

1. Oud, a founding member of De Stijl, had met Wright in Europe in 1910–1911, and the two had remained in correspondence. Perhaps he recommended Wright as his replacement. The famous Wasmuth Edition *(Ausgeführte Bauten und Entwürf von Frank Lloyd Wright)*, published in Berlin in 1910, established Wright's reputation in Europe.
2. Edgar Tafel, *Apprentice to Genius* (New York: McGraw Hill, 1979), pp. 133–134.
3. Arthur Drexler, *The Drawings of Frank Lloyd Wright* (New York: Horizon, 1962), p. 10.
4. Frank Lloyd Wright, *An Autobiography* (New York: Horizon, 1977), p. 331.
5. Tafel, pp. 129–131.
6. Wright, pp. 333–334.

45

Alexander Calder
(1898–1976)

BORN IN LAWNTON, PENNSYLVAnia, now part of Philadelphia, on July 22, 1898, Calder was the son of one sculptor, Alexander Sterling Calder, and the grandson of another, Alexander Milne Calder. He received an engineering degree from the Stevens Institute of Technology in 1919 before studying at the Art Students League in New York between 1923 and 1926 under George Luks, John Sloan, and others. During an extended stay in Paris in the late 1920s and early 1930s Calder became part of an avant-garde group of artists that

included Arp, Gabo, Miró, Mondrian, and Leger. It was at this time in Paris that he began to create the mobiles for which he is best known. At the time of his death in New York on November 11, 1976, Calder enjoyed an international reputation as one of the major innovative sculptors of the twentieth century.

Untitled 1930s?[1]
Gouache, tempera, black ink, and charcoal on paper
15³⁄₁₆ × 15¹¹⁄₁₆ in. (38.6 × 39.9 cm)
Inscribed, l.c.: "to the happy Hebbelns[2] —Sandy Calder"; l.r.: " – 5"
Gift of George D. Locke 1957
Acc. No. 57.3

Calder began painting gouaches in Paris in the 1930s,[3] about the time that he started creating mobiles and changed from a representational to an abstract style under the influence of Mondrian, Miró, and Arp. However, his first exhibition devoted to gouaches did not occur until 1945, at the Samuel M. Kootz Gallery in New York. It was a medium Calder found particularly satisfying. He once remarked: "I like making gouaches. It goes fast and one can surprise oneself."[4] In 1953, while living near Aix-en-Provence, he produced numerous *gouacheries,* to use his term, and later he had a special studio called Gouacherie on his property at Saché, France.

This work was supposedly presented by the artist to acquaintances, the Hebbelns, in the 1930s. If so, then it must be among Calder's earliest essays in the medium. With its yellow background, primary colors, and biomorphic forms, the composition is very reminiscent of paintings by Miró, a close friend since 1928.

However, the style raises questions about the time of execution. Its format, motifs, and technique are close to other gouaches Calder did in the mid-1940s and early 1950s.[5] No matter when it was executed, the work presents the fully developed idea of detached bodies of varying size, shape, color, and density, floating in space, which was central to Calder's aesthetic[6] after the early 1930s whether in a two-dimensional painting or in his more familiar mobiles.

EJN

1. The work was assigned a date of c. 1940–1950 in *American Drawings, Watercolors . . . in the Collection of the Corcoran.* A letter from Julius Carlebach, dated January 24, 1957, to Hermann Williams, Director of the Corcoran, on the occasion of the gift stated that it had been presented by Calder to the Hebbelns in the 1930s (object file, Corcoran Gallery). When Calder knew the Hebbelns has not been determined. Professor Joan Marter of Rutgers believes the work may date after 1950; letter to the author, January 23, 1986.
2. In *American Drawings,* the inscription was misread as "Hebbelus" instead of "Hebbelns."
3. Jean Lipman, with Ruth Wolfe, ed. director, *Calder's Universe* (New York: Viking Press and Whitney Museum of American Art, 1976), p. 119; Wahneta T. Robinson, "Introduction," *Calder Gouaches* (Long Beach, Calif.: Long Beach Museum of Art, 1970), [p. 2]. Also see Alexander Calder and Jean Davidson, *Calder, An Autobiography with Pictures* (New York: Pantheon Books, Random House, 1966), p. 218, for recollections of activity in 1953.
4. Quoted in Lipman, p. 119.
5. See, e.g., *On the Blue* from 1944, illustrated in Robinson, No. 1 [n.p.]; and *Constellation and Sea Horse* of 1948, illustrated in *Alexander Calder: Gouaches 1948–1962* (London: Brook Street Gallery, July 1962[?]), No. 16 [n.p.]. Many of the motifs recur in Calder's work throughout his life. See n. 1.
6. Calder and Davidson, p. 114.

Andrew Wyeth
(b. 1917)

BORN IN CHADDS FORD, PENNSYLvania, Wyeth is the son of the well-known illustrator N.C. Wyeth. Although he received his earliest training from his father, he remains basically a self-taught artist. Probably the most popular American painter living today, Wyeth met with public acclaim early; his first one-man show in New York in 1937 sold out in twenty-four hours.[1] His popularity has continued unabated, although some critics discern little that is unique in his extremely naturalistic work. His many exhibitions have included a retrospective at the Metropolitan Museum of Art in 1976–1977. Like his father, Wyeth has taught painting to those of his children who were interested. He continues to live and work in his family home at Chadds Ford.

November Fields, Chadds Ford, Pennsylvania c. 1945–1950
Watercolor and graphite on paper
14⁹⁄₁₆ × 20¹³⁄₁₆ in. (39.6 × 52.9 cm)
Inscribed, l.r.: "Andrew Wyeth"
Bequest of Mrs. David Edward Finley 1977
Acc. No. 1977.26

This drawing, like many of Wyeth's earlier works, presents a lonely sweep of landscape that has a disquieting quality; the vantage point from just above the artist's toes among the grasses captures a view of the world that is ambiguous and detached.[2] He examines in close detail a field at Chadds Ford, his home. Although the time of year is late fall, there is a suggestion of winter in the bare branches, brown tonalities, and stark blades of grass. Winter is a

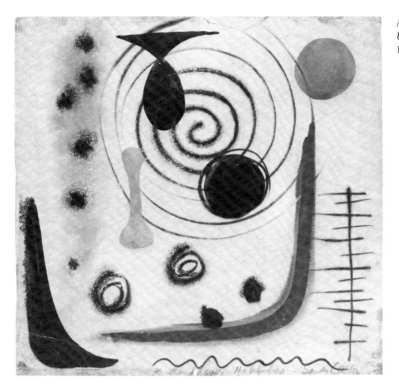

Alexander Calder
Untitled
1930s?

Andrew Wyeth
November Fields, Chadds Ford,
Pennsylvania
c. 1945–1950

season the artist prefers, "when you feel the bone structure in the landscape—the loneliness of it—the dead feeling of winter."[3] Wyeth accepts loneliness easily: "Whenever I paint an open field or the inside of a house with loneliness implied it's not a concocted dramatic thing—it's natural for me."[4] The youngest child in a family of five, Wyeth had a lot of time to himself and was encouraged by his father to look to nature with care, observing the details and seeing in the microcosm the wholeness of the universe.

Wyeth's wonder in nature is shared by other American artists such as Georgia O'Keeffe and Edward Weston.[5] Like them he has selected segments or details of nature by which to explore the extraordinary. This preoccupation with the ordinary and commonplace in quest of wider truths is consistent with an interest in Thoreau held by Wyeth father and son. According to Thoreau's vision of transcendentalism, the wide world could be found in a blade of grass.

Many subjects Wyeth painted in the late 1940s were occupied with an examination of life and death. His father, to whom he had been devoted, died in an automobile-train collision in 1945. The psychological tensions of many works in the following years appear to be part of his elegy for the departed parent.[6] In this view of wintry fields, time and motion are not the primary concern; it is the emotion of grief. There is no hint of new life in land, sky, or vegetation.

The technique utilized is dry brushstroke and watercolor over graphite pencil.[7] The facility with which he uses the brush and can

control line is evident in the two longest lengths of grass at right and left of center. Also evident is a quality Wyeth repeatedly refers to in discussions of his work—"messiness"[8]—the action of creation. This sheet has numerous accidental blobs of paint in the lower foreground and the right as well as frequent scratches or other abrasions: the dashing speed with which Wyeth creates these sketches allows little time for the care required in his tempera paintings, but works like this one should not be considered unfinished.

LCS

1. *Andrew Wyeth from Public and Private Collections* (Canton, Ohio: Canton Art Institute, 1985), p. 6.
2. Wanda M. Corn, *The Art of Andrew Wyeth* (Greenwich, Conn.: New York Graphic Society, 1973), pp. 106–108.
3. Quoted in "Andrew Wyeth: An Interview" by Richard Meryman, in Corn, p. 60.
4. *Ibid.*, p. 66.
5. Corn, pp. 139–140.
6. *Andrew Wyeth from Public and Private Collections*, p. 6.
7. *Ibid.*, p. 7.
8. Meryman, in Corn, p. 55.

47

John N. Robinson
(b. 1912)

BORN FEBRUARY 18, 1912, JOHN N. Robinson is a native of Washington, D.C. Orphaned at eight, he was raised by his maternal grandparents. During his youth he studied drawing on a tuition-free basis at Howard University under James A. Porter. In order to support his family, Robinson has held a variety of jobs, including kitchen helper and cook at St. Elizabeth's Hospital in Washington. Since his retirement he has devoted the majority of his time to painting.

In the Studio 1945
Graphite and watercolor on paper
17¹⁵⁄₁₆ × 24 in. (45.5 × 61 cm)
Inscribed, l.l.: "J.N.R."
Museum purchase with funds from the National Endowment for the Arts and the Richard King Mellon Foundation 1976
Acc. No. 1976.12

Robinson was raised in a family which considered the fine arts to be the province of the idle. Nevertheless, he began to draw in late childhood, and throughout his life has persisted in his attempts to be an artist.[1] Essentially self-taught, Robinson acknowledges a profound debt to the late Professor James A. Porter for helping him attain a basic understanding of the components of composition and design.[2]

Although a versatile landscape and still-life painter, Robinson makes some of his strongest and most uncompromising statements in portraiture. In his self-portrait *In the Studio*, the direct, confrontational gaze of the sitter is indicative of Robinson's ability to probe the psyche of a subject, whether it is himself or someone else. Here his intensity of observation is echoed in the attention paid to details. Product labels, finished works of art, and other objects provide insight into the artist's personality and tastes. Robinson's visual sophistication is evidenced by the contrast between the sawtoothed central bar in the back of the easel and the elaborately decorated arm of the chair in which he is seated. The folds of his clothing contribute to the animation of the central area of the composition.

Robinson did not formally study European and American realist painting as a young man, but he was familiar with such popular illustrators as Maxfield Parrish and Norman Rockwell. In his

John N. Robinson
In the Studio
1945

own compositions, however, he avoids the sentimentality frequently found in the work of these artists. His portraits, sometimes blunt and painful in their directness, simply convey what he sees; they never idealize.

In the Studio is a work stripped to its bare bones. Its pronounced linearity affords a rare glimpse of the artist's structural use of line. Although Robinson originally intended to complete the work in watercolor, he later decided that the drawing could stand on its own. The limited and restricted use of color creates a tension in the piece that is both visual and psychological. The bright, sensuous outside world glimpsed through the window contrasts sharply and tellingly with the spareness of the artist's interior domain.

ESC

1. John N. Robinson, "An Autobiographical Sketch," in Adolphus Ealey and John R. Kinard, *John Robinson: A Retrospective* (Washington, D.C.: Smithsonian Institution Press, 1976), pp. 13–14.

2. *Ibid.*, and personal interview with the artist on August 29, 1985.

48

Reginald Marsh
(1898–1954)

BORN MARCH 14, 1898, IN PARIS, Marsh was the son of two artists, Fred Dana Marsh and Alice Randall Marsh, who returned to America in 1900. Marsh received his first art instruction at Yale, and upon his graduation in 1920 he began freelance work as an illustrator in New York and also designed theater sets and curtains. His art studies continued at the Art Students League under John Sloan and George Luks among others. Constantly studying and experimenting with media and techniques, he worked on copper engraving with Stanley William Hayter, fresco with Olle Nordmark, sculpture with Mahonri Young. In 1935 he executed frescoes in the Post Office Department Building in Washington, D.C., and in 1937 did a series of murals for the Customs House in New York. After his first one-man exhibition at the Whitney Studio Club in 1924, Marsh exhibited annually in New York and in competitive shows throughout the country, receiving many prizes. He taught at the Art Students League, Mills College, and the Moore Institute of Art, Science, and Industry in Philadelphia. In 1934 he married Felicia Meyer, herself the daughter of two painters. The couple made their weekday home in New York and spent their weekends in Dorset, Vermont. It was on July 3, 1954, while visiting friends there that Marsh died of a heart attack.

Recto: *Derelicts under the "El"* 1946
Verso: *Derelicts under the "El"* 1946
Black ink, wash, sanguine Conté crayon, and watercolor over graphite on paper
26⅝ × 39¹¹⁄₁₆ in. (67.6 × 100.8 cm)
Inscribed, recto and verso, l.c.r.: "Reginald Marsh 1946"
Bequest of Felicia Meyer Marsh, wife of the artist 1980
Acc. No. 1980.46

Burlesque halls, night clubs, dime-a-dance halls, Coney Island, the Bowery—this is Reginald Marsh's New York City. Lush young girls stride with confidence past tattered bums, hopeless cripples, or sleeping drunks. Marsh ponders these scenes, and the human interrelationship becomes not merely a disturbing element but the major subject of his work.

For over three decades, beginning in the 1920s, he was a dispassionate observer of city life who had a deep sympathy for the human race. This feeling is probably best exemplified in portrayals of the homeless man, singly or in groups.[1]

Marsh's men are separated from the ordinary everyday world; their haunts were the Bowery, below the El, in bread lines, and in grimy doorways. The Depression played a large part in creating many of these outcast figures. They have been stripped of their jobs and identities and are adrift in the world.

For Marsh depiction of the human form was grounded in the work of the Old Masters: "For the head copy and learn by heart the heads of da Vinci; for the body, Michelangelo and Dürer; for everything, Rubens: light, shade, modeling, head, feet, hands, men, women, animals, nature, architecture, composition, deep space composition." This dictum he combined with direct observation: "Go into the street, stare at the people. Go into the subway. Stare at the people. Stare, stare, keep on staring. Go to your studio; stare at your pictures, yourself, everything."[2] As a teacher he recommended, "Get some theme and give it passionate force. A single recurrent theme is enough."[3] Thus Marsh investigated scenes such as the Bowery beneath the El repeatedly in drawings and paintings.

In the 1940s Marsh had begun using Chinese ink, Windsor Newton watercolor cakes, and Whatman paper, large sheets 27 by 40 inches in size.[4] Marsh considered working with large brushes and Chinese ink, "an excellent medium . . . very beautiful . . . cheap, procurable, the least trouble of all

Recto

Verso

Reginald Marsh
Derelicts under the "El"
1946

and very permanent."[5] The Corcoran's work has two images back to back on the sheet.

LCS

1. F.A.B., "Reginald Marsh as a Painter," *Creative Art* (April 1933): 164.

2. Reginald Marsh, "Let's Get Back to Painting," *Magazine of Art* (December 1944): 296.

3. Douglas Dreishpoon, *Reginald Marsh (1898–1954): Paintings and Works on Paper* (New York: Hirschl & Adler Galleries, 1985), p. 6.

4. "A Half-Day in the Studio of Reginald Marsh, Virile Painter of the American Scene," *American Artist 5* (June 1941): 7.

5. Marsh, "Let's Get Back to Painting," p. 293.

49

John Marin
(1870–1953)

BORN IN RUTHERFORD, NEW Jersey, on December 3, 1870, Marin did not receive any formal training in art until he entered the Pennsylvania Academy of the Fine Arts in 1899. He was then twenty-nine and a practicing architect. From 1905 until 1910 he was in Europe, living mostly in Paris where he came under the influence of Whistler as well as the Post-Impressionists. It was also in Paris at the end of 1908 that he met Edward Steichen and through him was introduced to Alfred Stieglitz, who in March of 1909 gave Marin his first New York exhibition at the "291" gallery and remained the artist's friend and dealer until his death in 1946. In 1911 Marin returned finally to America. Four years later he visited Maine, which became one of his major sources of inspiration; after 1920 he spent almost every summer there. He eventually bought a house on Cape Split near Addison, where he died on October 2, 1953.

From Flint Isle No. 1 1947
Watercolor and gouache over graphite on paper
15¾ × 20⅞ in. (40 × 52.8 cm)
Inscribed, recto, l.r.: "Marin 47"; verso, ctr.: "20 / Flint Isle / No. 1"
Gift of the Women's Committee 1957
Acc. No. 57.9

In 1948, a year after this watercolor was executed, a poll of the art field by *Look* magazine showed Marin to be the pre-eminent artist living in America.[1] Although his *oeuvre* included oils and prints, his reputation had been made by his watercolors. He came to be considered the greatest American watercolorist since Winslow Homer, one critic going so far as to dub him the "Beethoven" of the medium.[2] The brilliance and fluidity of color combined with an expressionistic and idiosyncratic style made Marin's work distinctive and modern. His subjects varied, but he is best known for his paintings of the rocky coast of Maine and the architecture of New York; with his passionate use of color and line he was able to capture the power of the former and the dynamism of the latter.

From Flint Isle is one of two works Marin created with that title in 1947.[3] It depicts a sea view from a favorite family spot. The composition is reminiscent of earlier Maine scenes.[4] The framing edge was a device occasionally used by Marin. Here it seems to cup the waves, to preserve them as a pictorial image by denying the spatial illusionism of the subject even as it suggests the shape of a cove.

The work was executed during a period when Marin was painting in oil as well as in watercolor. He looked upon these compositions less as depictions of scenes and more as representations of movement. "Using paint as paint," he remarked at the time, "is different from using paint to paint a picture. . . . I'm calling my pictures this year 'movements in paint' and not movements of boat, sea, or sky, because in these new paintings, although I use objects, I am representing paint first of all, and not the motif primarily."[5] While Marin was speaking of his work in oil, his interest in medium as opposed to setting is apparent here in the broad sweeps of color, the bold strokes of the brush, the airy thinness of the pencil line. To be sure, Marin conveys a sense of the rolling sea, the choppy waves, the delicate spray, but it is the act of painting as much as the ocean that is his subject here.

EJN

1. "Are These Men the Best Painters in America Today?" *Look* 12 (February 3, 1948): 44.

2. Matthew Josephson, "Leprechaun on the Palisades," *The New Yorker* 18 (March 14, 1942): 26.

3. Sheldon Reich, *John Marin*, 2 vols. (Tucson: University of Arizona Press, 1970), Vol. I, p. 752, Nos. 47.10 and 47.11.

4. See Reich, Nos. 14.18, 22.31, 32.50, and 45.3 for representative examples in each decade.

5. MacKinley Helm, *John Marin* (Boston: Pellegrini and Cudahy, 1948), p. 101.

50

George L. K. Morris
(1905–1975)

BORN IN NEW YORK ON NOVEMber 14, 1905, Morris was educated at Yale, where he studied literature and art. Upon graduation in 1928, he attended the Art Students League in New York and the Académie Moderne in Paris. His studies, travels, and literary interests brought him in touch with the avant-garde in Europe

John Marin
From Flint Isle No. 1
1947

George L. K. Morris
Indentation
1948

and America and led him to become a vocal advocate of abstract art. His articles and essays appeared regularly in the *Partisan Review,* which he edited from 1937 to 1943. One of the founders of the American Abstract Artists in 1936, Morris was particularly sympathetic to the geometrical rationalism of Cubism, Constructivism, and Neo-Plasticism. He died on June 26, 1975, in New York.

Indentation 1948[1]
Gouache and collage of sheet music
 on paper
13¹¹⁄₁₆ × 10½ in. (38.4 × 26.7
 cm)
Inscribed, l.l.: "1948 [or 9]"; l.r.:
 "Morris"
Museum purchase through a gift of
 Mrs. J. L. M. Curry 1977
Acc. No. 1977.18

Morris was making collages by the mid-1930s[2] as a natural outgrowth of his immersion in European abstraction. Around 1930 he met Braque and Picasso, both seminal figures in the development of collage as an artistic form in the early twentieth century. They frequently introduced musical imagery in their work, including actual scores. The major influence on Morris' early essays in the medium, however, was Arp, whom he got to know in 1934.[3]

The musical fragments in *Indentation,* both from a classical piano score, were not the first to appear in Morris' oeuvre. Some ten years before, *Precarious Balance* had incorporated part of a sheet of nineteenth-century orchestral music.[4] That fragment is one of several large wedge-shaped forms in the horizontal composition; the rest are painted. The sheet contrasts with the painted surface on which it is applied, providing a visual stop to the lateral movement across the surface.

The design of *Indentation,* on the other hand, appears orchestrated by the music. Small quadrilaterals of white or brown gouache echo the notes just as the horizontal bands of color, the curving forms connecting parts of the composition, and the semicircular motif on the left suggest, respectively, lines of a staff, slurs linking notes, and a treble clef. Like Mondrian's *Broadway Boogie-Woogie* or *Victory Boogie-Woogie* from the early 1940s,[5] *Indentation* uses form and color to visualize rhythmic abstraction.

The musical fragments in *Indentation* function in another way. The inherent properties of the two pieces of paper both enhance and contradict the recessional movement of the concentric composition. Their whiteness punctures the picture plane (an optical effect implied in the title) while their corporeality establishes it. Treating perspective abstractly was a major concern of Morris' from the late 1940s. *Indentation,* though modest in size, serves as a paradigm for his stated artistic aim: to open space and at the same time to retain control of each symbol of perspective so that the picture plane remains inviolate.[6]

EJN

1. The work has been published with the date of 1949 in *American Drawings, Watercolors. . . . in the Collection of the Corcoran* and in Melinda A. Lorenz, *George L. K. Morris: Artist and Critic* (Ann Arbor: Research Press, 1982), p. 103. However, I read the last digit as an eight.
2. See, e.g., *Indians Fighting* of 1935 and *Portrait Construction* of 1936, illustrated in Lorenz, Figs. 7 and 11.
3. See Lorenz, pp. 18–19, for a discussion of Arp's influence on Morris' collages.
4. See a letter dated January 3, 1986, from Mrs. Morris (Suzy Frelinghuysen) to the author (Corcoran Archives), in which she discusses Morris' use of music in collages. *Precarious Balance* is illustrated in

George L. K. Morris: Abstract Art of the 1930s (New York: Hirshl & Adler Galleries, 1974), No. 42, n.p. Attempts to identify the specific pieces of music have not been successful.
5. Morris, who visited Mondrian's studio in New York frequently between 1940 and 1944, would have known these works. Lorenz, p. 105.
6. George L. K. Morris, "Reflections," *George L. K. Morris: A Retrospective Exhibition* (New York: Hirschl & Adler Galleries, 1971), n.p.

51

Pietro Lazzari
(1898–1979)

BORN IN ROME ON MAY 15, 1898, Pietro Lazzari studied at the Ornamental School of Design in that city, where he received the degree of Master Artist shortly after the end of World War I. He left Italy in 1929 and came to New York, were he was one of the founders of the Secession Gallery in the 1930s with Mark Rothko and others. During the Depression he executed murals in many government buildings. In 1936 he became a U.S. citizen, and in 1942 he settled permanently in Washington, D.C., where he taught throughout his career. He was a prolific and successful artist, noted for his ink drawings, silverpoints, oil and watercolor paintings, as well as abstract and representational sculpture. He died on May 1, 1979, in Washington.

Untitled c. 1960–1970
Stylus and black ink on white paper
22⁹⁄₁₆ × 28½ in. (57.4 × 72.4 cm)
Inscribed, u.r.: "Pietro Lazzari"
Gift of Franz Bader 1980
Acc. No. 1980.106

Lazzari's art is frequently populated by female nudes, solitary horses, and horses with humans. These creatures tend to inhabit an ideal space, but Lazzari also had a fascination with the grotesque

and the phantasmagorical. This particular work typifies the dark side of Lazzari's imagination. With its pointed ears and attenuated form, the male figure assumes a subhuman, almost demonic appearance. It is clearly a terrifying apparition, a supernatural creature. This nightmarish quality is reinforced by the figure's aggressive and predatory sexuality. The image's intensity is further conveyed by Lazzari's nervous, calligraphic line. The line is varied to accentuate the form—a technique frequently encountered in the artist's work. The figure's taut posture, not unlike that of a crouching cat ready to spring, heightens the tension of the composition.

Like many of Lazzari's drawings, this work hints at a hidden narrative. While the creature's tentative gesture toward the human arm reaching up from a hole in the ground suggests an episode from Dante's *Inferno*, a work the artist greatly admired,[1] the setting is ambiguous. Without visual references, no definite link can be made to the poem. The drawing may simply be a general comment on human suffering, a recurrent theme in Lazzari's work.[2]

Lazzari's academic education placed a strong emphasis on drawing. Although he later broke with that background, he retained his interest in line to create form and convey meaning. Drawings such as this exhibit his ability to adapt an academic tradition to a modern mode of expression.

ESC

1. From a conversation with Evelyn Lazzari, widow of the artist, August 22, 1985.
2. Personal interview on October 24, 1985, with Franz Bader, Lazzari's dealer in Washington.

52
Sally Michel
(b. c. 1900)

SALLY MICHEL WAS BORN AROUND 1900 in New York City. She was already working as an artist and illustrator when she married the painter Milton Avery in 1926. Their daughter, March, who also became an artist, was born in 1932, and Michel's work as an illustrator provided the major financial support for the family in the early years.[1] She has taught at the New York Studio School, has had solo exhibitions in Provincetown and elsewhere, and has contributed to "Avery Family" exhibitions in the Allentown and New Britain museums. Her watercolors and oils have won numerous awards. She continues to live in New York.

Portrait of Milton Avery 1961
Black ballpoint pen ink and craypas on paper
11 × 3⁷⁄₁₆ in. (28 × 21.4 cm)
Inscribed, l.l.: "Sally Michel / 6/15/61"
Gift of William H. G. FitzGerald, Desmond FitzGerald, and B. Francis Saul II 1978
Acc. No. 129.172

Sally Michel writes: "I can't remember a time when I wasn't sketching and drawing. It held endless fascination for me."[2] Indeed, in Milton Avery's early work he often depicts his wife at her drawing table. Michel's life has been dominated by her family and her art: "I was very lucky to marry a painter and lucky to have a daughter a painter too."[3] All three of them have painted each other in quiet domestic interiors and beach scenes.

Sally and Milton Avery traveled together, working side by side, to Vermont, the Gaspé Peninsula, California, Mexico, and Florida until his death in 1965. Avery had long been plagued by heart trouble and suffered his first heart attack in 1949–1950. A later attack occurred in 1961 when this portrait was made:

> Milton pale & wan was just recovering from his second heart attack. Mornings were spent lounging in an overstuffed chair and frequently dozing. This created a chance for me to make drawings of him which I did over and over again.[4]

Michel's drawing, in its spare but lively lines and uncomplicated colors, inevitably brings to mind her husband's work. But there is a lyricism to the lines and a softness and serenity that is Michel's alone. In a quick sketch she has captured a sleeping but strongly concentrating face.

CA

1. Hilton Kramer, *Milton Avery: Paintings 1930–1960* (New York: Thomas Yoseloff, 1962), pp. 10, 13.
2. Letter from the artist to the author, July 5, 1985.
3. Quoted in *The Milton Avery Family* (New Britain, Conn.: New Britain Museum of American Art, 1968), n.p.
4. Letter from the artist, July 5, 1985.

53
Willem de Kooning
(b. 1904)

BORN IN ROTTERDAM, HOLLAND, April 24, 1904, de Kooning began his artistic training as an apprentice in a decorating firm. He enrolled at the same time in the Rotterdam Academy of Fine Arts and Techniques, studying from 1916 to 1924. In 1926 he immigrated to the United States, first settling in Hoboken. In 1927 he moved to New York, where he met Arshile Gorky, Stuart Davis, and other artists. He worked as a commer-

Pietro Lazzari
Untitled
c. 1960–1970

Sally Michel
Portrait of Milton Avery
1961

Willem de Kooning
Untitled
c. 1965–1975

cial artist, sign painter, and carpenter until the mid-1930s, when a year with the Federal Art Project convinced him that he should be a painter. His *Woman* paintings began in 1938, the year he met the artist Elaine Fried, who later became his wife. His first one-man show was held in 1948; that year he taught at Black Mountain College under Josef Albers. For the past four decades he has taught, exhibited frequently, and his work has been widely collected. In 1978 the Guggenheim Museum held a major retrospective of his work. Since 1962 he has lived and worked in The Springs, East Hampton, Long Island.

Untitled c. 1965–1975
Graphite on paper laid down
13 × 18½ in. (33 × 21.6 cm)
Inscribed, l.l.: "de Kooning"
Gift of William H. G. FitzGerald,
 Desmond FitzGerald, and B.
 Francis Saul II 1978
Acc. No. 1978.129.71

Willem de Kooning is considered to be one of the great draftsmen of this century as well as a master of Abstract Expressionism. This drawing includes elements seen in his work since the 1930s, when he began his lifelong homage to the female form. Although these images have the ability to shock the viewer and provide new and startling interpretations,[1] they are also an extension of an iconography traced back to 18,000 B.C. in the Venus of Willendorf, one of the first known art objects.[2]

De Kooning's women have appeared in a multitude of poses and settings. Usually they stand filling the entire picture plane; less frequently they squat or sit, as does the figure in this drawing. But the lack of certainty in pose allows this to become an ideograph for

the act of sitting or squatting. The compression of the form into the lower half of the sheet is matched by the feeling of pressure from the vigor of the lines. De Kooning prefers a hard surface for drawing and likes semi-transparent papers with a slick, smooth surface,[3] allowing him to work with the speed and freedom so much a part of his act of creation. Seldom does he use a paper with tooth or texture. It is from the goggle-like eyes and the squatting pose, similar to works of the 1960s and 1970s, that a possible date of 1965 to 1975 is deduced.[4] De Kooning almost never signs or dates his drawings. Many are created almost as exercises without a model; few are regarded as finished works. His drawings are enmeshed in his creative procedures, but very few are studies or sketches as these terms are conventionally applied to drawings at various stages in the systematic development of a composition or refinement of a form.

LCS

1. See, e.g., Jack Cowart and Sanford Sivitz Shaman, *De Kooning 1969–78* (Cedar Falls: University of Northern Iowa, Department of Art, 1978), p. 8.
2. Diane Waldman, *De Kooning in East Hampton* (New York: Guggenheim Museum, 1978), p. 21.
3. Thomas Hess, *Willem de Kooning: Drawings* (Greenwich, Conn.: New York Graphic Society, 1972), p. 14.
4. Telephone conversation with Xavier Fourcade of Xavier Fourcade Inc., January 29, 1986. Mr. Fourcade feels this work could even be as late as 1976.

54

Philip Pearlstein
(b. 1924)

BORN MAY 24, 1924, IN PITTSBURGH, Philip Pearlstein is now the leading figure in American realist figure painting. After serving in Italy during World War II, Pearlstein graduated with a studio degree from the Carnegie Institute of Technology in 1949 and moved to New York, where he worked in commercial art during the day and painted his own abstracted landscapes at night. From 1950 to 1955 Pearlstein was a student at the Institute of Fine Arts, New York University, writing his Master's thesis on Francis Picabia. Throughout his career Pearlstein has written about his own work and about issues in modern art. Following a year in Italy in 1958 on a Fulbright grant, Pearlstein began to teach painting at the Pratt Institute and then joined the faculty of Brooklyn College, becoming Distinguished Professor there in 1977. In 1975 there was a retrospective of his drawings and prints, and another of his paintings, drawings, and prints in 1983. The artist continues to work and teach in the New York City area.

Untitled 1966
Brush, brown ink, and wash on
 wove paper
27⁵/₁₆ × 20⅝ (69.4 × 53.4 cm)
Inscribed, l.r.: "To the new york
 Studio School / Philip Pearlstein
 '66"
Gift of William H. G. FitzGerald,
 Desmond FitzGerald, and B.
 Francis Saul II 1978
Acc. No. 1978.129.198

In painting the nude, Philip Pearlstein has removed it from its traditional roles as an idealized, romanticized, or eroticized subject and turned it into a formal object. In the late 1950s the artist joined a group of painters who gathered one night a week to draw for up to six hours from life models. During these sessions, organized by the artist Mercedes Matter,[1] Pearlstein decided to discard the psychological and narrative

overtones usually associated with realism and figure painting and to paint the models as they were—bored and distracted forms. "I decided that they were doing nothing but sitting there while I painted them. That was the biggest breakthrough of my career."[2] And so the models in this drawing have their own particular bodies; their poses are human and disassociated, their expressions absent.

Pearlstein allows the models to take their own positions. He then circles them until he finds the vantage point that offers a placement of the figures and the negative space he finds interesting in its interaction, coincidence, contrast, or shape. Using a Japanese brush and ink,[3] positioned within a few feet of his models, Pearlstein begins to draw.

> I start to draw somewhere that gives me the most difficult juxtaposition of forms . . . usually I start with the hands . . . the first form drawn provides a module for the rest of the drawing: all successive forms are visually measured against it. I concentrate on drawing the contours of shapes, seeing them for the moment as flat areas. If I get the contours of all the shapes, including the shapes of the empty spaces, correctly measured against one another, the drawing works itself out. I don't bother with proportion, anatomical knowledge or foreshortening. . . .[4]

A feeling of inertia settles over the models, as if they may never move again. The artificial light washes harsh shadows across the bodies, contrasting with the sinuous silhouette. The broken lines mark interior contours and also areas where shadows will fall.[5] The cropping of the figures is considered a major element in the work of Pearlstein, who sees it as a way of increasing the scale of the

portion of the pose he is most interested in: "if the torso is moving well, it doesn't need the head. If the head is moving in an all together different way and I like it, I'll start with the head and let the feet go. It's how things crisscross across the surface of the canvas that really matters."[6]

The coolness of the approach is in contrast to the cropping of the forms and the explicitness of the image, resulting in an aggressive composition. The large forms are axial and dimensional, bursting from the picture plane. Pearlstein quotes Al Held as wanting "to back the viewer up against the opposite wall."[7] "Everybody assumes it's erotic because of our conditioning. But to deal with it in a cold, objective, almost clinical way sets up a pictorial tension, which I like in paintings. . . ."[8] Critics of his work complain of this cold handling and austere tone that leaves nothing to steer the viewer's response. Pearlstein responds that the artist cannot manipulate the viewer in an assured way. "I really believe that if the artist just paid enough attention to making a good painting in terms of all the things he can control, rather than worrying about what it conveys . . . that would take care of itself anyway, and you end up with a much better painting."[9]

MK

1. See Paul Cummings, *Artists in Their Own Words* (New York: St. Martins Press, 1979), for a further discussion of this life class.
2. Linda Nochlin, *Philip Pearlstein* (Athens, Ga.: Georgia Museum of Art, 1970), n.p.
3. Cummings, p. 165.
4. Philip Pearlstein, *A Statement* (New York: Gimpel and Weitzenhoffer, 1972), n.p.
5. Cummings, p. 164.

6. *Ibid.*, p. 171.
7. Philip Pearlstein in *Philip Pearlstein: A Retrospective* (New York: Alpine Fine Arts Collection and the Milwaukee Art Museum, 1983), p. 14.
8. Sanford Sivitz Shaman, "An Interview with Philip Pearlstein," *Art in America* (September 1971): 125.
9. Ellen Schwartz, "A Conversation with Philip Pearlstein," *Art in America* (September 1971): 52.

55

Stephen Antonakos
(b. 1926)

BORN IN ST. NICKOLAS, GYTHEreion, Greece, November 1, 1926, Stephen Antonakos emigrated to the United States at the age of four. He lived in New York City and later became a student at Brooklyn Community College. He has taught or served as artist-in-residence at many institutions, including the Brooklyn Museum Art School, the University of North Carolina, Yale University, and the University of Wisconsin. He began exhibiting in 1957 and had his first one-man show of "sewlages," large sewn collages, in New York during 1958. From those works he moved to assemblages, free-standing sculpture, and then pillow forms. The pillow series introduced neon, the medium which has continued to be his primary concern since the mid-1960s. He lives and works in New York City.

Large Floor Neon 1969
Blue pencil, wash, and fixative on paper
$13^{15}/_{16} \times 21^{15}/_{16}$ in. (35.4 × 55.8 cm)
Inscribed, u.r.: "Size—at least / 20' high / color? / timing?"; c.r.: "Jan 19 1969 / Antonakos"; u.c.: "Large Floor Neon"
Gift of William H. G. FitzGerald, Desmond FitzGerald, and B. Francis Saul II 1978
Acc. No. 1978.129.7

Philip Pearlstein
Untitled
1966

Stephen Antonakos
Large Floor Neon
1969

Neon light, a new art medium in this century, has a distinctly modern yet artificial quality. The name itself means "new" and was given to this inert gas upon its discovery in 1898. A number of artists and commercial designers have utilized it in a variety of ways, but Stephen Antonakos is considered one of the outstanding pioneers exploring the artistic potential of the medium.

In his drawings from 1964 to 1974 Antonakos made many direct studies for pieces in neon. More recent drawings of the past decade, though continuing the idea of three-dimensional pieces of neon sculpture, have been conceived of as independent works of art and rarely executed as free-standing objects.

With a vocabulary of squares and circles as well as their segmented sections such as arcs and right angles, Antonakos creates a lively rhythm based on nonobjective forms. His concern with large scale is evident not only in the inscription but also in the implied grandeur and massiveness of the blue L-forms. The cumbersomeness of the four segments present the piece in three dimensions, a quality missing in later drawings of the 1970s. The lines representing tubes suggest the crackling and contained energy of the neon and coursing electricity. The force and impact that this free-standing neon piece could have are effectively conveyed.

As is his practice, the artist has first considered in this study the form and structure of the neon. The added effects of color and the programmed sequence of light going on and off, on and off, are queried in his inscribed notations but decisions are left for a later date—the next step in the creative process.

LCS

56

Mitchell Jamieson
(1915–1976)

MITCHELL JAMIESON WAS BORN IN Kensington, Maryland, on October 27, 1915. Except for military duty in World War II as combat artist and a three-year stay in Seattle, Jamieson spent his life in the Washington, D.C., area. As a young man he studied at the art school of the Corcoran Gallery, where he also frequently exhibited his work. For almost twenty years Jamieson taught at the University of Maryland. He died on February 4, 1976.

Pax Americana—Plague Series
1970
Pen and black ink with charcoal
over monoprint on paper
27¾ × 16⁹⁄₁₆ in. (70.5 × 42.1 cm)
Inscribed, l.l.: "Pax Americana—Plague Series"; l.r.: "Mitchell Jamieson"
Gift of Mrs. Mitchell Jamieson
1980
Acc. No. 1980.26

Pax Americana is obviously an ironic title for this image of mutilated victims of the Vietnam War. Between 1967 and 1973 Jamieson executed hundreds of drawings as a result of a visit to that beleaguered country in the summer of 1967 at the invitation of the U.S. Army. While not all of the drawings in the series are as pointed as this particular piece, most are overtly critical of American involvement in Southeast Asia.

As a body of works dealing with Vietnam, the Plague Series is unique in American art of the period. The title for the series consciously refers to Albert Camus' existential novel, a book that Jamieson had with him on the trip.[1] It also reflects the artist's view of that war as "simply the most violent manifestation of a spreading and profound spiritual plague" in America, at the core of which he found racism.[2]

The drawings, singularly and together, further demonstrate Jamieson's belief that "the only strong justification for art in any period consists of its being central, not peripheral, to human experience."[3] Yet they are not simply visualizations of the artist's opposition to American military action in Southeast Asia: they transcend the particulars of Vietnam and deal with the outrages of war and the dehumanization of man. In *Pax Americana* the generalized treatment of the mutilated figures contributes to their martyr-like appearance.

Most of the drawings in the series are in black and white. Not only did the artist feel that color was inappropriate to the horror of war,[4] but the graphic quality of the works reinforces their ties to prints of Callot, Goya, and Kollwitz, to name just a few of Jamieson's antecedents.[5] The infrastructure, to use the artist's term, is a monoprint.[6] Random blots of black wash or ink serve as the background on which and from which the figures evolve, for these blots suggested compositions the artist then reinforced with lines and dots. Using accidental blots to create a drawing is an old artistic practice,[7] but here it also has associations with Rorschach tests. Archetypal figures free Jamieson's art of temporal constraints and allow the Plague Series to be relevant to a post-Vietnam world.

EJN

91

Mitchell Jamieson
Pax Americana—Plague Series
1970

Ray Johnson
Cervix Dollar Bill
1970

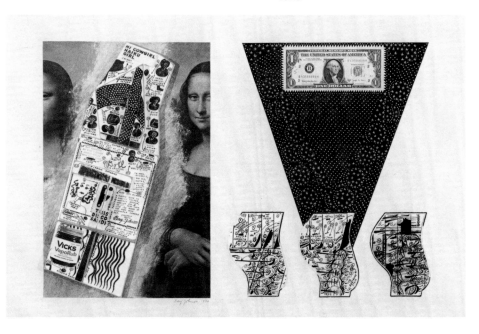

1. Edward J. Nygren, *Mitchell Jamieson: Two Wars* (Washington, D.C.: Corcoran Gallery of Art, 1979), pp. 17 and 25 (n. 5).

2. Mitchell Jamieson, "The Plague," *The Washingtonian* (September 1968): 48. Also, Nygren, p. 17.

3. Mitchell Jamieson, "Motivation, Method and Madness," 1969, manuscript in the collection of Mrs. Mitchell Jamieson.

4. Mitchell Jamieson, "Notes for September [1975] Show," manuscript in the collection of Mrs. Mitchell Jamieson.

5. Nygren, pp. 18–21.

6. Jamieson, "Motivation," quoted in Nygren, p. 18.

7. Nygren, pp. 18–19.

57

Ray Johnson
(b. 1927)

RAY JOHNSON WAS BORN IN DEtroit on October 16, 1927. At the age of eighteen he received a scholarship to attend Black Mountain College in North Carolina, where he studied for three years with Joseph Albers, Lyonel Feininger, and Jean Varda, among others. He moved to New York in 1948 and began exhibiting with the American Abstract Artists group, but by the mid-1950s he had abandoned abstract painting for collage. Since then he has had exhibitions at galleries in the United States and Europe. He lives on Long Island.

Cervix Dollar Bill 1970
Black ink, pen, acrylic paint, abrasions, cut, painted, and printed paper, and cardboard glued to prepared composition board
20 1/16 × 28 7/8 in. (50.9 × 73.4 cm)
Inscribed, l.l.: "Ray Johnson 1970"
Gift of Dr. and Mrs. Jacob J. Weinstein in memory of Mrs. Jacob Fox 1972
Acc. No. 1972.11.4

Ray Johnson's collages "are the equivalent of Rorschach ink-blot tests that can be interpreted in almost as many ways as there are individuals to examine them."[1] In *Cervix Dollar Bill* he has used handwritten messages and cutout images to create an intricate system of verbal and visual associations.

Cervix Dollar Bill is composed of two artworks sharing the same frame, the left one classical in form and the right relying on a more sculptural concept of objects floating in space.[2] On the left, a color reproduction of Leonardo's *Mona Lisa* is split by a raised cardboard surface covered with ink drawings and lettering. Its sandpapered edges cast a thin shadow on the roughly painted surface to which it is adhered. On the right, three pregnant female shapes cut from a single drawing move across a bandana-patterned triangle on which is glued an actual dollar bill.

Some connections between the two parts of the composition rely on the way words describing pictorial elements relate ("Mona" on the left sounds like "money" on the right), or the written word relating to visuals ("Doll" written on the left and a dollar appearing on the right). The arrangement of three female figures on the right is echoed in the two realistic female figures on the left flanking a third abstract figure. On both halves of the piece, numbers and arrows direct the viewer to link names of figures from the art, literary, and show-business worlds to names of female body parts.[3]

Other images in *Cervix Dollar Bill* recur throughout Ray Johnson's work. On the left, a head-and-shoulders drawing of a woman is derived from a chart he created detailing the various shapes of women's breasts; here, the drawing stops above the breast level, perhaps in deference to Mona Lisa's demure gown. Long, wavy lines represent the "comb" of Bridget Riley, the Op artist whose canvases often seem "combed" with lines of paint. Here it may allude to Mona Lisa's hair curling down her shoulders. Shapes of women's underwear appear in many of his pieces and in this work are implied in the large triangular area covered with dots and stars.

Though they make use of a multitude of ideas, none of Ray Johnson's collages carries a single underlying theme. His is an art based on the linking of words, images, and notions to one another, and it is the viewer's task to unravel the mystery of his meaning.

DS

1. David Bourdon, "Ray Johnson Collages: Valentines/Snakes/Movie Stars" in *Works by Ray Johnson* (Roslyn Harbor, N.Y.: Nassau County Museum of Fine Art, 1984), p. 10.

2. Telephone interview with the artist, February 7, 1986.

3. For the complete inscription—which includes the names of Edith Sitwell, Man Ray, and Djuna Barnes, among others—see *American Drawings, Watercolors . . . in the Collection of the Corcoran.*

58

Robert Gordy
(b. 1933)

BORN ON OCTOBER 14, 1933, IN Jefferson Island, Louisiana, Gordy spent most of his childhood in New Iberia, Louisiana, where his family moved in 1940. Even as a young boy, he wanted to be an artist. With the help of Weeks Hall, a New Iberian who had studied at the Pennsylvania Academy of the Fine Arts, and through his diligent reading of art magazines, Gordy learned about modern art.[1] In the summer of 1953 Gordy studied with the Abstract Expressionist Hans Hofmann in

Provincetown, Massachusetts, but his own art rarely became completely abstract. Gordy received both a bachelor's and a master's degree from Louisiana State University. In 1965, after several years of extensive travel in the United States and Europe, Gordy settled in New Orleans.

Study for Le Parc Series c. 1970
Felt-tip pen on two sheets of white
 paper mounted on black board
26 × 31 in. (60 × 78.7 cm)
Inscribed, l.l.: "R. Gordy"
Museum purchase 1975
Acc. No. 1975.1

This drawing is one of many studies for the Le Parc series of three paintings executed between 1968 and 1970.[2] Because Gordy "thinks by way of drawing in an ongoing process of amplification and refinement,"[3] the images presented here do not correspond exactly to those in any of the paintings. However, the same basic pictorial elements exist throughout the series: bands of flat color, geometric objects, curvaceous female nudes. Gordy's treatment of the traditional theme of a female nude in a landscape setting derives in part from his interest in modern French art, and the title of this series makes the connection explicit. Moreover, Gordy has acknowledged Matisse as his greatest artistic influence.[4] The idea of working with the figure occurred to him when he was in college in the 1950s, "and everyone was painting like de Kooning."[5] Although his interest in figuration came at a time when other artists were also questioning the aesthetic assumptions of the Abstract Expressionists, Gordy's decoratively patterned compositions show a closer affinity to the Art Deco style, which was then being re-

discovered, than to contemporary Pop Art.

Neither entirely representational nor abstract, the carefully outlined forms and figures in the Le Parc series are intensely stylized and rendered as flat patterns. Much of this stylization is dependent upon what Gordy calls the "step up of values."[6] Here, this technique is evident in the graduated gray and white clouds and in the white, pink, gray, and black layers that make up the interior of the female figures.

Gordy presents a dream world of masculine sexual fantasies and anxieties. The pointed hexahedrons which puncture the horizon line and penetrate the clouds are phallic forms that the artist contrasts with the rounded, reclining females and serpentine bands of color. This juxtaposition produces a tension that is at odds with the bucolic title of the series. The dominant bands of red and the angular, gray objects are more suggestive of a hostile industrial environment than of a pleasurable park. Moreover, the composition's spatial ambiguity contributes an air of anxiety. The alternating strips of red and black that comprise the background appear to converge at a horizon line two thirds of the way up the sheet; the female figures and phallic cones, on the other hand, do not diminish in size as they approach the same line. The result is both visually decorative and spatially disturbing. This tension between surface and depth, between form and content, is central to Gordy's art.
SF

1. Biographical information is found in Gene Baro, *Robert Gordy Paintings and Drawings: 1960–1980* (New Orleans: New Orleans Museum of Art, 1981), p. 7.
 2. Conversation with Arthur Roger, May 23, 1986. Mr. Roger, Gordy's dealer,

indicated that to his knowledge there were only three paintings in the Le Parc series.
 3. Baro, p. 8.
 4. Joseph Masheck, "Robert Gordy Discusses His Work," *Studio International*, 178 (December 1969): 241.
 5. *Ibid.*
 6. *Ibid.*

59

Lee Bontecou
(b. 1931)

LEE BONTECOU WAS BORN IN Providence, Rhode Island, on January 15, 1931. During the 1950s she studied with John Hovannes, William Zorach, and Robert Wade at the Art Students League in New York. After several years of study abroad, she began exhibiting at the Leo Castelli Gallery in Manhattan. She is best known as a sculptor, her most famous works being the large abstract wall pieces fabricated out of metal and canvas which she did in the 1960s. During the early 1970s she experimented with representational sculpture made of vacuum-formed plastic. At the same time she began to turn her attention toward lithography and other graphic media. She lives and works in Pennsylvania.

Untitled 1972
Graphite on paper prepared with a
 gesso ground
17⅛ × 25 in. (43.5 × 63.5 cm)
Inscribed, l.r.: "Bontecou 1972"
Gift of William H. G. FitzGerald,
 Desmond FitzGerald, and B.
 Francis Saul II 1978
Acc. No. 1978.129.33

Lee Bontecou, who has been exhibiting drawings since the early 1960s, does not give titles to her work.[1] She wants the viewer to respond directly and personally to the image rather than to a phrase. Nevertheless, the artist has spoken of this as an abstract piece expressing her concern for living

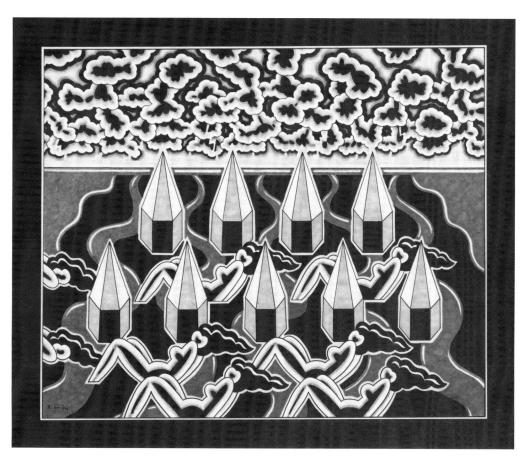

Robert Gordy
Study for Le Parc Series
c. 1970

Lee Bontecou
Untitled
1972

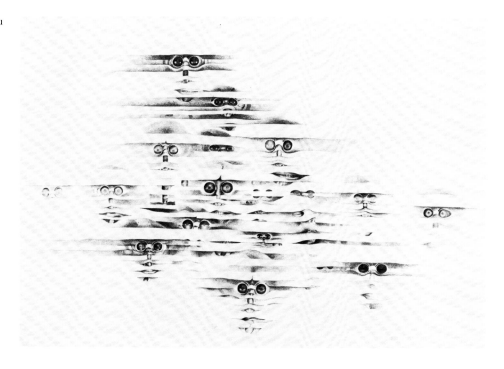

in a society that stifles personal growth and individuality. She talks of her perception of people everywhere as "being extremely fragile . . . being torn and buffeted" by oppressive forces which keep them from being free.[2] This drawing embodies her feelings about individuals attempting to break out of cultural restraints.

The deep spatial openings combined with interlocking horizontal elements are compositional devices found also in Bontecou's metal and canvas wall pieces. Here these elements, with their obscured but unmistakably human references, seem calculated to elicit fear. Strips fracture, elongate, bind, and yet reveal heads. All of these (save one) are encased in coverings that resemble helmets, gas masks, and goggles.[3] The hollow, frightened eyes glimpsed through a seemingly impenetrable screen convey a sense of menace, perhaps of paranoia. This psychological state is reinforced by the recognizable human head in the lower right center, biting one of the strips in an apparently futile attempt to rend its bonds.

Delicacy and precision of line are integral to Bontecou's graphic style. Here, minute pencil strokes are used to model the heads. The painstakingly drawn images juxtaposed against the sterile gesso background convey a clinical starkness that contributes to the work's psychological tension.

ESC

1. In *American Drawings, Watercolors . . . in the Collection of the Corcoran*, this piece was given the parenthetical title "Masks and Slats." The artist disavows any association with this title.
2. From a telephone conversation with the artist, October 8, 1985.
3. A similar drawing, dated 1963, is Fig. 15 in *Lee Bontecou: New York* (Rotter-

dam: Museum Boymans-Van Beuningen). Richard S. Field's discussion of Bontecou's oeuvre in *Prints and Drawings by Lee Bontecou* can be considered definitive (Middletown, Conn.: Wesleyan University Press, 1975).

60

George McNeil
(b. 1908)

BORN ON FEBRUARY 22, 1908, IN New York, McNeil studied at the Pratt Institute and Art Students League during the late 1920s and 1930s. From 1933 through 1936 he continued his studies with Hans Hofmann. McNeil was a founding member of the American Abstract Artists group in 1936 and was actively involved in the panel discussions and social gatherings of the New York School artists who formed the Eighth Street Club during the 1950s. He knew many of the leading Abstract Expressionists and painted in an abstract style until the 1960s. He lives in Brooklyn.

Dionysus 1973
Cray-pas and wash on Arches paper
25 × 19½ in. (63.5 × 49.5 cm)
Inscribed, recto, l.l.: "George McNeil 9/25/73"; verso, u.c.: "George McNeil / Dionysus Sept. 25, 1973"
Gift of William H.G. FitzGerald, Desmond FitzGerald, and B. Francis Saul II 1978
Acc. No. 1978.129.171

McNeil's work is idiosyncratic. Despite his early association with abstract art, he has never subscribed to any particular ideology or set of artistic theories. His work during the past fifteen years, which has focused on the human figure, is well represented by *Dionysus* with its brutal and cartoon-like images. According to the artist, it is a study for a lithograph that was never printed.[1] McNeil's figurative pieces have

been compared to those of Jean Dubuffet, particularly in their distortion of form and encrustation of paint.[2] Suggestions of these qualities appear here in the textured wash with traces of impasto and the crudely drawn leering face. Spontaneous and expressive, the brushwork seems appropriate to a representation of a god associated with the irrational and sensual.

The artist characterizes himself as an Expressionist, although he acknowledges no particular European influence. In spirit his work appears to be closer to that of Willem de Kooning, an Abstract Expressionist who has painted figures for most of his career. McNeil does not view himself as a part of the current Neo-Expressionist movement but states that he executed *Dionysus* when "Expressionism was an out-of-fashion style."[3]

Whereas the god himself is shown here, McNeil's pictorial world is usually inhabited by gyrating patrons of discos, punk-rock singers, and various denizens of the streets of Manhattan, who have taken Dionysus as the presiding spirit of their revels.[4] Portrayed in a wild and somewhat violent fashion, they appear to be totally immersed in the pursuit of pleasure.[5] These later depictions of the Dionysian nightlife of the city share with this earlier representation of the god a rawness and brashness that seem particularly American.

ESC

1. From a letter from the artist to the author, September 26, 1985.
2. Hilton Kramer and Gerrit Henry have both noted the similarity of the artist's work to that of Dubuffet. Hilton Kramer, "Two Polemicists Respond to the Mood of the Times," *New York Times* (January 18, 1981); Gerrit Henry, "George McNeil,"

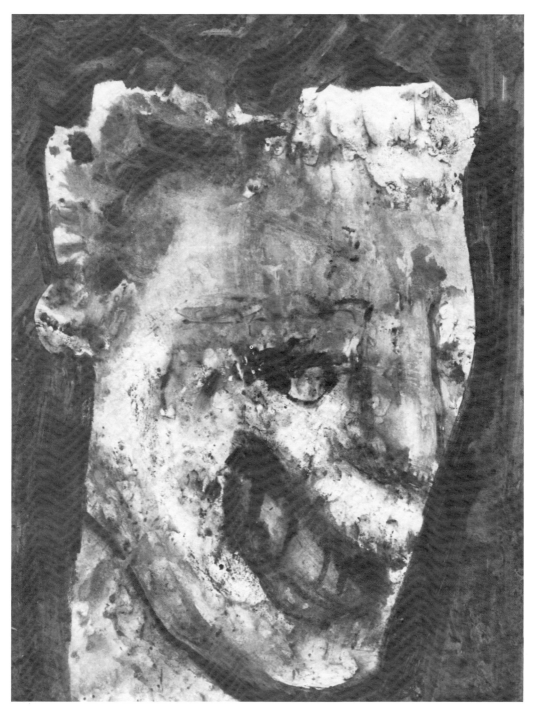

George McNeil
Dionysus
1973

Arts Magazine (December 1984): 19.

3. Letter from the artist to the author, September 26, 1985.

4. Two examples are *Dionysus Agonistes*, 1984, a lithograph, and *Dionysus Disco*, 1982, oil on canvas (letter from the artist to the author, October 17, 1985).

5. Carter Ratcliff, "George McNeil at the Gruenenbaum Gallery," *Art in America* (May 1981): 145.

61

Ed McGowin
(b. 1938)

ED MCGOWIN WAS BORN ON JUNE 2, 1938, in Hattiesburg, Mississippi. He was awarded a Master of Fine Arts degree by the University of Alabama in 1964. In Washington, D.C., during most of the 1960s and the early 1970s, McGowin experimented with sculpture made from vacuum-formed plastic and worked on a major piece, *Name Change*. His exploration of conceptual art culminated in a series of elaborate environmental works shown at the Corcoran in 1975. Since the mid-1970s McGowin has concentrated on both sculpture and painting. The artist presently lives in New York.

Untitled 1973
Colored ink with airbrush, and
 colored pencil over graphite on
 paper
40 × 30 in. (101.6 × 76.2 cm)
Inscribed, verso, l.r.: "Ed McGow-
 in/73"
Gift of Dr. Thomas Mathews
 1977
Acc. No. 1977.27

The installations which McGowin created during the 1970s were not just ends in themselves; they often provided material that he exploited in other media.[1] McGowin found that components of his sculptural installations took on separate identities in the studio. Elements came to be perceived as individual tab-

leaux or still-life arrangements which he then drew and painted. In the process, remnants of a large studio installation were transformed as they assumed an artistic life of their own. Such is the case here. Although the ambiguous shape in the center of this particular piece cannot be described as an actual object, it is in fact a wooden armature draped with cloth that sat in McGowin's studio for some time.

In this drawing the objects seem almost otherworldly. Removed from any association with the artist's studio, they are, by their very two-dimensionality, intangible. Their indefinite nature makes them mysterious, not easily described. They bear no relation to objects we know. The space in which they exist is also ambiguous. Without a sense of scale the image assumes a monumentality that is hallucinatory. The luminous glow surrounding the objects like a halo also increases their unreality, while the transparency of the inks, which allows light to reflect from the surface of the paper, adds to this luminosity.
ESC

1. Interview with the artist, November 9, 1985.

62

Dorothea Rockburne
(b. 1934)

DOROTHEA ROCKBURNE WAS born in 1934 in Verdun, Quebec, Canada. She came to the United States in the early 1950s to attend Black Mountain College in North Carolina. After receiving her Master of Fine Arts there in 1956, she moved to New York City, where she has lived and worked ever since. In 1970 she became an instructor in art history at the

School of Visual Arts in New York. She had her first one-woman show in 1970 at the Bykert Gallery. Since then she has had many individual exhibitions and has been included in group shows in the United States and Europe. She became a citizen of the United States in 1974.

Untitled 1973
Graphite and three-dimensional
 creased white wove paper
 mounted on rag board
30⁷⁄₁₆ × 40⁷⁄₁₆ in. (77.3 × 102.7
 cm)
Inscribed, l.r.: "Rockburne—73
 R.P. #5"
Gift of Mr. and Mrs. Howard
 Friedenberg 1983
Acc. No. 1983.67

This drawing is one of a group of six works of graphite on folded paper that belong to a larger series from the early 1970s called Drawings Which Make Themselves. Rockburne inscribed "R.P. #5" in the lower right corner to indicate that this is the fifth "rubbing piece," a term referring to the artist's method of drawing: three diagonal folds in the upper left, lower left, and lower right corners of the paper create the geometric forms that dictate the placement of the graphite lines, or "rubbings." The folding process is the basis of the Drawings Which Make Themselves, for it is "with the fold that the 'work' comes to exist" by transforming a blank sheet of paper into something more than that.[1]

The original concept for this series resulted from the artist's deliberation over "the possibility of making a drawing which only related to itself" and "that can affect only itself." Rockburne has said that when she began to investigate drawings in the early 1970s she did not want to look at or create them as "surrogate(s) of

Ed McGowin
Untitled
1973

Dorothea Rockburne
Untitled
1973

Michael Clark
Portrait of Lila Swift
1973

anything else [or as] illustrations of external objects" as they often are.[2] The subject of the Drawings Which Make Themselves is the actual process of "self"-creation, a process greatly influenced by Rockburne's interest in mathematical theory. In this work, she investigates the aesthetic and conceptual possibilities that arise from the interaction of a given set of variables: materials (paper and graphite) and operations (folding and drawing). In this way, her "works do not become objects but instead record the experience of how ideas infiltrate practice"[3]; it is the thought process and not the actual making of objects that is Rockburne's purpose. As she has said, "I'm interested in the ways in which I can experience myself, and my work is really about making myself."[4] Thus, the meaning and significance of Rockburne's Drawings Which Make Themselves lie in the metaphor of self-investigation and self-revelation implicit in the title.

SF

1. Jeff Perone, "Working Through, Fold by Fold," Artforum 7 (January 1979): 44.
2. Roberta Olson, "An Interview with Dorothea Rockburne," Art in America 66 (November/December, 1978): 144.
3. Mel Bochner, "A Note on Dorothea Rockburne," Artforum 10 (March 1972): 28.
4. Jennifer Licht, "Work and Method" (interview with Dorothea Rockburne), Art and Artists 6 (March 1972): 32.

63

Michael Clark
(b. 1946)

BORN IN DENVER, ON NOVEMBER 20, 1946, Clark moved to Washington, D.C., in 1959 with his family after several years in Texas. Interested in art at an early age, he explored the National Gallery and, as a teenager, took lessons from the Japanese master printmaker Hiratsuka. From 1965 to 1966 Clark attended the Pratt Institute in Brooklyn, where he studied drawing with Lennart Anderson among others. Returning to Washington, he enrolled at the Corcoran School of Art. A recipient of a Ford Foundation grant in 1968, he has frequently exhibited in museums and galleries in Washington and in other parts of the country. Recently Clark has been dividing his time between Washington and New York with extended trips to Europe.

Portrait of Lila Swift 1973
Pencil on wove Arches paper
$22\frac{3}{8} \times 15\frac{1}{16}$ in. (56.5 × 38.2 cm)
Inscribed, l.r.: "Michael Clark / 1973"
Museum purchase, Alice Graeme Korff Memorial Fund 1975
Acc. No. 1975.27

Clark is perhaps best known for paintings and prints of windows and facades, but his subject matter ranges from seascapes to cars, from George Washington to locomotives. Portraiture has always held a special place in his oeuvre, and he has at times contemplated devoting himself exclusively to it.[1] For Clark the human is the basis of art. A humanistic concern is at the center of all of his work, whether it is a portrait of a car, a window, a place, or a person.

This particular portrait was the result of a commission from the sitter's mother, who insisted that it be done from life. The artist remembers doing approximately twelve drawings of which he destroyed seven. Although there is a closely related painting,[2] the work under discussion was not a study for the canvas. A separate creation that the artist made for himself, this piece was, in fact, an enlargement of another drawing whose outline Clark transferred by a grid and tracing paper to this sheet. Rounded and with simplified features, the face here is more idealized than in the three drawings and painting still in the mother's possession.

The silvery quality of this work, attributable to the hardness of the pencil (9H), accounts for its delicacy and lightness. The medium allows for no erasures. The subtle shading, which blends into the whiteness of the paper and produces no hard outline, was achieved through repeated gentle strokes of the pencil against a straightedge that is being constantly moved. This technique, devised by Clark and shared with Kevin MacDonald, imparts a softness to the work.

Lila Swift exhibits the diversity of influences on Clark's art. The flattened figure and stylized forms recall Japanese and Art Nouveau prints; the confined composition and the sitter's sculptural beauty are reminiscent of Leonardo's *Ginevra de' Benci* in the National Gallery. But the work is in no way derivative. The surface tension and psychological projection are assertively contemporary and recognizably Clark. A haunting stillness pervades the portrait as it does the artist's images of facades. Like the opaque windows framed by decorative details and smooth architectural skin, Lila's eyes, piercing the perfect solidity of her face, hint at some mysterious inner world but admit no access.

EJN

1. Interview with the artist, February 17, 1986. For additional information on Clark, see his interview with Clair List in *Images of the 70's: 9 Washington Artists* (Washington, D.C.: Corcoran Gallery of Art, 1980), pp. 10–12.
2. The painting is reproduced in List, p. 13.

Tom Wesselmann
(b. 1931)

BORN FEBRUARY 23, 1931, IN CIN-cinnati, Tom Wesselmann began his art studies comparatively late in life. In 1956, after earning a degree in psychology at the University of Cincinnati and serving in the military in Korea, Wesselmann enrolled at the Cooper Union in New York to study cartooning. Working in New York at a time of intense activity in the artistic community, Wesselmann soon dropped cartoons for more serious painting. In the early 1960s Wesselmann was grouped with Pop Art: he shared their interest in commercial imagery and their ironic, teasing tone. Recently Wesselmann has worked on enormous, shaped paintings of objects grouped together, large portrait faces, and nudes of specific rather than fantasy women. Wesselmann remains an active figure in the New York art scene.

*Double Drawing for Long Delayed
Nude* 1973–1975
Colored pencil and ball point pen
on tracing paper
6⁵⁄₁₆ × 4¹⁵⁄₁₆ in. (17.5 × 12.5 cm)
Gift of William H. G. FitzGerald,
Desmond FitzGerald, and B.
Francis Saul II 1978
Acc. No. 1978.129.260

Double Drawing for Long Delayed Nude is part of Wesselmann's Bedroom Painting series, begun in 1967. These tight, compressed compositions focus on portions of the nude body arranged with still-life elements in a bedroom setting. Wesselmann's nudes are drawn from life models. He works quite close to the model, carefully distilling his descriptive lines. In the final draw-ing, the nude is depicted by contour lines only; a bright smile is the only facial feature. Bereft of individual identity, the figure is both provocatively erotic and cooly abstract. Still-life props are added and arranged around the nude, until all the elements lock into position. Wesselmann then transfers this perfected drawing to tracing paper. The original tracing for *Double Drawing* was made in 1973; the colored pencil was added in 1975.[1]

Each still-life object is an expression of a sensual pleasure in itself, but they also relate to the nude body: the orange to the breast, the lotion bottle and its cap to the erect nipple, the pillow to the flesh, the light tissues to the hair, and the photograph of a face to the undescribed face of the woman. "I want to stir up intense, explosive reactions in the viewer. . . . As for the erotic elements, I use them formally, without any embellishment. I like to think that my work is about all kinds of plea-sure."[2]

The end image is a unique expression of Wesselmann's interests. After abandoning cartooning Wesselmann painted in a direct, aggressive style, like that of de Kooning, the Abstract Expressionist he most admires.[3] Eventually this was tempered by the control and formalism Wesselmann saw in Mondrian and other abstract painters. Nonpainterly influences are apparent in the choice of subject and the tone the artist strikes. Wesselmann himself has mentioned the unconventionally personal, sexually preoccupied novels of Henry Miller, the forceful newness of Jack Kerouac, and the Theatre of the Absurd.[4] The use of household objects and commercial images remains from Wesselmann's earliest works— the small collages made from his drawings and clipped advertisements, and the Great American Nude series in which the artist placed life-sized painted nudes among appliances and architectural elements.

Despite the light tone, the artist's interest in formalism and the aesthetic concerns of traditional art are apparent.[5] The result is something out of schoolboy pornography: intimate in size, personal in iconography, codified in its eroticism. Explicit and coy, the nudes are always exaggerated, perfected, and ultimately divorced from the reality from which they rise.

MK

1. Undated note from the artist, autumn of 1983.
2. Quoted in Paul Gardner, "Tom Wesselmann," *Artnews* (January 1982): 69.
3. *Ibid.*, p. 70.
4. Slim Stealingworth, *Tom Wesselmann* (New York: Abbeville Press, 1980), p. 13.
5. Trevor Fairbrother, "Interview with Tom Wesselmann/Slim Stealingworth," *Arts Magazine* (May 1982): 136.

Al Held
(b. 1928)

BORN OCTOBER 12, 1928, IN BROOK-lyn, Al Held attended public schools before serving in the Navy from 1945 to 1947. On the G.I. Bill he attended the Art Students League before studying for three years in Paris. There, Held was part of the expatriate artists' circle that would produce most of the leading figures in American post-war abstract painting. In 1952 he returned to New York; from 1962 to 1980 he taught in the Department of Painting at Yale University. In 1967 Held broke with

Tom Wesselmann
Double Drawing for Long Delayed Nude
1973–1975

Al Held
Isabella I
1974

much of his earlier painting. His new works were done in black and white, diagrammatically outlining three-dimensional shapes floating in space. In the past ten years Held has continued to develop these floating forms while injecting a surprising color sense.

Isabella I 1974
Graphite on paper
22½ × 30⁹⁄₁₆ (57.7 × 77.5 cm)
Gift of the American Academy and
 Institute of Arts and Letters,
 Hassam and Speicher Funds 1979
Acc. No. 1979.83

The large, cool drawings of Al Held offer an immediate invitation to the viewer: the precise geometric shapes lure him into a picture of seeming calm and simplicity, then ensnare him in a net of paradox. The subtle complexity of the drawing and the completeness of its achievement are a reflection of Held's creative capacities.

His drawings display the same working method he uses in his paintings. He begins to draw his shapes intuitively, then as the composition takes form, Held paints and repaints layer upon layer, developing individual shapes and the whole, weighing the variables and making adjustments.[1] While the drawings might be in preparation for a painting, Held's method does not allow for strict repetition, only evolution; so no painting imitates a drawing.

In *Isabella I* the creation of the composition is suggested by the mark of the compass and the eraser. These reminders of the creative process imply time and movement, two important elements in Held's content. His drawings and paintings of this time frequently have titles that evoke outer space and exploration—*Solar Wind IV, Jupiter I, Skywatch*. Isabella I was

Queen of Castile and Aragon and the sponsor of Christopher Columbus.

Space and the way a two-dimensional drawing or painting can expand and control space beyond the picture surface have interested Held since the 1950s. In an early statement of intent he wrote: "The space between the canvas and the spectator is real . . . emotionally, physically and logically. It exists as an actual extension of the canvas surface."[2] It is surprising to note the expansive, aggressive, and protean qualities of *Isabella I,* a drawing of remarkable austerity and control. The Cubist-inspired shapes loom forward and fall backward in a picture plane that has no definable depth. The larger shapes refuse to be confined by the edges of the sheet and effortlessly push off in all directions.[3] The end result is the unlikely mixing of the expansiveness of Pollock and the structure of Mondrian.[4]

The complexity of the drawing arises from the enormous quantity of visual information and misinformation Held provides the viewer. These endless paradoxes and contradictions[5] leave no foothold. The resulting confusion reminds us that these are merely lines on a two-dimensional plane, not forms existing in a three- or four-dimensional environment— a beautiful joke in an analytical Cubist mode.

MK

1. Eleanor Green, *Al Held* (San Francisco: San Francisco Museum of Art, 1968), p. 3; Andrew Forge, *Al Held: New Paintings* (New York: Andre Emmerich Gallery, 1978), n.p.
2. Al Held, *It Is* (Autumn 1958): 78.
3. See Marcia Tucker's catalogue *Al Held* (New York: Whitney Museum, 1974) for a detailed discussion on the dialectics of space.
4. John Gruen, "Artist's Dialogue: Al Held," *Architectural Digest* (May 1986): 80.
5. Louis Finkelstein, "Al Held: Structure and the Intuition of Theme," *Art in America* (November–December 1974): 86.

66

Dennis Oppenheim
(b. 1938)

OPPENHEIM WAS BORN IN MASON City, Washington, September 6, 1938. His formal training in art began at the California College of Arts and continued at Stanford University, where he earned a Master of Fine Arts degree in 1965. He has exhibited widely in this country and Europe, including solo exhibitions at the Tate Gallery, London, in 1972 and a retrospective at the Musée d'Art Contemporain, Montreal, in 1978. Fellowships have come from the National Endowment for the Arts and the Guggenheim Foundation. During the late 1960s and early 1970s he taught or worked as artist in residence at several institutions including Yale University, the Pratt Institute of Art, and the Art Institute of Chicago. Oppenheim lives and works in New York City.

Dead Dog on Organ (drawing of
 installation "Works/Words" at
 The Clocktower, New York, September 1974) 1974
Cray-pas on paper
18¾ × 23⅞ in. (47.7 × 60.7 cm)
Gift of William H. G. FitzGerald,
 Desmond FitzGerald, and B.
 Francis Saul II 1978
Acc. No. 1978.129.189

Oppenheim's career has been a creative and varied one; his oeuvre, as a result, resists the application of a single label. Often called conceptual, he has ranged through varied media and ideas from early earthworks to body works, interior installations, dra-

mas, video film, and machine works.[1] These shifts appear to be conscious, a continuation of his lifelong investigation of man and art and their interrelationship. But throughout his work he has followed a consistent approach, beginning with an idea and subsequently recording it in his notebooks. The earliest of these volumes included "rather traditional sketches," but as his focus changed and his substructure relied increasingly on language, "the material in these books shifted from pictoral to words." Most of his work "stems from these notebooks, and although the thoughts are often fragmentary and disjointed, they make up the original pattern that underlies the finished work."[2]

The idea for the installation piece shown in the Corcoran drawing is found in the first entry for the notebook dated 1974: "installation with dead dog lying on top of organ—sound changes as body deteriorates—equipment is dragged through graphite to form X pattern."[3] The drawing serves as a schematic description of this idea and was made after the proposal was realized. It is inscribed in the upper left corner of the sheet with the name of the gallery, The Clocktower, and location, 108 Leonard Street, New York City. Review comments and photographs further document the piece:

> As one opens the door and mounts the stairs to the room, one's ears fill with the incessant reverberation of a simple chord. At the top of the stairs one stops. Directly in front is a dead German shepherd sprawled on top of an electric organ keyboard. The floor is covered with asphalt swirled in a spiral pathway which suggests the prior dragging of the dog and organ across the surface.[4]

The performance proceeded for six hours without climax or discernible change. In her review Susan Heineman noted a feeling of loneliness and awe occasioned by the ritual and by the sacrificial nature of the installation.[5] Viewing the drawing made of that exhibition, one can imagine some of her reactions but may be most struck by an aesthetic "gut reaction" inspired by Oppenheim's choice of a dead dog as the central feature of the piece.[6]

The image is vigorously drawn, and the composition follows the spiraled arrangement of the installation piece. (It should be noted that both drawing and installation were a change from the original idea of an X.) Moving around the sheet from the upper left to the upper right, the eye is led through the drawing. Utilizing colors that seem to be derived from the chromatic range of television, video, or commercial printing, the principal objects— dog, organ, and swirl—are defined in strong lines. The drawing retains the ability that the installation obviously possessed to surprise, shock, and dismay the viewer. Its strength remains basically undiluted by the lack of physical presence, smell, and ringing sounds found at The Clocktower.
LCS

1. S. Morgan, "Dennis Oppenheim: Gut Reaction," *Artscribe* 16 (February 1979): 34.
2. Dennis Oppenheim, "Catalyst 1967–1974," in Alan Sondheim, ed., *Individuals: Post-Movement Art* (New York: Dutton, 1977), p. 246.
3. *Ibid.*, p. 262.
4. Susan Heineman, "Dennis Oppenheim, The Clocktower," *Artforum* 13 (September 1974): 85. Photographs appear in Oppenheim, p. 260.
5. Heineman, p. 85.
6. Morgan, p. 34.

67

Robert Stackhouse
(b. 1942)

ROBERT STACKHOUSE WAS BORN on July 24, 1942, in Bronxville, New York. He received his Bachelor of Fine Arts degree from the University of South Florida in 1965 and a Master of Fine Arts from the University of Maryland in 1967. Stackhouse has been teaching at the Corcoran School of Art since 1967. He divides his time between New York and Washington.

Drawing for "Ghost Dance" 1974
Watercolor, gouache, and charcoal over graphite on paper
37¾ × 36 in. (95.6 × 91.4 cm)
Inscribed, l.c.: "r. Stackhouse 10/74"
Gift of the Women's Committee 1974
Acc. No. 1974.73

Drawing for "Ghost Dance" is a very literal drawing of an abstract sculpture. The title refers to the ritualistic "spirit quest" ceremonies performed by American Indian tribes, and also to the rituals an artist performs in his studio while searching for new ideas.[1] Stackhouse's ritual involves the execution of a cycle of literal source drawings that culminate in a sculpture. The cycle continues as he documents the constructed piece with up to twenty literal renderings depicting the work from different angles. More than just documentation, however, the drawings are the process that carries him to the creation of his next piece.

The three source drawings for *Ghost Dance* include a literal self-portrait whose shadow wears deer antlers, a meticulously rendered profile of a deer head, and a simple drawing of a curve which became the form of the five-by-

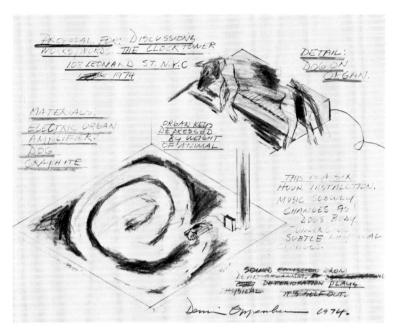

Dennis Oppenheim
Dead Dog on Organ
1974

Robert Stackhouse
Drawing for "Ghost Dance"
1974

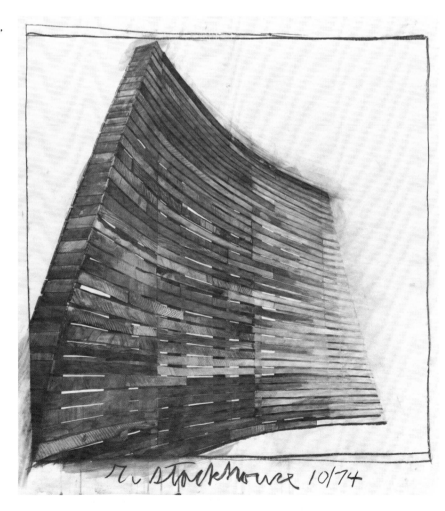

106

fifteen-foot sculpture Stackhouse constructed of wood lathing strips, two-by-fours, and brass screws, and exhibited at the Corcoran. Painted white on the inside, the sculpture creates a play of light and shadow between the spaced wooden slats screwed to either side of the upright posts. The viewer participates in the mystery of the ritual circle dance by following the curve of the semicircular piece across the floor.

This drawing was executed after *Ghost Dance* had been disassembled. Employing variable hues on a palette limited to four colors, Stackhouse lays down opaque areas of watercolor pigment to portray the unmatched wood lathing strips, then brings out their rough texture with crosshatching in pencil and charcoal. Details begin to fade as the curved monolith recedes into the picture plane. Charcoal smudges along its edges add an aspect of movement or vibration to the piece, implying on paper the dance performed by its three-dimensional counterpart. Making drawings like this is the ritual that satisfies Stackhouse's need to record the existence of his disassembled sculpture, at the same time continuing the creative cycle that leads to his next sculpture. DS

1. Personal interview with the artist, February 10, 1986.

68

Christo
(b. 1935)

BORN JUNE 13, 1935, IN GABROVO, Bulgaria, Christo Javacheff began his art education early. From 1951 to 1956 he was a student at the Academy of Fine Arts, Sofia, taking classes in painting, sculpture, and theater, and also participating in government-sponsored student "agitprop" activities in the countryside. After studying at the Burian Theater in Prague in 1956, Christo left the political instability of Eastern Europe and from 1958 to 1964 lived in Paris. When he moved to New York in 1964 his work took on a new scale. Before, he had wrapped bottles and boxes in canvas, stacked small piles of oil drums, and draped shop windows. The landscape projects that followed were vast and included *Wrapped Coast*, Australia, and *Wrapped Museum of Contemporary Art*, Chicago (both 1969); *Valley Curtain*, Rifle Gap, Colorado (1971); *Surrounded Islands*, Miami (1984); and *Wrapped Pont Neuf*, Paris (1985). Christo became an American citizen in 1973 and continues to live and work in New York City.

Otterlo Mastaba (Project for Rijksmuseum Kröller-Müller, Otterlo) 1975
Oil pastel, crayon, red ballpoint pen ink, graphite, and masking tape
17 × 24 in. (43.2 × 61.6 cm)
Gift of William H. G. FitzGerald, Desmond FitzGerald, and B. Francis Saul II 1978
Acc. No. 1978.129.58

Christo first stacked oil drums in a "temporary monument"[1] in Cologne in 1961, when he was still closely associated with the Nouveaux Réalistes, a French group that scorned traditional art and art institutions and promoted the use of modern materials and commonly available objects.[2] The use of such mass-produced, industrial material as oil drums recalls the post-Revolution Russian art movement Constructivism, particularly the work of Vladimir Tatlin, another artist who advocated the use of real materials in real spaces.

In June 1962 Christo blocked the Rue Visconti in Paris with a wall of 240 oil drums which were stacked, documented, and disassembled in just seven hours. This simple display inspired myriad responses. Symbolism was detected in the wall: it was related to the Iron Curtain, the Berlin Wall, and the street barricades of nineteenth-century Paris. Political motivations were put forward, including anarchy and the Algerian War. Today we would find oil drums symbolic of man's wastefulness, the ruining of the environment, and OPEC. However, Christo chose his medium because it was cheap and available.

The mastaba is an ancient Egyptian funerary structure from which the pyramid developed. Christo has proposed mastabas constructed of oil drums for several other locations: Abu Dhabi, Philadelphia, and Houston. None of the really large mastabas—including the Otterlo Mastaba, at 250,000 oil drums—have been built. This simple, fairly broad drawing actually contains important "specs" for the Otterlo Mastaba. It was to be constructed of 250,000 fifty-pound drums, each row 111 barrels long, combining to make the mastaba 25 × 63.2 × 52.47 meters. In the upper left Christo has included three tiny figures to give a sense of scale.

When a project leaves the planning stage and is ready to be implemented, Christo gathers a working team of contractors and crew who are necessary to realize works of the scale he deals with.[3] To Christo, the process of construction is an aspect of the art, along with the planning, discourse, anticipation, viewing, dismantling, and remembrance.

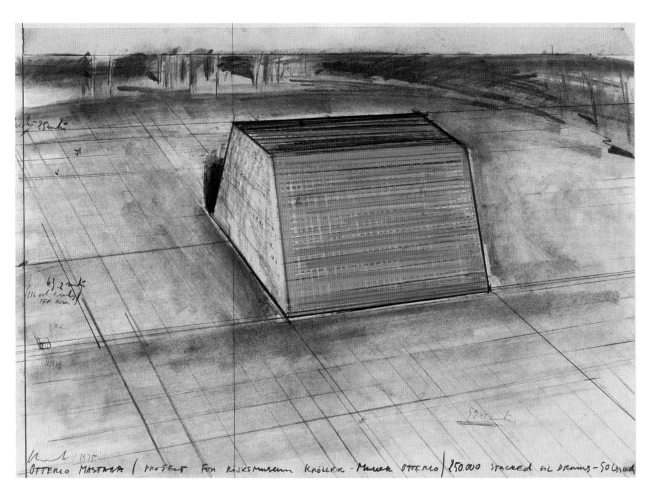

Christo
Otterlo Mastaba
1975

From his student days in the agit-prop corps he knew the excitement of working in a group on a big project.[4] This fondness for a team is also rooted in his theater training in Prague,[5] where the innovative tradition of Russia's post-Revolution theater ranged from stylized, didactic performances on a barren stage to mass participation spectacles in the street. If his art work is viewed as a performance, then its transitory quality is understandable (*Valley Curtain* blew down after just twenty-four hours; *Surrounded Islands* was dismantled after two weeks).

Christo chooses challenging sites.[6] He incorporates political resistance and public response into his art process to create the context for the work and to give it unanticipated meaning. The site at Otterlo (Waterloo) is historical—the sweeping field where the Napoleonic Wars ended—and yet this is no monument to the battle. The mastaba comes with no exterior meaning; the artist lets the viewer load the image with whatever interpretation he wishes. In a way, the mastaba would echo the shape of the huge observation mound built at the battlefield from 1823 to 1827. Ironically, although one stands on the mound to look out over the battlefield, the lay of the land is not that which Napoleon and Wellington knew, for in fact the whole site was scraped up to build the mound. This becomes a lucky metaphor for Christo's dynamic, temporary art.

MK

1. The temporary quality of his work is a frequent point of contention with viewers. In defense, Christo reminds us that "Praxiteles is considered [an] important artist, yet not one of his works survives."

Stephen Singular, "The Running Tale of Christo's *Running Fence*," *New Times* (September 3, 1976): 59.

2. Pamela Allara and Stephen Prokopoff, *Christo, Urban Projects: A Survey* (Boston: Institute of Contemporary Art, 1979), n.p.

3. "The work develops its own dimension. . . . It is always bigger than my imagination alone." Lisbet Nilson, "Christo's Blossoms in the Bay," *Artnews* (January 1984): 59.

4. *Ibid.*, p. 61.

5. Allara and Prokopoff, n.p.

6. Singular, p. 55.

69

Robert Motherwell
(b. 1915)

BORN ON JANUARY 24, 1915, IN ABerdeen, Washington, Motherwell lived most of his early life in San Francisco. As a youngster, he exhibited artistic talent; however, when he went to Stanford, he chose to study philosophy, and as a graduate student at Harvard, he focused on aesthetics. After a stay in Europe and a year as a teacher in Oregon, in 1940 he moved to New York, where he studied art history at Columbia before deciding to become a painter. Manhattan during the war years was a mecca for avant-garde European artists, and Motherwell got to know many of them. In the mid-1940s, he began to write and lecture on contemporary art; he also directed the Documents of Modern Art series being published by George Wittenborn. By the early 1950s New York had emerged as the center of artistic activity, and Abstract Expressionism had become a powerful aesthetic force. A pivotal figure in this development, Motherwell remains one of the most important artists of the post-World War II period. Since 1969 he has lived in Greenwich, Connecticut.

Gesture Paper Painting #2 1975
Acrylic, gouache, and crayon on handmade, laid brown paper
18¾ × 24⅛ in. (47.7 × 60.8 cm)
Inscribed, l.l.: "Motherwell 75"
Gift of William H. G. FitzGerald, Desmond FitzGerald, and B. Francis Saul II 1978
Acc. No. 1978.129.183

In 1968 Motherwell began a series of paintings of geometric austerity which signified a major departure from the organic forms of his preceding work. Called the Open series, these compositions usually consisted of rectangular or U-shaped motifs placed asymmetrically on a field of one modulated color. The form, suggestive of a window or door, had appeared in earlier works,[1] but in this group it was the only pictorial element. The precisely drawn lines of these geometric images, controlled and deliberate in their execution and placement, have a cerebral, almost serene quality.

With its vestigial rectangular form, *Gesture Paper Painting #2* is both a variation on the basic geometry of the Open series and a departure from it. The title itself alludes to the major aesthetic difference.[2] Moreover, this work is part of a larger body of acrylic drawings on handmade paper executed in the mid-1970s which are marked by a fluid sweep of the brush.[3] Here, however, the image is static, its form particularly reminiscent of the oriental calligraphy Motherwell admires. The broad but rigid strokes serve as a visual link between the crisp straight lines of the Open paintings and the organic forms of other gestural works on paper from the same period.

Motherwell's artistic obsession with black and white and his associations with these colors are well

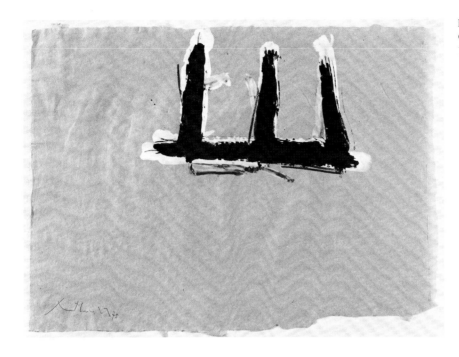

Robert Motherwell
Gesture Paper Painting #2
1975

Philip Guston
Untitled
1975

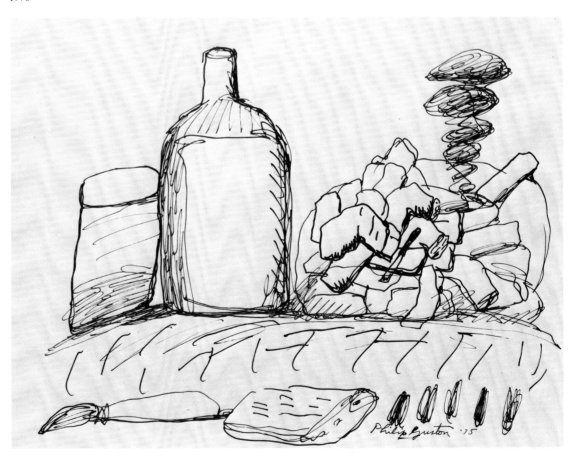

known.[4] He equates white with life and being, black with death and nonbeing.[5] *Gesture Paper Painting #2* expresses his view of the colors as protagonists: the underlying white motif is obliterated, destroyed as it were, by the black overpaint. Motherwell undoubtedly did not set out to visualize death destroying life. Drawing, for him, was and is an unconscious act. The shapes he draws result from artistic impulses, from confrontations with his materials. In this work the confrontational nature of the process is graphically explicit: the physical, violent cancellation of the white strokes by the black produces a visual statement that is psychologically disquieting.

EJN

1. Dore Ashton, "On Motherwell," *Robert Motherwell* (New York: Abbeville, 1983), p. 34.
2. The title was inscribed on the original mat.
3. For another example, see H. H. Arnason, *Robert Motherwell* (New York: Abrams, 1982), p. 93.
4. Stephanie Terrenzio, *Robert Motherwell and Black* (Storrs, Conn.: William Benton Museum of Art, 1980).
5. Robert Motherwell, "A Conversation at Lunch," *An Exhibition of the Work of Robert Motherwell* (Northampton, Mass.: Smith College Museum of Art, 1963), n.p.

70

Philip Guston
(1913–1980)

PHILIP GUSTON WAS BORN IN Montreal on June 27, 1913, to Russian Jewish immigrants. When he was six, the family moved to Los Angeles. When he began to draw at the age of twelve, his mother gave him a year-long correspondence course at the Cleveland School of Cartooning, which he never completed. At the Manual Arts High School in Los Angeles, Guston

met Jackson Pollock, who became a lifelong friend. After a brief period at the Otis Art Institute and several years of experience as a muralist, Guston went to New York late in 1935 where he became involved with the Federal Art Project of the WPA. In the 1950s he emerged as a key figure in Abstract Expressionism. A radical change in his style to cartoon-like representation made his later works controversial. He died in Woodstock, New York, on June 7, 1980.

Untitled[1] 1975
Black ink on paper
19¹⁄₁₆ × 25⅛ in. (48.3 × 63.8 cm)
Inscribed, l.r.: "Philip Guston '75"
Gift of William H. G. FitzGerald, Desmond FitzGerald, and B. Francis Saul II 1978
Acc. No. 1978.129.118

In the late 1960s Guston's art underwent a major shift. Dissatisfied with the abstractions he had been making for the past two decades, he began to draw objects in his studio out of a need to cope with tangible forms.[2] The style that emerged as Guston's final artistic statement created a controversy, as some critics welcomed its freshness and others saw it as self-conscious primitivism or found its political content simplistic.[3]

The essential ingredients of the style are evident in this drawing. Cartoon-like forms with strong outlines are silhouetted against an essentially void background. Generally flat in appearance, the objects are arranged as in a frieze on top of a broad, extended baseline. Most frequently the images in both paintings and drawings are autobiographical. Such is the case here with the pile of smoldering cigarette or cigar butts, whiskey bottle and glass, paint brush and palette—referring to Guston's

vices and passions.

The sloppy strokes applied quickly speak for the artist's interest in process; they also assert an anti-aestheticism. This is not a beautiful drawing finely executed but a seemingly fast recording of sensations or associations. Guston has written on how a drawing makes itself, how the image takes hold, and how this development in turn moved him toward the canvas.[4] In this way drawing was directly related to painting. Pieces such as this one, while preliminary to his work in oil, were not necessarily studies for specific canvases. They served as warming-up exercises in which images were explored.

The absurd, bulging, monumental forms turn this conventional still life of banal if personal items into a funky kind of self-analysis. They spread out and fill the picture plane as they did the artist's vision. The excessive character and obsessive recurrence of these particular motifs in Guston's work suggest that the images may be something more than humorous comments on the artist's bad habits,[5] but what they mean is ambiguous.

EJN

1. An erroneous descriptive title, "rocks and other objects," is given in *American Drawings, Watercolors . . . in the Collection of the Corcoran.*
2. Dore Ashton, *Yes, But . . . A Critical Study of Philip Guston* (New York: Viking, 1976), p. 154.
3. See Hilton Kramer, "A Mandarin Pretending to be a Stumblebum," *New York Times* (October 15, 1970): II, 27, and Robert Hughes, "Ku Klux Komix," *Time* (November 9, 1970): 62. For a favorable response, see Harold Rosenberg, "Liberation from Detachment," *The New Yorker* (November 7, 1970): 136–141.
4. Quoted in *Philip Guston* (New York: George Braziller, with the San Francisco Museum of Modern Art, 1980), p. 41.
5. An oil with the title *Bad Habits*, executed in 1970, contains some of these

objects as well as Ku Klux Klan figures (*Guston*, p. 86, Plate 44).

71

William S. Dutterer
(b. 1943)

WILLIAM S. DUTTERER WAS BORN on July 14, 1943, in Hagerstown, Maryland. He received his Bachelor of Fine Arts and Master of Fine Arts degrees from the University of Maryland. He has been teaching at the Corcoran School of Art since 1967. He divides his time between Manhattan and Washington and has exhibited his figurative work in both cities.

Topiary 1977
Acrylic paint and sgraffito on paper
49¾ × 38 in. (126.5 × 96.5 cm)
Inscribed, ctr.: "Top/William S.
 Dutterer/1977/Topiary"
Gift of the Women's Committee
 1979
Acc. No. 1979.16

Topiary is typical of a group of paintings on paper that William Dutterer executed between 1975 and 1977, a time when he was moving away from the minimalism that had characterized his previous work.[1] During this period of experimentation, Dutterer was attempting to develop a "vocabulary of images," expressed here in the combining of word and picture. Although the majority of these resulted from free association and many refer to Dutterer's personal interests, including stock-car racing and tatoo designs, others were the product of a methodical search through old dictionaries for archaic and whimsical words. Such was the case with *topiary*, a word not unfamiliar to the artist, but one that struck his visual fancy. The viewer would not know what signifi-

cance to attach to the oddly shaped animal if the word, given equal visual importance, did not bring to mind ornamental gardening.

The drawing of the giraffe-like animal is deliberately awkward, crude, and spare. The form is incised in layers of gray, green, and orange acrylic paint. Tiny flecks of green and orange are seen on the topmost gray layer. Dutterer began incising the surfaces of paintings at the same time that he developed an interest in tatooing and being tatooed. In his work, the artist often displays an absurdist sense of humor, which is well represented in *Topiary*.
ESC

1. Interview with the artist on November 9, 1985.

72

Jane Margaret Dow
(b. 1945)

BORN IN WASHINGTON, D.C., ON March 7, 1945, Jane Dow grew up in nearby Alexandria, Virginia. Although she had some art training when young and as a student of interior design at Purdue University, it was not until after returning to Washington in the late 1960s that she decided to become a painter. Between 1971 and 1973 she attended the Corcoran School of Art, working under Robert Stackhouse and Gene Davis among others. She exhibits frequently in the Washington area, where she makes her home.

Richmond Drawing #2 1978
Graphite over gouache on pale-
 gray-green Reeves paper
23¼ × 17½ in. (59.1 × 44.5 cm)
Inscribed, l.r.: "J. M. Dow 4–78"
Gift of the Women's Committee
 1980
Acc. No. 1980.52

This work is from a series of four graphite and gouache drawings done when the artist was visiting friends in Richmond, Virginia.[1] Circular bands of alternating mat black gouache and plain paper create a target configuration, barely discernible beneath swirls of shiny graphite that expand from left to right, activating the image. Within an elemental geometric form, the artist achieves complexity, movement, and depth.

The series occupies a special place in Dow's artistic development. The circular motif is a significant departure from earlier rectilinear compositions, which are self-contained and introspective. While the iconic presentation still invites contemplation, the circle, in retrospect, serves as a humanizing bridge between Dow's earlier meditative squares and her later figural compositions. Dow sees the circle as an organic and human form, suggestive of growth and fertility.

Placed below the center of the paper, the orb in this drawing appears simultaneously buoyant and weighty. Like the circle whose circumference is constantly changing and the twisting forms that move across it, the floating image—whether it is rising or falling—is in a state of flux. Alive with interior motion, the dark and mysterious globe seems to contain a core of light glimpsed through the black swirls.

Dow expressed the unlimited artistic and philosophical potential of the circle (or "O") in a poem written shortly after the Richmond drawings were created. Like the "O" in her poem, the circle here "in its finite form enables infinite explorations of space, mood, surface, subject, re-

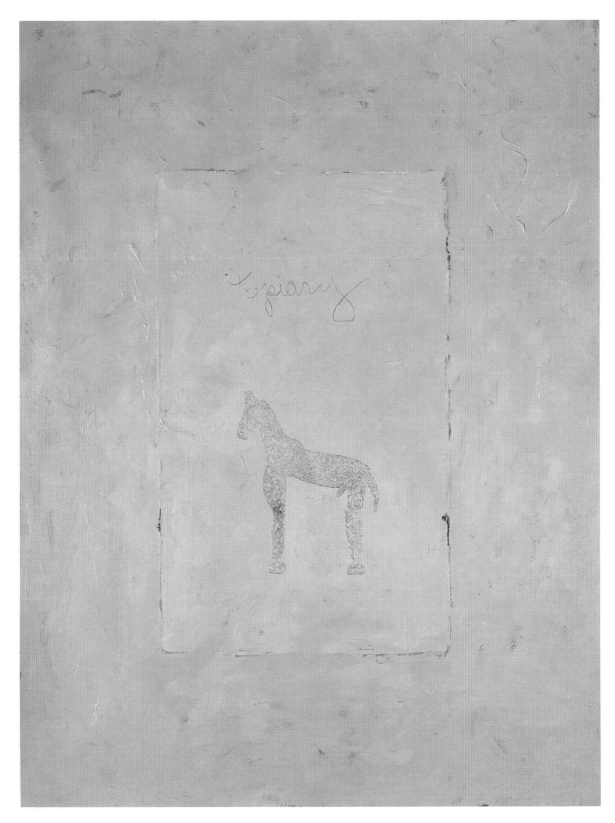

William S. Dutterer
Topiary
1977

Jane Margaret Dow
Richmond Drawing #2
1978

Kevin MacDonald
Kitchen Still Life
1980

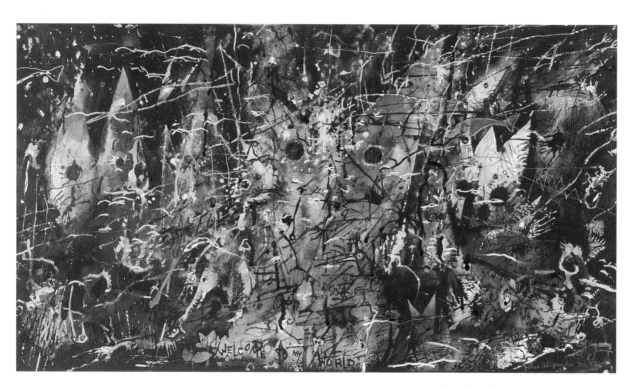

John Alexander
Welcome to My World
1982

lationships."[2] Both image and poem reflect Dow's interest in Oriental art and thought.

EJN

1. Interview with the artist January 13, 1986. See further her interview with Jane Livingston in *Five Washington Artists* (Washington, D.C.: Corcoran, 1976), pp. 54–56.
2. Quoted by permission of the artist in a modified prose form; for the original, see the brochure that accompanied her exhibition at Middendorf Lane Gallery, Washington, D.C., in February 1980.

73

Kevin MacDonald
(b. 1946)

BORN IN WASHINGTON, D.C., ON July 2, 1946, MacDonald studied art at Montgomery College, the Corcoran School of Art, and George Washington University. Trained as a painter, he began to focus on drawings after seeing an exhibition of Michael Clark's work at the Corcoran in 1971. At first he did architectural drawings, but by 1972 he was rendering interiors. In 1974 he introduced color into his work, and he has recently expanded his media to include pastel and oil.

Kitchen Still Life 1980
Colored pencil and powdered
 graphite over graphite pencil on
 Arches paper
22⁵⁄₁₆ × 30⅛ (56.7 × 76.5 cm)
Inscribed, recto, l.r.: "Kevin Mac-
 Donald '80"; verso, u.l.:
 " 'Kitchen Still Life' 1980"
Museum purchase 1980
Acc. No. 1980.102

Like so many of MacDonald's compositions, *Kitchen Still Life* is a memory image. Based on a particular kitchen from a house in West Virginia where he vacationed, the work was created sometime later. Although not a frequent subject in his oeuvre, the

kitchen is typical of the commonplace environments the artist favors.[1]

MacDonald is not interested in capturing a moment or in describing a scene. His people-less compositions, tinged with an air of loneliness and melancholy, achieve a timelessness through elimination of detail, simplification of form, and manipulation of light. It is the remembrance of an experience that he seeks, not the naturalistic recreation of a specific setting. The memory and the actuality blend to form a new reality free from temporal constraints.

Bathed with a light that emanates from the room itself, the kitchen in this work glows in a dream-like vision. MacDonald presents a mythic world: no flaw mars the crisp and beautiful forms; no clutter disrupts the distilled purity of the scene; no human presence destroys its unrelieved stillness. The inner light that emerges through veils of thinly applied color both defines and dissolves the objects and space. The artist's fastidiousness and his obsessive technique, which allow for no mistake or corrections, contribute to the magic of the image.

EJN

1. Interview with the artist, December 31, 1985. For additional information on MacDonald's subject matter, philosophy, and techniques see Clair List's interview published in *Images of the 70's: 9 Washington Artists* (Washington, D.C.: Corcoran Gallery of Art, 1980), pp. 50–57.

74

John Alexander
(b. 1945)

JOHN ALEXANDER WAS BORN ON October 26, 1945, in Beaumont,

Texas. He spent his formative years there studying art at Lamar University before going on to Southern Methodist in Dallas for a Master of Fine Arts degree. Alexander has had many individual exhibitions and participated in numerous group shows throughout the United States. His work is in major private and public collections. He presently divides his time between New York and Houston.

Welcome to My World 1982
Watercolor, sgraffito, and colored
 pencil on paper
16¼ × 28¹⁵⁄₁₆ in. (41.3 × 73.5
 cm)
Inscribed, l.c.: "Welcome to My
 World"; l.r.: "John Alexander
 Feb. 82."
Museum purchase, Anna E. Clark
 Fund 1982
Acc. No. 1982.7

Welcome to My World is typical of Alexander's compositions of the last ten years, whether in oil or watercolor. Fantastic creatures populate a landscape dense with vegetation and evocative of the swamps near Beaumont that figure prominently in the artist's work. Not infrequently saints and demons dominate his scenes, but here only the fish and the trinity of cat heads that loom like spectres in the dark expanse suggest some underlying spiritual meaning. Although he consciously employs such symbols, his pieces are less religious than psychological. They are dreamscapes; and despite the gestural brushstrokes derived from Abstract Expressionism, they share an affinity with the work of the nineteenth-century American artist Albert Pinkham Ryder, and more distantly with the fantasies of Hieronymus Bosch, whose *Garden of Earthly Delights* is among Alexander's

earliest memories.[1] Alexander views his painting as a form of exorcism,[2] an outlet for strong personal feelings, an attempt to capture the energy found in fanaticism or voodoo. Making art is a spiritual experience, the artist has remarked, and it must come from the heart and inner psyche.[3]

Welcome to My World reveals Alexander's emotional response to an internalized world in its haunting subject matter, scarred surface, and impenetrable space illuminated and charged by vibrant color-like brilliant flashes of hallucinatory light. The title, inscribed in childish block printing across the bottom, contrasts with the adult script signature of the artist in the lower right; it reinforces the impression that the image was executed in another state of consciousness. It also invites the viewer to enter the painting as well as the dark recesses of the artist's mind. Alexander does not expect us to linger in this primal and frightening dream world any more than we would linger in our own nightmares, but the archetypal forms provide a link between the artist's vision and the collective unconscious.

EJN

1. Telephone conversation with the artist, December 27, 1985.
2. *Ibid.*
3. From an interview with the artist conducted by Jane Livingston and Donna Tennant, *John Alexander* (Washington, D.C.: Corcoran Gallery of Art, 1980), n.p.

75

William Dunlap
(b. 1944)

WILLIAM DUNLAP WAS BORN ON January 21, 1944, in Webster County, Mississippi. He attended Mississippi College in Clinton and the University of Mississippi, which awarded him a Master of Fine Arts degree in 1969. Dunlap has taught art at Appalachian State University in Boone, North Carolina, and at Memphis State University, Tennessee. His work, frequently shown in museums and galleries, is in private and public collections in this country and abroad. He now lives in McLean, Virginia, outside of Washington.

Spring Storm—Valley Series 1982
Acrylic, graphite, and colored pencil on paper
44¼ × 89½ in. (112.4 × 227.3 cm)
Inscribed, l.r.: "W Dunlap '82"; l.l.: "Spring Storm—Valley Series"
Gift of the Women's Committee 1982
Acc. No. 1982.43

Spring Storm is part of an open-ended series Dunlap began in the early 1970s. The artist views the works as autobiographical reflections of his agrarian roots and of his travels on Interstate 81, which runs along the Blue Ridge Mountains.[1]

His work combines the pictorial illusionism of nineteenth-century American landscape paintings with contemporary interest in process as an artistic concern. Dunlap wants the viewer to become involved with the way in which the work was created as well as with its subject matter.

Artistic process is evident in *Spring Storm* in the gestural spattering of paint, the incised grid-like lines, and the unfinished foreground. But the painting also poses contradictions, visual and intellectual, which are perhaps at the heart of Dunlap's vision. Works like *Spring Storm* seem topographical when in fact they portray no specific place. They are amalgams of visual elements lifted from photographs taken during the artist's extensive travels. The resultant images are intentionally deceptive; Dunlap wants the viewer to think he remembers the actual site depicted.

The work is contradictory in other ways. Although *Spring Storm* is illusionistic in its almost photographic representation of a synthetic "real" landscape, the artist destroys the illusion and reasserts the two-dimensionality of the picture plane with the spattered paint, incised lines, superimposed letters and numbers. The lines suggest a grid, but they do not function as such. The numbers and letters, too, hint at some hidden meaning, and yet there is no conscious symbolism. The medium is primarily thin acrylic washes, but the effect is that of watercolor.

Dunlap talks about how the numbers and letters are selected randomly; they and the lines function compositionally. But they are also reminders of how the land has been surveyed and divided. At the same time that these anti-illusionistic forms establish the two-dimensionality of the image, they suggest a tension, if not an antagonism, between nature and the geometry of landscape fashioned by man. The ambiguity of these nonpictorial elements, their provocative presence in a seemingly naturalistic landscape, command the contemplation the artist desires. They also, perhaps unconsciously, visualize the contradictions inherent in both contemporary art and life.

EJN

1. Interview with the artist, December 3, 1985.

William Dunlap
Spring Storm—Valley Series
1982

Index to the Catalogue

Catalogue numbers preceed
illustration references.